50 PORTRAIT LIGHTING TECHNIQUES

FOR PICTURES THAT SELL

John Hart

50 PORTRAIT LIGHTING TECHNIQUES
FOR PICTURES THAT SELL

AMPHOTO
American Photographic Book Publishing
An imprint of Watson-Guptill Publications/New York

Copyright © 1983 by John Hart

Published in New York, New York by Amphoto Books:
American Photographic Book Publishing, an imprint of
Watson-Guptill Publications, a division of
Billboard Publications, Inc., 1515 Broadway,
New York, N.Y. 10036

Published in Great Britain by Patrick Stephens Limited,
Bar Hill, Cambridge, CB3 8EL
ISBN 0-85059-653-X

Library of Congress Cataloging in Publication Data
Hart, John Patrick.
 50 portrait lighting techniques for pictures that sell.
 Includes index.
 Supt. of Docs. no.: I 28.156:
 1. Photography—Portraits—Lighting and posing.
I. Title. II. Title: Fifty portrait lighting techniques
for pictures that sell.
TR575.H26 1983 778.9'2 82-24462
ISBN 0-8174-3861-0

Manufactured in the United States of America

First Printing, 1983

2 3 4 5 6 7 8 9/88 87 86 85 84

Concept and documentary photography by Els Sincebaugh
Edited by Marisa Bulzone
Designed by Bob Fillie
Diagrams by David Lindroth
Graphic Production by Hector Campbell

This book is dedicated to my parents, Elizabeth Ruth Hart and Charles Edward Hart.

A very special thank you to Ron De Martino and Herb Fogelson, whose advice has always been appreciated. Custom photographic services were provided by Dan Demetriad, Inc., of New York City. My gratitude also goes to the following people, who were kind enough to model for the photographs in this book.

Dixie Briden
Tim Cahill
John Calonius
Jill C. Cronin
Margie Currie
Renee Ennis
Michele Ferguson
Cathy Greene
Mary Kay Greene
Geoffrey H. Haberer
Carol A. Hansen
Bob Heitman
Michelle Jones
Charlie C. Jordan
Andrew Leone
Cathy Lewis
Paul H. Linnell
Denise Marcoux
Paul D. Mazza

Michael McDonnell
Sean Murphy
Cindy Neilson
Missy O'Shea
J. Lawrence O'Sullivan
Ilana Rapp
Lea Rapp
Claudia Rhodes
Fred Rose
Robert M. Rowley
Winnie Sager
Carol Lee Shahid
Mary L. Snead
Cynthia Sullo
Crist Swann
Frederick C. Venturelli
Kate Warne
Robert Winston

CONTENTS

THE PROFESSIONAL SIDE OF PORTRAIT PHOTOGRAPHY

PREFACE

When I was in the eighth grade I sent away for my first mail-order camera (could it have only cost $20?), and began to use it to photograph my family and friends. I remember sketching portraits at the time as well—even then I was fascinated by people's faces.

I went to Fordham University in New York to get a degree in education and returned to Indiana to get my M.A. in Fine Arts, specializing in portrait painting, from Notre Dame University, but I kept up with my camera work on the side. While on my fellowship at Notre Dame, I taught basic drawing, shading, perspective, and figure drawing in the Art Department. After I got my degree they hired me for the Theater Department as a set designer and painter. I also had to light the stage and this is where I developed my basic understanding of lighting.

I returned to New York in the late sixties and I was doing part-time photography and graphic designs for a company called Unicorn Creations when, for extra money, I joined Actors Equity. I was cast to play Lentilus in *Androcles and the Lion*, and found myself on tour in western Massachusetts with a group of actors. For three months we were giving performances for grade school kids at 9:00 in the morning. To save my sanity, I bought a used Leica III and photographed the cast, the show, and other local scenery. When I returned to New York I showed the portraits I had taken to various actors' agents that I knew, and brought my portfolio around to some others. The agents liked what they saw and began recommending me to actors who needed 8 x 10 glossies for their acting work. That was over ten years ago and I've been busy ever since.

I learned to use reflectors and hand-held meters for incident light readings in New York while I was working as an extra on movies. I saw them being used, studied how they were used, and learned to use them myself. I also learned a lot from studying pictures of how movies are made.

I didn't start out with a studio. I had a four-flight walk-up near Central Park, so I'd simply meet clients in the lobby (it was a nice one) and we'd walk over to the park. I was lucky—the weather was good most of that year. I still had that Leica III and I got great shots using just the camera along with my trusty reflector. If actors and models wanted a variety of portfolio pictures, I used the city as my studio, and got terrific location shots!

I finally got my own small studio (noisy, but still close to the park), and a new Nikon with a 105mm portrait lens. The 105mm lens is considered the best lens for portraiture and is the lens I use most in my work. Business became quite regular, and I eventually moved to a larger studio, but I still try to take one roll in the park and one indoors.

I found, in photographing people outside, that there are two ideal outdoor situations: either they're in the sunlight with their backs to the sun and their faces are lit by the reflector, or they are standing in the shade, facing the light source. Tunnel lighting is a perfect example of this—light coming at the subject from a diffused source. Light from the shade of a tree with the subject facing the sun gives the same effect.

In the studio I set up my lighting to simulate outdoor lighting. I backlight the hair (sun), and use the large, soft, reflected light (natural diffused fill light) plus the reflector.

I think the ideal studio setup would be to have a curvilinear Cinemascope screen with a row of lights behind it. That would give almost 180 degrees of light coming at a face. This is why scoop lights were invented—the light source is behind a concave reflector, so the light is bounced off a large curved area—as is natural light outside in our environment.

So here I am, some years later, and I'm still excited about my work—always looking forward to seeing the shots I took today. I try to vary the backgrounds and accoutrements of the studio a bit to break the visual monotony—a new chair, a new light, a new hair filter or lens (like a new piece of clothing or a new hairstyle, it keeps your morale up).

Portrait photography to me is the top of the line for a photographer. We're right in line with the old masters of painting. We deal with people and their personalities, human beings with all the pluses and minuses of their lives, and for a brief moment of a given day they

are putting themselves in our hands with their trust. We have to capture that trust, along with their sensitivity and warmth.

Are you going to be able to capture that "spark of fire," as George Bernard Shaw said, and put it on film for all time? Yes! Why shouldn't your best photographs be seen and admired now and for times to come. Never forget that you are an artist—anything less and you're not being true to a creative profession. Strive for that excellence—you're going to be too good to settle for less-than-the-best!

I wrote this book because I felt that photographers needed a comprehensive text dealing with the very specialized area of lighting portrait photography. Other books seemed either too technical or too esoteric and difficult to follow. My aim was to make available to the serious photographer an attractive, easy-to-follow book on portrait lighting techniques that also conveyed my love of photography as an art.

As a portrait photographer working in New York City, under the pressures of giving my clients a photograph that not only has to please them, but be acceptable to a wide range of demanding theatrical agents and movie and television casting personnel, I feel I have developed a style that is successful and techniques that

will be useful to other photographers, especially those just starting out.

I photograph between four and five hundred actors, executives, and various professional people each year. Each portrait has to please a wide audience because it is used primarily for publicity purposes, to be seen by thousands, even millions of people in newspapers and magazines.

These added "pressure points" have helped me to refine and chisel my techniques. Thus, my style, with its various ramifications, I feel, can be of use to the beginning photographer, and to the established photographer who wants to develop some new techniques of his own. In any case, I hope you will find that it is a beautiful book just to look at and enjoy.

To the photographer just starting his own studio, be it in a small town or large city, here, at last, is a book from which he or she will derive all of the knowledge needed to get started. And, although the technical side of the business is certainly stressed, the dedicated photographer as a creative artist is constantly emphasized.

To each of you, I wish the same sense of fulfillment that I have experienced over the years being involved in portrait photography. Good luck!

WHAT YOU CAN LEARN FROM THIS BOOK

This is an unusual book on lighting. The technical section covers 50 portrait sessions, illustrates the procedures involved in each of them, includes diagrams to show the setup of lights and reflectors, and critiques the resulting images. You can teach yourself to set up professional lighting arrangements, and to take top-quality portraits by using this book.

Each description has an introduction that tells you the nature of the lighting technique, when to use it—and when not to use it. Some techniques are better applied to certain subjects than to others.

The introduction is followed by a brief discussion of equipment and setup, which is illustrated with pictures of the actual portrait in progress. A diagram supplements these pictures, giving you complete information on how the lights were placed.

The procedure section tells you exactly how to re-create the same portrait session in your own studio. It tells you how to arrange the studio and coach your model through the session for spectacular portraits. Helpful advice is given when needed in this section. After you've studied all 50 technical sessions, you'll have an excellent knowledge of the craft and art of fine portraiture.

The conclusions are the final section of each of the 50 technical demonstrations. Each is a critique of actual pictures that resulted from the sessions shown, and explains why the final picture was chosen.

One of the main purposes of this book is to teach you that the use of reflectors and reflected light is as important as the use of lights. Light bounces off everything in its path. I like reflected light—it is softer because it has become diffused after bouncing off something in the

path of the original light source. It's more natural, and gives a more natural glow to the face. Reflected light imitates outdoor lighting. Direct sunlight is too harsh, as is a direct spotlight on the face. You have to use reflected light to soften it and keep a portrait realistic. No one walks around in real life with a hot, strong light on his face. We see people lit by natural light or light bouncing off walls and ceilings.

Portraits that emulate natural light are still the best. Nothing excites me more than seeing a portrait with natural looking light.

In the business section of this book, I have adopted a question-and-answer format that I know will be of great usefulness. Most of the questions I am most often asked pertaining to the starting of a portrait studio are answered, and I've given advice on everything from beginning camera and lighting equipment to general makeup advice, and bookkeeping and financial procedures.

I have tried to make this a comprehensive book that attractively illustrates techniques without becoming too remote or academic. There are 50 techniques explained here; however, most photographers don't use this many because they've gotten into a rut, or have developed a specific style of their own that they need to continue for their creative identity. For the more specialized photographer, these techniques can broaden the range of his style. For a beginning photographer who doesn't want to spend the time and money involved in opening his own studio, this text will be a marvelous reference for the "semi-professional." I hope that all of you will find this book to be the stimulus for that creative impulse that has perhaps lain dormant.

SEVEN KEYS TO SUCCESSFUL PORTRAITURE

SKILLFUL LIGHTING

The essence of a good portrait is defined by its lighting. It is light that shapes and defines a face, emphasizes certain features over others, and it is the lighting that makes the difference between a good and bad portrait.

Learning to work with light and reflected light is a highly developed skill with which a photographer can draw out a representation of an individual that expresses his subject's personality as well as physical appearance. A portrait is the communication of what people *are* like as much as what they *look* like.

CONCEPT AND MOOD

Many portraits are successful because they are *conceptual*; they signify an emotion, mood, or state of mind. The pose becomes important in the creation of a conceptual portrait. A slight tilt of the head, the expression in the eyes, a captured second of spontaneity—all add up to more than just a picture of the face.

The environment or studio setup plays a role as well in building up a mood in a photograph. Authentic-looking indoor and outdoor backdrops and lighting based on outdoor light help to develop a natural style in your portraiture.

DIRECT EYE CONTACT WITH THE CAMERA

Professional models learn to relate directly to the camera so that in the finished photographs their eyes meet with those of the viewers. This is an important element in a successful portrait, whether working with professional models, or nonprofessional subjects.

You, the photographer, are the catalyst who draws out a subject's personality and captures it on film. Looking through the camera, you have contact with the subject's eyes. Learning to direct the subject to relate to the camera will give your portraits impact and personality.

PHOTOGRAPHER/CLIENT RAPPORT

The individual coming to you for a portrait has a personality different from every other person in the world. The portraits that you take of that person should look different from all of the others you have ever, or will ever, photograph. To do this, you have to establish a rapport with your client, and concentrate solely on that individual during the session. If you are relaxed and professional, your client will relax and be cooperative. Try to establish a positive, upbeat relationship as soon as your client arrives at the studio. Let the client feel as if he or she is special, unique, and has never felt better.

COMPOSITION

A subtle use of good compositional techniques will improve your portraits.

Try frontal, three-quarter, and profile views. Study the background and have it shaded in a way that becomes a compositional element. Work with props for dynamic structure in your images.

As in any kind of visual art, certain compositional techniques always add to a strong image: arranging elements along the diagonal in a picture, dividing the background into thirds, offsetting the head from the middle of the frame, framing the face with various elements—all of these compositional considerations will add quality to your portrait work.

MAKEUP

Professional-looking makeup is a key to good portraits for both men and women in color and black-and-white portraiture. Makeup can bring out the best features of a subject, define bone structure, highlight an individual's coloring, and create a special "look" that will result in a superior image. Makeup need not be professionally done to be successful. There is a brief section in this book that will teach you the basics.

COACHING THE SUBJECT THROUGH THE SESSION

Knowing how to direct the portrait session involves telling the subject how to move, how to pose, what to say, and where to look.

Coaching a client is simple—asking the subject to say "Hi!" or "Gee, I feel terrific!" to the camera can bring flattering spontaneity into the images, and a good, positive attitude to the session. Imagination on your part as well as your client's is one of the secrets to successfully coaching a model through a session.

MAKEUP TECHNIQUES FOR MEN

The subtle application of makeup is an important element in a successful portrait. Makeup can bring out the best features of your subject's face, and help retain a three-dimensional appearance in a portrait. Even your male subjects will benefit from the skillful application of makeup for highlighting and shading.

In general, men should be made up to give the illusion of a tanned, sporty look. This effect is created by imitating a slight sunburn on the forehead, the top of the cheekbones, and the nose and chin. For an executive portrait, this effect would be toned down slightly.

Your male subjects may resist the idea of wearing makeup for their portrait, but you can simply explain that you are making them up as if they are an anchor man on the evening news.

The following procedure outlines the basic diagram on the next page. You don't have to follow it exactly.

1. Use a dry pancake makeup in a bronze color to give a tanned look to the brow, chin, neck, and sides of the face.

2. Brush a bit of red-brown powder on the bridge of the nose.

3. Add darker pink or burgundy blush to the *top* of the cheekbone.

4. Shade the temples with a deeper burgundy color.

5. Lighten the areas under the eyes, if necessary, with flesh-toned cover stick.

As with all makeup, but most especially for men, use natural colors, blend carefully, and use a subtle hand in application.

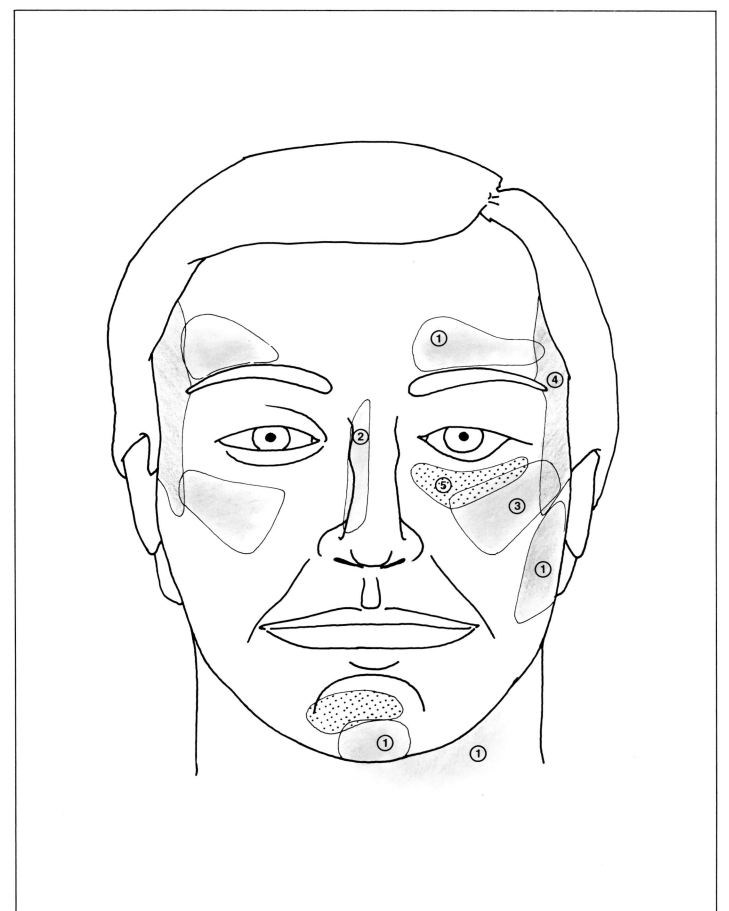

MAKEUP TECHNIQUES FOR WOMEN

Always avoid thick makeup or a heavily made-up look. Keep the face soft and natural looking by building the makeup up in layers. Check the face through the lens before you begin shooting to see how it looks under the lights, and make any necessary adjustments.

Your main purpose is to give each individual face the contouring it needs for the camera. Some highlighting and shading is needed for practically everyone to help the face hold on to its contours. Makeup helps the portrait photographer achieve that sculptured look we observe in real life.

Flat powder makeup is preferred for the base and for adding highlights. I find the liquid foundations a little too thick and shiny. The lights seem to blend better on the face with flat powder makeups.

Don't overdo eye makeup. Like everything else, it's a balancing act. Not too much here, a little more there—it's different for each individual face.

Never forget that for all the makeup in the world, nothing makes up for the beauty within. That's your job—capturing the inner *and* outer beauty.

The following sequence corresponds to the basic diagram on the following page. It does not have to be followed exactly.

Apply a light beige foundation to the face, and then:

1. *Highlight and shade the nose subtly.* Often, with a very aquiline nose, no shading is needed. Only use shading for a slightly larger nose, or for one that is slightly larger around the nostrils. Be subtle about it—you don't want the shading to come out too dark in the final portrait, be it color or black-and-white.

For shading I use a sable brush and two basic shades of powdered blush. Use a deeper burgundy color for the shaded areas of the face and a pink for the cheeks.

2. *Shade the temples with deep blush.* This temple area can also be blended into the outside of the eyelid. Blend *softly* into the forehead.

3. *Define the eyes with shading.* Add a deeper copper or darker brown to the outer bone structure of the eye socket.

4. *Remove the shadows under the eyes.* It seems that everyone goes a little darker under the eyes. It goes from a a bluish color in some to a darker brown in others. Depending on the degree of darkness, you can first use a white coverstick, and then cover with the lighter beige base.

Think of a half moon as you extend the lighter shade from under the eye back over the top of the cheekbone and then blend it into the darker temple.

5. *Use pink blush on the cheeks.* Barring the high fashion look, I think that a bit of pink is a young, fresh look for women of all ages. It seems to lift the entire face and give it a natural buoyancy. It is particularly good for women with long or thin faces, as it adds a horizontal look to the face, offsetting its longness. For the fuller face, keep the pink and burgundy shades more to the area of the cheekbones.

6. *Shade under the cheekbones.* For most women, shading under the cheekbones brings out the whole contour of the face and defines the eyes, the nose, and the lips. Highlight the jawline to bring out the shaded cheekbone. With your brush, bring the deeper shade of blush down from below the temple at an angle towards the mouth.

7. *Highlight the chin.* This brings out the chin and keeps it from receding.

8. *Makeup the eyes.* A separate diagram follows, detailing this procedure.

9. *Makeup the lips.* Pink shades of lipstick, perhaps leaning to an orange-red, used with a not-too-shiny lip gloss, are best for black-and-white and color photography. Deeper burgundys can be used for a more glamorous or high-fashion look. Experiment here for your own "look." Try to avoid a harsh, brittle look for the lips. Don't outline too much—think soft, soft, soft.

10. *Shade under the jawline.* Depending on the fullness of the face, some shading under the jawline will be beneficial. Use the darker shade of blush for this.

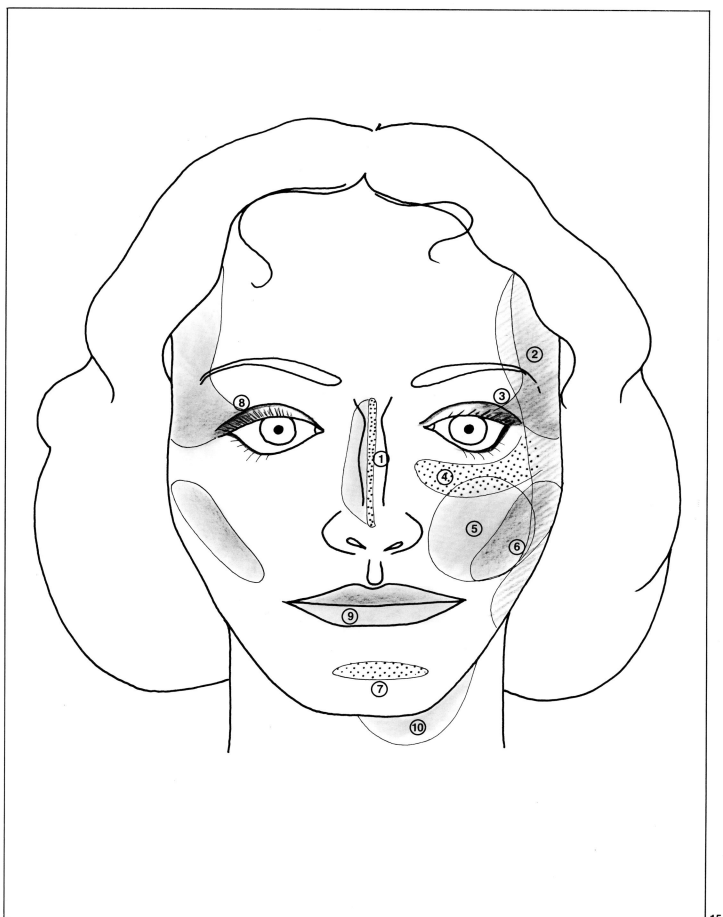

EYE MAKEUP

1. Eyebrows should be soft and feathery. No harsh lines.

2. Highlight here by adding some white to the beige base.

3. Blend the deeper blush in gradually, back toward the temples. Add some dark brown to the base of this area.

4. Darken the upper eyelid with dark brown pencil or a small sponge applicator. Always start blending from the center out. Don't carry a harsh black line all the way over to the inside of the eye. Don't line the top of the lower eyelid.

5. Apply black mascara to the upper and lower lashes—not too thickly, however.

6. Apply eyeliner to the outer edges of the lower lid. Start the eyeliner from the center of the eyelid, thick-ening it gradually as it moves to the outer edge of the eye.

7. Some white cover stick and the lighter base have lightened and highlighted this area. Take this lighter shade and blend it back into the temple area. More white can be added to highlight the cheekbone a bit more.

8. Blend pink blush on top of the base with the sable brush.

9. The area under the cheekbones is shaded with the deeper blush colors. The shading is angled slightly down from the back of the cheekbone toward the outer edge of the lips, stopping, of course, just below the cheek area.

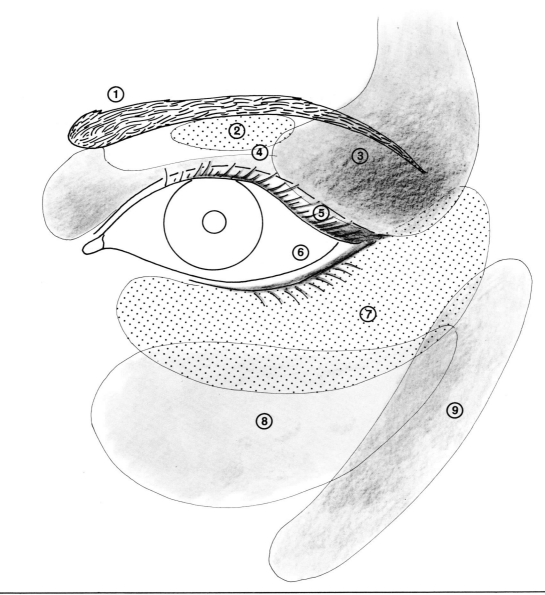

MAKEUP TECHNIQUES FOR CHILDREN

Makeup for children is, as you might expect, kept at a minimum. However, the child will have a healthier-looking skin tone in a portrait with the addition of a little color.

For girls, use a touch of light cover up under the eyes to avoid shadows (yes, some children do have them). Add some pink blush to the cheeks, as shown in the diagram above, for a nice, healthy, outdoor look. For children who are very blonde, you might want to add a minimum of mascara.

Little boys absolutely hate to wear makeup, so don't bother to use any. Just have them pinch their cheeks lightly to add some color to the face.

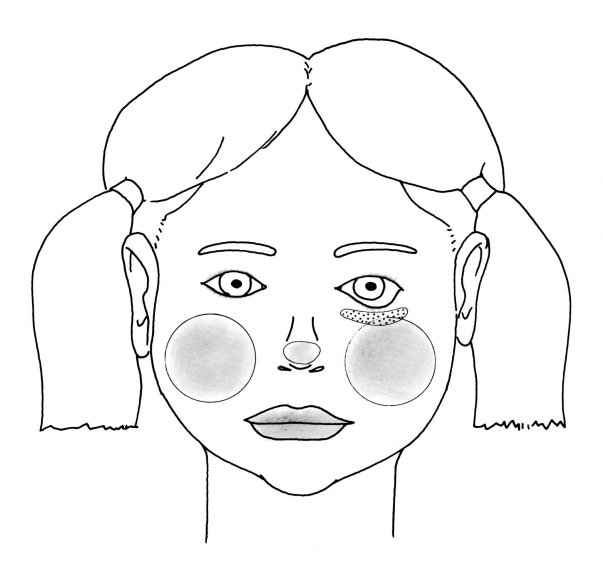

PART ONE

THE TECHNIQUES

UNDERSTANDING THE LIGHTS USED IN THE 50 TECHNIQUES

The lighting techniques presented here range from using available light alone to techniques using flash (indoors and outdoors), and indoor techniques requiring from one to five lights. The majority of portrait lighting techniques employ three lights in varying arrangements. With whatever equipment you have, you can use some—or all—of the 50 techniques to improve your portrait photography.

As you study the sessions and diagrams shown in each technique, you will learn the two essential aspects of lighting in portraiture: 1) the placement of lights for specific effects and 2) the use of reflectors to bounce additional light onto the subject. Learning the skillful use of both aspects will help you refine your portrait lighting skills to professional standards.

A few words are in order on the terminology applied to the lights used in the 50 sessions that follow.

A—*key light.* This is the light that essentially creates the specific lighting effect. It is supported by the hair light and fill light. Because of its role in creating an effect, the key light is used in a wide variety of positions. Study its position carefully in the diagrams.

B—*fill light.* This light adds diffused illumination to areas that would be in heavy shadow if you worked with the key light alone. Its position varies from technique to technique, but it basically remains in front of the model to fill in shadows that would detract from the portrait effect.

C—*hair light.* This light generally adds extra illumination to brighten the hair and one side of the face.

D—*additional fill light.* In certain situations where a great deal of fill light is required, an additional diffused light is used.

S—*strobe unit with umbrella.* Additional synchronized units are designated S1, S2, etc.

You will notice that most of the techniques shown here are accomplished using lights rather than strobe units. Though strobe portraits are perfectly acceptable for personal and commercial use today, the art of portrait lighting is still best learned and assimilated through working with lights. Many subjects prefer working under hot, bright lights, as it helps draw out their innate "star quality." And many photographers prefer the finely modelled effects they can obtain from a creative use of lights, individualized for a perfect portrait expressing each subject.

All of the 50 techniques are equally applicable to working in black-and-white or color. Many of them are shown in black-and-white in order to help you *see the effects of light* in each situation without being distracted by color.

Working with these techniques should help you learn to see light better than you ever have in the past. This will improve not only your portraits, but your photography in general, for photography is, very simply, the process of recording light on film.

This is a pair of diagrams to illustrate the explanation of lights. The pair of diagrams show how (A) moves but retains its role as the key light. It is essential to your understanding of lighting arrangements to know that (A) can move all around the studio to act as a hair light or fill light, while (B) and (C) remain in their roles for the most part.

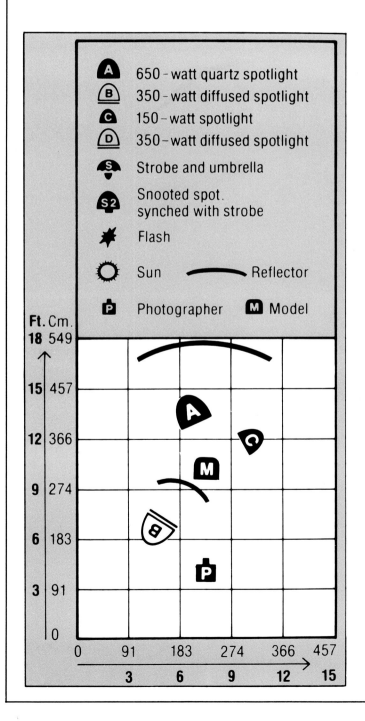

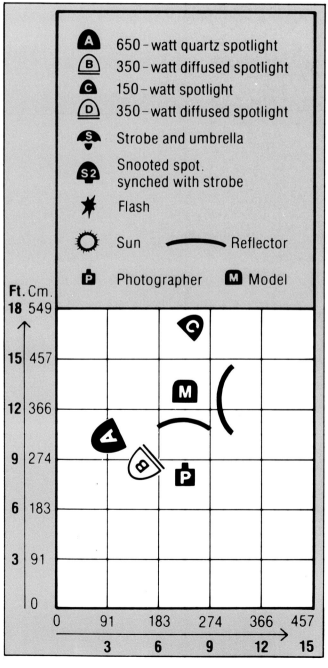

BUTTERFLY LIGHTING

Butterfly lighting is a romantic portrait technique. It also has a nostalgic aspect, because it was used for many portraits of movie stars, particularly Marlene Dietrich. The technique derives its name from the distinctive, butterfly-shaped shadow that appears under the subject's nose as a result of a lighting scheme involving a strong, elevated, frontal-light arrangement. This is a good technical choice for a pretty model with classic features, and is much more effective for fine portraits of women than of men. Since the object of this technique is to produce a pictorial shadow under the nose, this technique is most appropriately used with a subject whose nose is attractive. Butterfly lighting is a center-weighted portrait technique in the sense that the result of the lighting is to draw the viewer's attention firmly toward the center of the face. Experiment with however dark a shadow you feel is best when using this technique—it may be most attractive if it is dark, but you might find that it works better if filled somewhat with reflected light.

EQUIPMENT AND SETUP

Three lights are used for this setup. The 650-watt quartz key light (A) is raised to a height of about seven feet (213 cm) for this seated model, and placed nearly above the photographer's head, but slightly to the left of the center of the model's face. This slight variation from straight-on lighting serves to add variety to the portrait by emphasizing one side of the face. This light is placed high to draw out the cheekbones and define the butterfly shadow. The 350-watt front diffused scoop light (B) is about two feet (61 cm) lower than the main light, and is directed at the right side of the model's face. It is angled downward a bit to strike the reflector, which will bounce light back into the eye area. This light is used to gently fill in the facial shadows, without losing the impact of the lighting setup. A 150-watt spotlight (C) is used as a hair light for this setup. It is placed behind the model, and to one side. Its position is adjusted to suit the photographer's position, achieve proper hair lighting with no obtrusive reflection off the aluminized backdrop, and ensure that there is no glare on the part in the model's hair.

PROCEDURE

1. Adjust and turn on the key light (A). Raise it until the butterfly shadow is regular and apparent, but not touching the lips.

2. Turn on the diffused fill light (B) and angle it so that when the reflector in front of the model is tipped, there is a visible difference.

3. Check the model's hair and makeup.

4. Turn on the hair light (C). Move your hand back and forth between the model and the light to test that it is not hot enough to burn the model or her clothing. Turn on a fan if it will keep the model more comfortable, but move it far

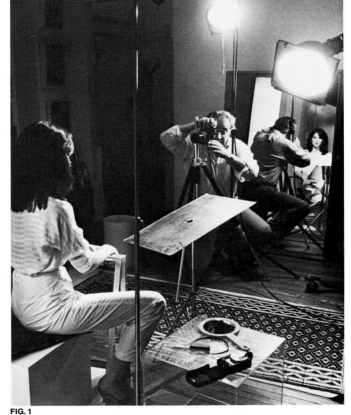

FIG. 1

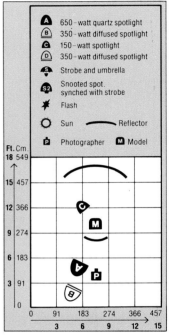

Ⓐ	650 - watt quartz spotlight
Ⓑ	350 - watt diffused spotlight
Ⓒ	150 - watt spotlight
Ⓓ	350 - watt diffused spotlight
Ⓢ	Strobe and umbrella
Ⓢ2	Snooted spot. synched with strobe
✳	Flash
○	Sun — Reflector
Ⓟ	Photographer Ⓜ Model

enough away that it won't blow her hair into her face.

5. Check the setup through the viewfinder.

6. Take an exposure reading and select your setting.

7. Check the background and make sure that there is no flare caused by the lights.

8. Tell the model what you are trying to do. Work with her to adjust the reflectors properly.

9. Experiment with the reflectors and try a few shots with tonal variations in the butterfly shadow.

10. Check that the model is keeping her chin slightly lowered and that the butterfly shadow is regular and no longer than half the distance between the nose and lips.

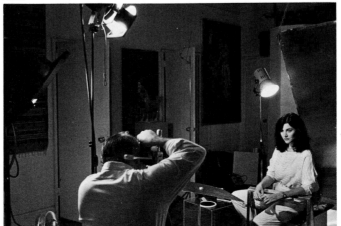

FIG. 2

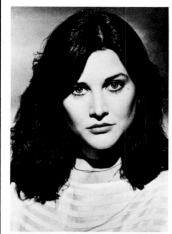

FIG. 3

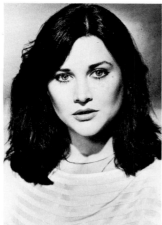

FIG. 4

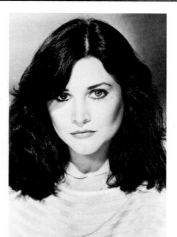

FIG. 5

CONCLUSIONS

Fig. 3 was taken using only the main 650-watt quartz light (A), elevated high above the level of the model's head. Asking the model to lower her chin brought out the butterfly shadow, but the overall effect obtained by using only one light is flat and severe. Fig. 4 demonstrates the addition of the diffused, frontal fill light (B), which brightens the face considerably and makes it more three-dimensional. Though there is good eye contact; the picture does not adequately highlight the eyes. The importance of working with reflectors as well as lights is shown in Fig. 5. Notice how the addition of an aluminized reflector, tipped by the model, brings light and even more depth to the face. Using this reflector, rather than more lights, gives the portrait a rich glow while enriching shadow detail and maintaining good contrast.
Fig. 6 is the portrait finally chosen from the session. It features modified butterfly lighting—the characteristic shadow under the nose is filled in somewhat by reflected light, producing a softer effect. This portrait is successful because the lighting flatters the model's distinctive cheekbones, lights up her large eyes, and maintains her rich, dark hair against a simple, but varied, background. It is a classic portrait employing a specific lighting effect. The technique does not overwhelm the beauty of the model, it compliments her.

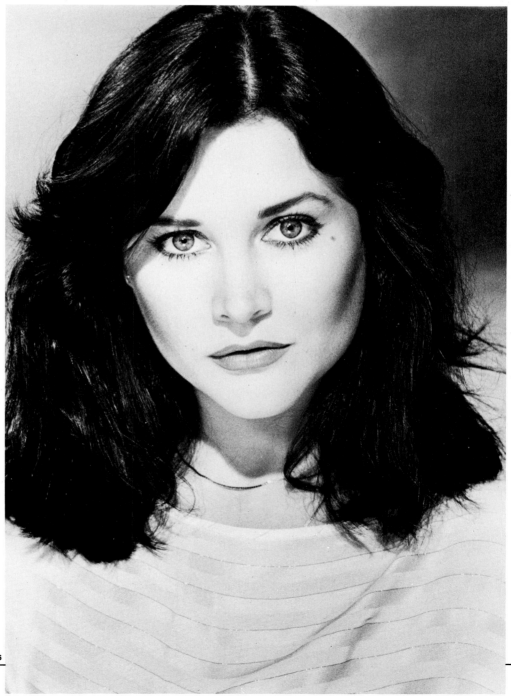

FIG. 6

REVOLVING AROUND A LIGHTED SUBJECT

Portraiture is an art that relies on the photographer's skill in building an environment of light and shadow that shows his subject to the best advantage. Learning to compliment a person with lighting setups is a process that demands creativity and good photographic knowledge. It's important to follow the "rules" in photography, but don't overrule your visual instincts when you look through your camera and see something special that those "rules" didn't anticipate. For example, moving around a subject within the same lighting setup can result in surprising lighting effects and portraits that are out of the ordinary. Keep in mind that portraits need not all be taken from a frontal view. Once your model is well lit, take a moment to walk around and observe the effects of your lighting arrangements in profile, three-quarter, and from other angles. Though our habitual view of people is straight on, fine portraits can be made from other angles, which express the subject differently by emphasizing aspects of the bone structure. Look for the angle that expresses your subject best.

EQUIPMENT AND SETUP

A simple, three-light setup is used for this session. The diffused frontal key light (B) is located to the left of and behind the 650-watt quartz key light (A), and is also aimed directly at the model to fill in the harsh shadows cast by the key light. The key light is elevated to four feet (30 cm) and is a 650-watt quartz light placed directly in front of the model, and angled directly onto her face. A 150-watt hair light (C) is directly opposite the key light, and is fairly low. The hair light is angled downward to illuminate one side of the hair, and also so that there is no flare in the lens as the photographer works at eye level. The camera is mounted on a tripod to maintain shooting at eye level, and is moved throughout the session in an arc around the model. The arrangement of reflectors works to fill in shadows subtly. The hair light is reflected onto her face from the model's white blouse, the columnar reflector at her left, and the aluminized reflector positioned in front of her, and onto her back from the floor and backdrop.

PROCEDURE

1. Turn on the key light (A) and raise it to the height that best illuminates the model's face.

2. Turn on the fill light (B) and position it so that it fills in any harsh shadows.

3. Check the model's makeup, hair, posture, and clothing. Make sure there are no hot spots on jewelry and that the collar is straight.

4. Turn on the hair light (C), and check that it does not cause flare in your lens. Angle it down to bounce off the reflective surfaces.

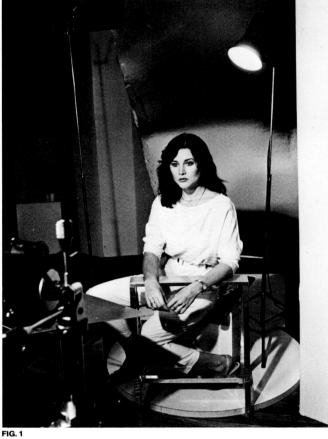

FIG. 1

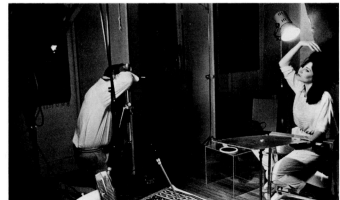

FIG. 2

Ⓐ	650 - watt quartz spotlight
Ⓑ	350 - watt diffused spotlight
Ⓒ	150 - watt spotlight
Ⓓ	350 - watt diffused spotlight
Ⓢ	Strobe and umbrella
Ⓢ2	Snooted spot. synched with strobe
✦	Flash
○	Sun
⌒	Reflector
Ⓟ	Photographer
Ⓜ	Model

5. Turn on a fan if the environment is too hot. Move it far enough away so that the model's hair doesn't blow in her face.

6. Take an exposure reading and choose an appropriate setting. Keep in mind that you will have to check your exposure as you move around the model.

7. Check the background with each shot. Make sure you don't see the edges of your backdrops as you change position.

8. Work with the model to find a good pose. Then move around the model in an arc, taking pictures from different angles.

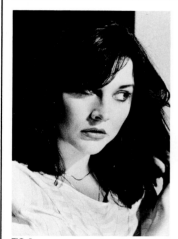

FIG. 3

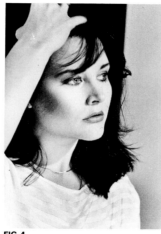

FIG. 4

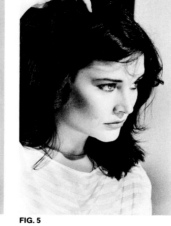

FIG. 5

CONCLUSIONS

After moving around the model and photographing in an arc of about 200 degrees, this shot (Fig. 6) was selected from the take. The model was asked to brush her hands through her hair, and to move slightly to add a natural, candid feeling to the portraits. This portrait is effective because it expresses a delicate mood that is harmonious with the model's personality and appearance. Her hand, gently brushing through her hair, adds a kind of motion to the picture that avoids the stiffness conveyed by so many portraits. The shadows under the lips and nose are evident, but are filled in sufficiently to become attractive elements in the overall design of the image. This portrait *works* because it is unusual—the photographer creatively sought out variations of his lighting scheme by moving the camera around the model. Fig. 4 and Fig. 5 are also interesting, relaxed portraits. Though they are sharp and well composed, Fig. 4 and Fig. 5 were rejected because of the unfortunate claw-like position of the hand as it brushes through the hair. However, Fig. 5 may be cropped to become a good portrait. Fig. 3 has no problem with the model's hand postion, but does have a fairly deep shadow crossing her right eye. Since viewers look to the eyes in a portrait first, it is essential that they not be hidden in shadow.

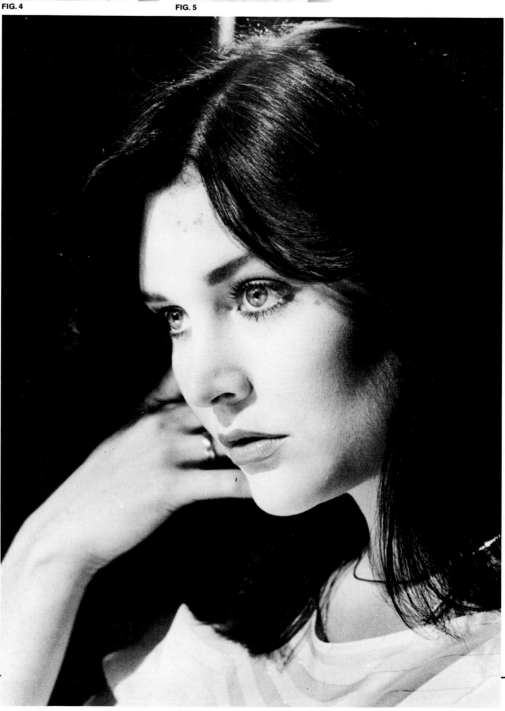

FIG. 6

COMMERCIAL HEADSHOT

Portraits are known as *headshots* for the acting professions, and are an essential sales tool for actors, actresses, and models. Producing good portraits for this use involves setting up a lighting arrangment that shows the model as a lively, evocative person who could effectively represent a product or play a certain role. These pictures are usually included as part of a portfolio that the professional shows to agents and producers. What agents look for is a good smile, poise in front of the camera, good eye contact, and memorable features. The right headshot can make or break a model's or actor's career, so producing effective shots for commercial use is a challenge for the portrait photographer. The photographer's role in this type of shooting is to draw out what is *characteristic* and *attractive* about the person, as this is the basis of casting someone for a television commercial or theatrical production. Since commercial headshots have to be current, assembling a group of theatrical clients can assure you of future repeat business and recommendations for new clients from their agents.

EQUIPMENT AND SETUP

Three basic lights are situated around the model, lowered somewhat from their positions in the preceding two lighting setups. A range of carefully positioned reflectors results in the well-balanced lighting required for commercial portraits. The 650-watt quartz key light (A) is positioned next to the photographer, and is aimed directly at the center of the model's face from a height of 5 feet (152 cm). To the left and slightly in front of the quartz key light is a diffused frontal fill light (B) whose purpose is to softly fill in all the shadows. The hair light (C) is slightly behind and to the right of the model, and is angled downward to avoid flare in the lens or overlighting the part in the model's hair. The use of reflectors is essential to this setup, as it allows working with fewer lights. The main reflector is the one in front of the model, which she holds in the position selected by the photographer. This reflector lights up the eyes and gives the kind of eye emphasis agents and producers look for. The aluminum backdrop is placed so that it provides a soft, gray, unobtrusive background. The portable, white, columnar reflector to the left of the model bounces light onto the side of the face that is not illuminated by the hair light.

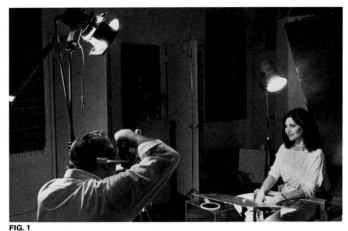

FIG. 1

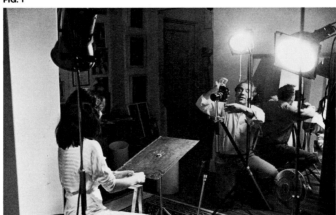

FIG. 2

PROCEDURE

1. Turn on and adjust key light (A).

2. Turn on and adjust fill light (B).

3. Correct the model's makeup—emphasize the cheekbones, cover up dark circles under the eyes. Check the hair and blouse.

4. Turn on and adjust the hair light (C). Check through your viewfinder that it does not cause flare or glare on the model.

5. Show the model how to tip the reflector so that it will bounce light up into the face. If you have a mirror, show the model the effect.

6. Check the background.

7. Take an exposure reading. Choose a setting that will guarantee a sharp portrait.

8. Coach the model through the sitting. Keep her chin lowered slightly to keep the eye area filled in with bounced light. Ask her to say "Hello" or "Hi" so that the portrait will have an active look, as if it were a frame of a television commercial.

9. Shoot a number of frames, as even a slight variation can determine whether the picture will bring the model job opportunities—or lose assignments.

10. Maintain direct eye contact with the camera. Ask the model to pretend she's doing a commercial by talking to the camera.

A	650 - watt quartz spotlight
B	350 - watt diffused spotlight
C	150 - watt spotlight
D	350 - watt diffused spotlight
S	Strobe and umbrella
S2	Snooted spot. synched with strobe
✳	Flash
☼	Sun ⌒ Reflector
P	Photographer **M** Model

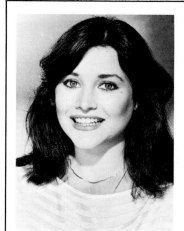

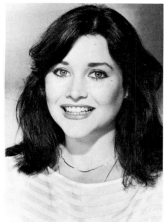

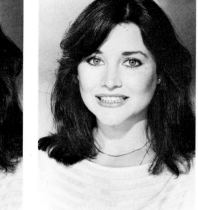

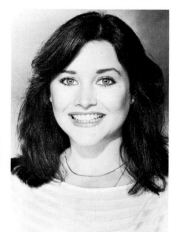

FIG. 3 **FIG. 4** **FIG. 5** **FIG. 6**

CONCLUSIONS

After consulting with the photographer and her agent, the model chose Fig. 7 as the new additon to her commercial portfolio. There is an ease about this picture that shows the model is a professional, and the lighting results in a totally attractive headshot. Though the model's head is slightly tilted, the direct eye contact and perfect smile make this a winning commercial shot. Notice the slight differences in the ones *not* chosen (Fig. 3–6). Though each shot is technically a good portrait, Fig. 7 is the one selected by three experienced professionals: the model, the photographer, and the model's agent. A model has to rely on her agent's experience, as well as the photographer's, in selecting commercial shots with the right "look." The shot selected will be duplicated hundreds of times, and will be sent as her application for many commercial and acting opportunities. The quality of the finished print is important, too. The final headshot should be somewhat contrasty, so that it has *impact*. Too "soft" a print will undermine the handsome modeling of the face brought out by good lighting, and might be ineffective in terms of finding work for the model. This shot complements the others already in the model's portfolio (a wide range of shots ranging from action to headshots with different hairdos and makeup, demonstrating how many "looks" this model has). Look through a portfolio you're shooting for, and try for a good, commercial look that is somewhat different from the shots already there. The most effective commercial headshots are classic, frontal portraits with a good smile, but there is a place in a portfolio for profiles and three-quarter pictures as well.

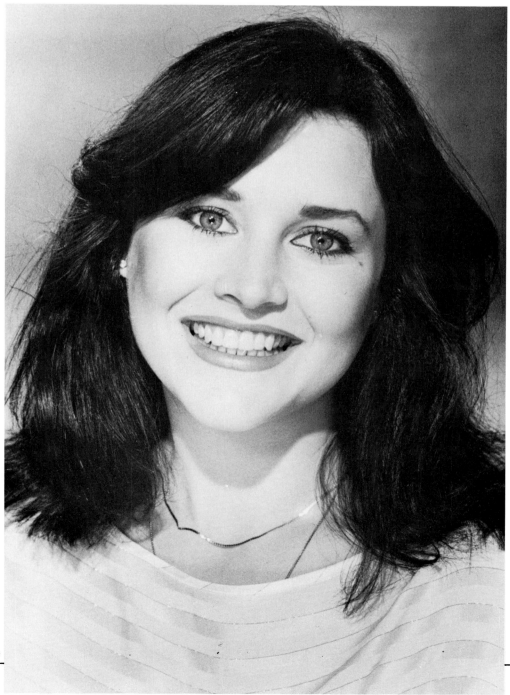

FIG. 7

OUTDOOR TOPLIGHT WITH REFLECTOR FILL

Portraits do not always have to be taken in a studio with a careful arrangement of lights and reflectors. On a nice day, excellent portraits can be shot outdoors, if the photographer is skillful and knows how to use reflectors to best advantage with sunlight whether it is bright or overcast. Studio lighting is a system involving various lights that are moved about to produce natural-looking light, and is the result of the wish to transfer light to an indoor environment the photographer can control. Sunlight can be understood and transformed in much the same way as indoor lights, with the exception that the main, bright light cannot be moved (though the subject can). Reflectors are just as effective outdoors as they are in the studio. Light reflectors are portable and easily used outdoors, and can make the difference between an amateurish outdoor portrait with deep shadows caused by overhead lighting, and a professional outdoor portrait with modified shadows despite the brilliant light.

EQUIPMENT AND SETUP

A dual reflector was chosen for this portrait session. Measuring about 2½' x 3½' (76 x 107 cm), it is matte white on one side and gold-toned on the other. When working outdoors, a reflector may be propped against a tree (Fig. 1), held by the model (Fig. 2), or held by a third person. Since midday light is essentially toplight that is diffused somewhat by the atmosphere and bounced by leaves and other elements of the environment, the reflector is best used to bounce light up into the face. Just as with indoor lighting, a reflector is essential to brighten the eyes and tone down strong facial shadows. A two-sided reflector offers options when the light is changing, for example, as the sun moves behind clouds. The gold side of the reflector casts a much brighter glow onto the face than the white, matte side. Take a good exposure meter with you when you're working outdoors, and confirm your exposure regularly. Outdoor light can be misleading, especially if there is haze. Take along a comb and some basic makeup in case the model needs a bit of touching up during the session. To make the most of the session, take a selection of shirts, jackets, or scarves to vary the model's look.

PROCEDURE

1. Position the subject so that the sun is behind him. This session occurred at about 11 AM in the summer, so the light is almost directly overhead. However, having the sun basically behind the model helps minimize direct shadows and reduce glare in the model's eyes.

2. Test both sides of the reflector, and study the change in the light, first with the white side and then the gold side. If you are in doubt as to the effect of the reflector, hold it in place and pass your hand over it while observing the subject's face. If you see a shadow pass across the subject, then you know you've chosen the right reflective surface for the light you're working in.

3. Take an exposure reading and set your exposure. Choose your aperture with care, keeping in mind that it may be preferable to let an outdoor background go somewhat out of focus.

4. Study the background. Make sure there are no trees, poles, or other objects directly behind the subject's head. Think about the composition of the picture, and where you want the horizon to be placed within the frame. Watch for shadows from trees or wires on the top of your model's head.

5. Ask the model to say ''Hello'' or ''Hi!'' (this gives a more natural look than just saying ''Cheese!'') and study the light falling on the model while you shoot. In between shots or changes of location, have the model close his eyes for a moment to rest them. The reflector can bounce so much light that it may be nearly impossible for the model to keep his eyes open. If this is the case, ask the model to keep his eyes closed until a count of three, and coordinate your shots with this count.

6. If the model is holding the reflector, let him rest from time to time—exhausting your model will only make him look tense in the final portraits.

7. If it is windy, try to wait for the wind to die down a bit. Otherwise, the model's hair will blow in his face, and it will be difficult to keep the reflector in place.

FIG. 1

FIG. 2

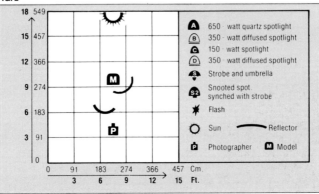

A	650 watt quartz spotlight	
B	350 watt diffused spotlight	
C	150 watt spotlight	
D	350 watt diffused spotlight	
S	Strobe and umbrella	
S2	Snooted spot synched with strobe	
✳	Flash	
○ Sun	Reflector	
P Photographer	**M** Model	

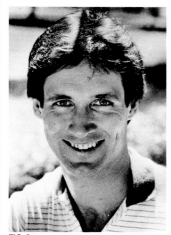

FIG. 3

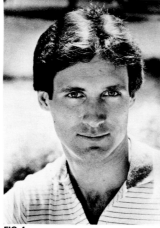

FIG. 4

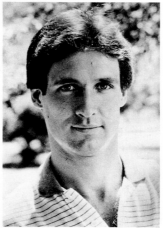

FIG. 5

CONCLUSIONS:

Light can have an infinite number of subtle effects in a portrait. Study Fig. 3–6. All of them were taken outdoors with the aid of a reflector in midday light. Though the fluctuations in the light did not seem obvious during the portrait session, the effects in the final shots are quite distinct. Fig. 3 is a good example of a reflector casting an even glow onto the face, filling in the strong toplighting from the sun. The reflector is held at head height. Fig. 4 shows the effect of holding the reflector a bit lower, and toward the model's left side—this brings a sidelighting effect to the model's jaw on the left. Notice how his shirt has reflected light onto his neck and jaw on the model's right side. A branch's shadow falls across the model's hair in Fig. 4, and a tree in the distance disturbs the background. In Fig. 5, the sun has moved behind a cloud. The reflector is in the same position as in Fig. 4, and still casts some light, but the overall effect is too low-key. Fig. 6 is the shot the model chose from this session. The sun is less brilliant than in Fig. 3 and Fig. 4, but this allowed the model to relax his eyes, and gave a softer lighting effect, which resulted in a successful portrait.

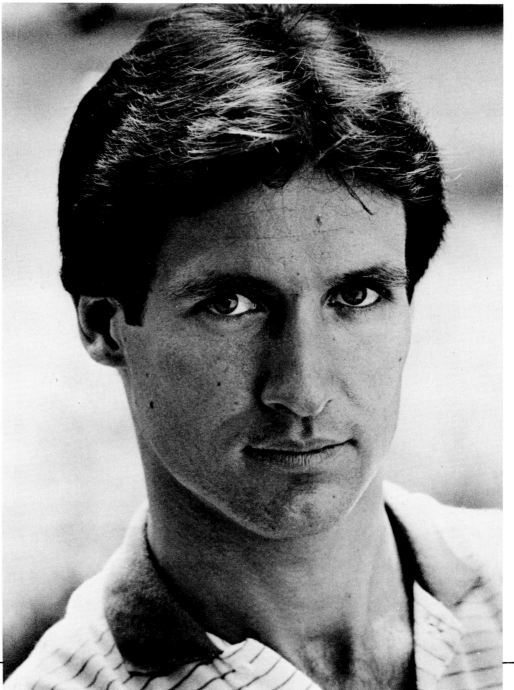

FIG. 6

PHOTOGRAPHING IN MIDDAY SHADE

Midday sunlight is very bright, and portraits may be ruined by a model blinking or squinting in such bright light. A good way to take successful outdoor portraits on bright days is to place the model in the shade. The shadow cast by a tree is ideal, as the leaves filter the light and diffuse it so that the illumination, while not bright, is often sufficient, even without the use of a reflector. Even with the gentle light in the shadow of a tree, a reflector can be effective in filling out the light on the face and brightening the eyes. Remember that in portraiture you are translating a three-dimensional person into a representation in a two-dimensional medium. This means that every effort made to light the face to show its forms, planes, and shapes will increase its effectiveness when it is seen printed on paper in the form of a photographic portrait. Study the following example showing the difference a reflector can make in the shade and in the photograph.

EQUIPMENT AND SETUP

This session occurred around noon on a very bright day in the summer. The equipment is simple: one camera body with a 105mm portrait lens, and a single, lightweight, double-sided reflector (gold and white). The foot of a wide, leafy tree was chosen as the portrait site for the softly filtered light it offered, as well as a level of illumination that would be comfortable for the model. Shots were taken without a reflector (Fig. 1), and with the gold side of a hand-held reflector (Fig. 2). This location also offered a background of foliage that the photographer knew would be attractive when rendered out of focus. This setup is the outdoor equivalent of working with bounced light in the studio, and gives an even, flattering illumination that is often preferable to the stark detail direct sunlight offers. The subject's choice of clothing is important in portraiture. For this portrait, the photographer requested that the model wear a white shirt, as even this helps reflect light onto the neck, thereby defining the jaw line while the hand-held reflector fills in the nose and eye areas.

PROCEDURE

1. Find a location in shade that offers gentle, diffused light. The area under a tree is often ideal.

2. Position the model, and test both sides of the reflector, studying the effect of each side on the model's face. Try the reflector on the left, then the right side of the face, angled upward so as to "scoop" light onto the subject to determine which is the best effect.

3. If it's windy, determine whether the wind gives the subject a sporty look, or whether it is blowing the hair around too much. Try moving the model so that the trunk of the tree blocks the wind (Fig. 3).

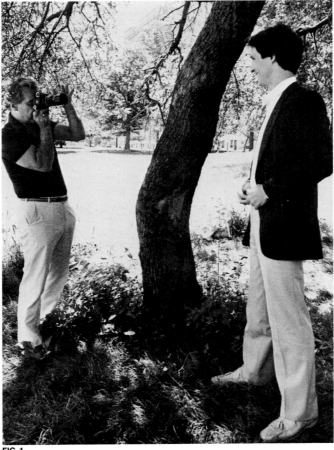

FIG. 1

FIG. 2

4. Take an exposure reading and select an exposure that emphasizes the subject, not the background.

5. Study the background through your viewfinder, and if you have a depth-of-field preview button, use it to make sure there are no bothersome elements that will appear behind the subject's head in the finished portrait.

6. The exposure reading was taken off the reflector, not off the subject's face, with an incident light meter. Bracket if you're not certain of your exposure.

7. When working without a tripod, brace the camera in some way—hold it firmly with one elbow pressed to your side, or lean against another nearby tree.

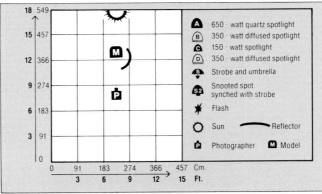

A	650 - watt quartz spotlight	
B	350 - watt diffused spotlight	
C	150 - watt spotlight	
D	350 - watt diffused spotlight	
S	Strobe and umbrella	
S2	Snooted spot synched with strobe	
✳	Flash	
☼	Sun	
⟍	Reflector	
P	Photographer	
M	Model	

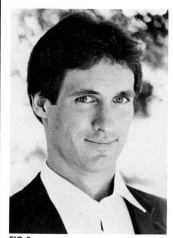

FIG. 3

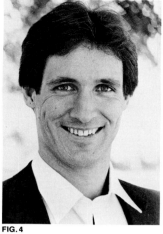

FIG. 4

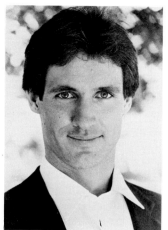

FIG. 5

CONCLUSIONS

The subtleties of reflectors used in natural midday shade are evident if you compare Fig. 4 and Fig. 5. The even, overall lighting in Fig. 4 is simply the result of daylight that is naturally diffused through the leaves of a tree. This is a good portrait, but is somewhat flat when compared to Fig. 5, which illustrates the addition of a hand-held reflector. Fig. 5 is a more handsome portrait because the reflector bounces light up into the eyes and onto the cheeks, and adds depth to the portrait. The shadow under the chin is minimized, as is the shadow cast by the nose. The out-of-focus foliage in the background creates a harmonious backdrop, and no unsightly objects interrupt the viewer's attention to the subject. The expression is comfortable, and the eyes are bright and direct. The overall composition and tonal balance are successful, and a good example of the fine portraits that can be accomplished in midday shade.

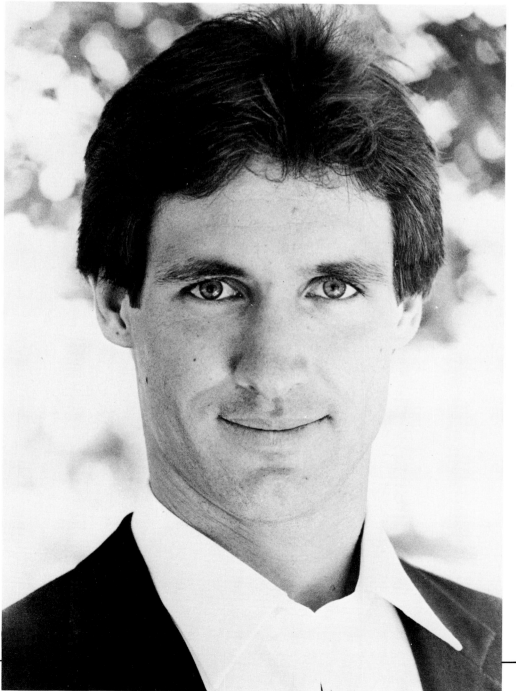

FIG. 6

TUNNEL LIGHTING

Every object in our environment reflects light to one degree or another. Learning to be aware of how various surfaces affect outdoor light is essential for outdoor portrait work. *Tunnel lighting* refers to light bounced around between two large, light-colored objects, such as between a pair of buildings, or under a highway overpass, as shown in this demonstration. Working inside a tunnel environment and making use of its diffused light is a good option on a bright day. Careful placement of the subject in a tunnel lighting environment can give refined portrait effects that look as though a complicated group of reflectors was used. This example shows how a curved, white retaining wall can function as a reflector and brighten up what might seem, at first glance, to range from a low level of available light to overhead light that is too harsh. This is a technique that can make you an expert at taking portraits without any equipment other than your camera—and your knowledge.

EQUIPMENT AND SETUP

The challenge of this technique is to study the environment and observe how its features affect the direction and quality of light. This location is a highway tunnel passing through a park near the photographer's studio. The tunnel offers a range of lighting from fairly deep shade to bright sunlight and features a white, curved wall on one side that bounces light upward. The photographer walks along with his subject, stopping from time to time to observe the light and built-in "reflectors" on the highway. The object is to find a spot that provides an illumination that is balanced between direct overhead sunlight and light bouncing off the concrete. Study tunnel lighting that is bright (Fig. 1) and shaded (Fig. 2). If you take a mirror along, you can discuss the lighting with your model.

PROCEDURE

1. Locate a shaded place—between two buildings, or in a highway tunnel, as shown—and walk through it. Check the light level at various points through the area with a good exposure meter.

2. Try several variations when posing the subject. Even though the light level may be low, keep altering the pose and location until the light effectively models the face and the features are properly emphasized.

3. Take an exposure reading, and remember to check it often. Even slight variations in outdoor light can have a strong effect on portraits, so learn to be aware of subtle changes in outdoor lighting. Make it a habit to double-check your exposure often.

4. When working in bright tunnel lighting, remember to let the model rest his eyes from time to time to avoid blinking and squinting.

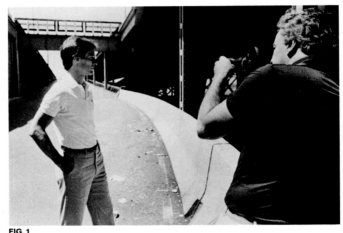

FIG. 1

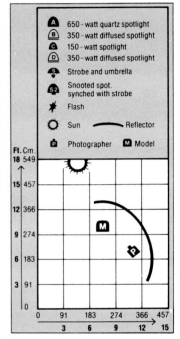

A	650-watt quartz spotlight
B	350-watt diffused spotlight
C	150-watt spotlight
D	350-watt diffused spotlight
S	Strobe and umbrella
S2	Snooted spot. synched with strobe
☀	Flash
☼	Sun — Reflector
P	Photographer **M** Model

Keep an eye on the background, and make sure steetlights and other objects don't clutter up the area behind the subject's head. This is the most common error made in outdoor portraiture, and is easily avoided by taking a moment to study the background.

5. Think about contrast and tonal balance while you're shooting portraits. If the model is in a shady tunnel, position him so that you get a brighter background, and perhaps a form of halo lighting. Try to make sure the background differentiates itself tonally from the subject.

6. Don't be afraid to move around, or to ask your model to move, sit down, or do whatever is necessary to make the light work best for the picture.

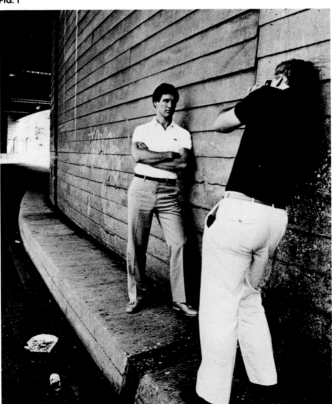

FIG. 2

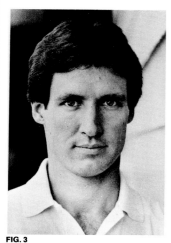

FIG. 3

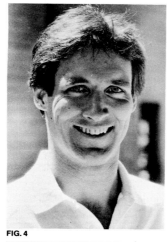

FIG. 4

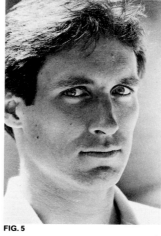

FIG. 5

CONCLUSIONS

Compare Fig. 3, Fig. 4, Fig. 5, and Fig. 6. Fig. 4 was photographed outside the tunnel itself, and shows sunlight that is too harsh and direct overhead, though a great deal of light is bouncing upward from the walls of the environment. Turning the model's head away from the sun resulted in the improved look of Fig. 5. Notice the bright reflection along the left side of the model's face—this is caused by the low, white retaining wall on the highway, and by his light-colored shirt. Moving in for a closer shot emphasized this lighting. The hair is nicely lit, and the background is acceptable, though its tone is too close to that of the face to provide good differentiation. For Fig. 3 and Fig. 6 the model was placed at one end of the tunnel, so there was little direct sunlight on his face, but a lot of light diffused by the walls of the tunnel. The half-light, half-dark background is an interesting effect. Fig. 6 is the portrait chosen from this session because of the straight, masculine angle of the model's face and the relaxed position of the eyes.

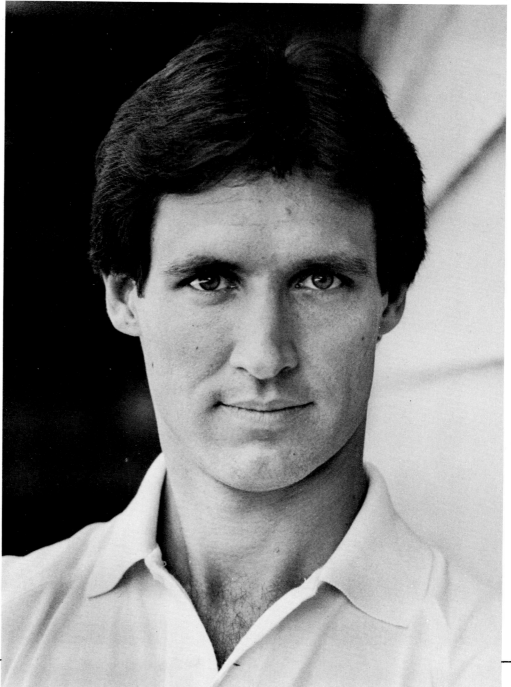

FIG. 6

MODIFIED REMBRANDT LIGHTING

The object of Rembrandt lighting is to arrange the lights in such a way as to obtain a triangular-shaped shadow on either side of the model's face, which is caused by a strong form of sidelighting. This technique bisects the face, and makes us look at each side differently than we would in an even, overall light. This is effective because it emphasizes one of the subtle aspects of every face: the two sides are different. This technique can be modified with fill lighting to any degree desired by the photographer. This is a distinctive technique, and at its most extreme, may not be entirely flattering. However, with sensitive use of reflectors and additional light, Rembrandt lighting may be adapted so that its overall effect can result in a pretty, and unusual, portrait. Though this technique is generally used for portraits of men, this demonstration shows the effects that can be obtained with a female model. Her features are regular and attractive, and though a contrasty form of Rembrandt lighting is interesting, this is a good example of how minimizing an effect can strengthen an overall portrait.

EQUIPMENT AND SETUP
Two lights are used for Rembrandt lighting, and a third for the modified version. The model is seated on a backless chair in the studio, which allows unimpeded changes of position (Fig. 2). Notice the bar, placed in front for the model to lean on, and the reflector stand, which is not used for the Rembrandt technique, but will be used to modify the effect toward the end of the session. The 650-watt quartz key light (A) is high, and set well to the left of the photographer. It is directed at the right side of the model's face, as is the diffused frontal fill light (B), though the latter is just to the left of the photographer. The fan is on, but set to the side so that it doesn't blow the model's hair around too much. Remember that it can be very hot sitting under photographic lights, and a fan can keep the model much more comfortable. The white, columnar reflector is at the model's left. It bounces some light onto the unlit side of the face. The addition of the hair light (C), which bounces light from the reflector back into the model's face, serves to modify the distinctive Rembrandt triangle and brighten the overall tone of the portrait.

PROCEDURE
1. Turn on the 650-watt quartz key light (A), and direct it so that the Rembrandt triangle is cast across the dark side of the face.

2. Turn on the main diffused frontal light (B), and direct it toward the light side of the face as well. This light will brighten the face and give it more depth, though the triangle of bright light is still apparent.

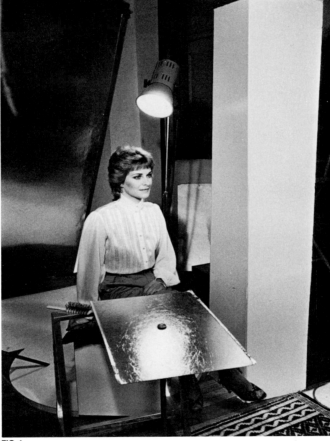

FIG. 1

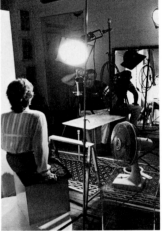

FIG. 2

3. Correct the model's makeup and hair, if necessary. Have her turn her head until the Rembrandt triangle is well positioned across her cheek. Ask her to keep her chin down to maximize the eye contact.

4. Take an exposure reading, and choose your camera's setting.

5. Take a moment to check the background—make sure, if you're using modified Rembrandt lighting, that the hair light is neither causing a hot spot on the backdrop, or causing flare in your lens.

6. Talk to the model—let her relax so that the portraits will reflect her personality better. Make sure the model is comfortable and has something to lean on when necessary. Expecting a model to smile when she's straining to hold a pose will not bring you the best results.

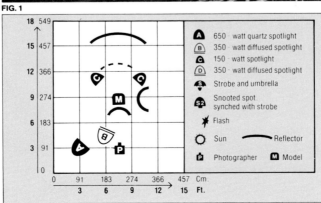

A	650 - watt quartz spotlight	
B	350 - watt diffused spotlight	
C	150 - watt spotlight	
D	350 - watt diffused spotlight	
S	Strobe and umbrella	
S2	Snooted spot synched with strobe	
✦	Flash	
○	Sun	Reflector
P	Photographer	**M** Model

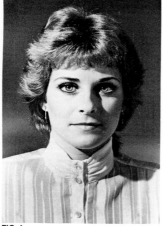

FIG. 3

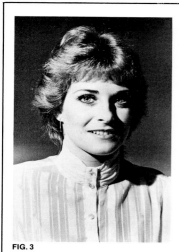

FIG. 4

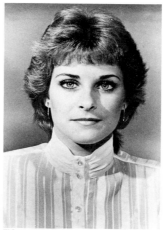

FIG. 5

7. Try a few frames with unmodified Rembrandt lighting, then show the model how to tip the reflector in front of her to bounce light up into her eyes. Then add hair light (C) and experiment with the modified version. Make sure your model isn't getting burned by the hair light. Work with the hair light so that it diminishes but does not erase the characteristic Rembrandt triangle of light on the model's cheek. (Note: Addition of a hair light (C) is especially recommended for blondes, as it takes a great deal of illumination to keep light hair looking blonde in black-and-white portraiture.)

CONCLUSIONS

Fig. 3, Fig. 4, Fig. 5, and Fig. 6 demonstrate a range of effects you can achieve with the Rembrandt lighting technique. Fig. 3 was taken using only the high, key, front quartz fill (A), directed at the right side of the model's face. This is much too harsh an effect for a pretty young face, so in Fig. 4 the diffused frontal light (B) is added. The triangle is still obvious, but both eyes are lighted better, the hair appears lighter, and the picture is improved. This is still a heavy effect, so for Fig. 5, the white, columnar reflector and the front, hand-held reflector are used in conjunction with a hair light to brighten the overall picture. In Fig. 6, the Rembrandt triangle is not very obvious, but through its modification, we notice the model more than the lighting effect. It is important in portraiture not to overpower a face with a technique.

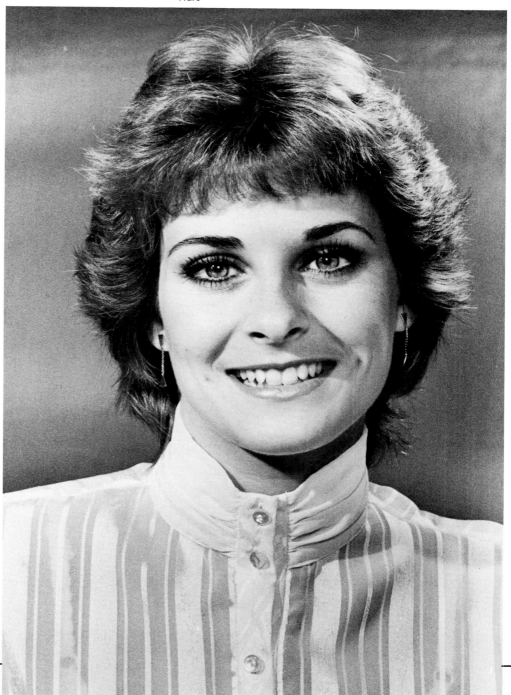

FIG. 6

35

HALO LIGHTING

One of the most spectacular portrait lighting techniques is *halo lighting*, which is a technique that results in a bright outline of light around the subject's head. Like all indoor studio lighting techniques, this is a variation of a kind of lighting that occurs naturally outside—the halo effect the sun causes when it's behind someone's head. This is a dramatic technique when properly done. The halo is very bright, and the background dark, and the face must be filled in with additional light for the best effect. Try this one with various poses—it's just as attractive when used with a profile or three-quarter portrait as it is for a frontal shot. This is particularly attractive for blondes, as the edge of light is even brighter. This technique will result in stunning portraits of anyone. It takes some care in setting it up and perfecting the halo effect, but succeeding at this technique will result in a portrait that gets a lot of attention—and lots of new referrals!

EQUIPMENT AND SETUP
Halo lighting requires only two lights. For this setup, a 650-watt quartz key light (A) was placed directly behind the model's head, far enough away that its heat wasn't uncomfortable. When placing this light, make sure that it is fully blocked out by the model's head so your shots aren't lost due to flare. Careful experimentation can help you to use flare and even overexposure for good effect at times, but begin by making sure that from the camera's position you only see the halo of light, not the light itself. The second light is used to fill in the front of the face. Here a large, diffused fill light (B) was positioned directly in front of the model, slightly above the level of her head and about 5 feet (152 cm) in front of her. A fan is used to keep the model cool under the lights. The background is a large sheet of aluminized Styrofoam, suspended from the veiling and angled back, away from the model. Its position is adjusted so that the hot spots caused by the 650-watt quartz light (A) are a positive element in the picture.

PROCEDURE
1. Turn on the 350-watt front fill light (B). To demonstrate the effect a backlight placed behind the model's head can have, Fig. 3 shows this setup with only the front fill light. There is such insufficient light that the model's hair has gone completely dark, and there is nothing to give the picture any sparkle.

2. Now turn on the 650-watt quartz key light, which is placed directly behind the model at head height. Test that it is far enough away by putting your hand between the light and the model's hair. Move the light farther back if it's too hot. Fig. 1 shows the distance required to keep the model from being scorched by the backlight.

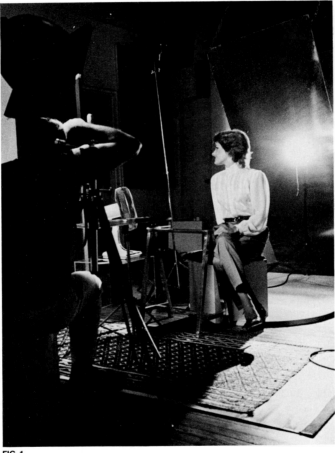

FIG. 1

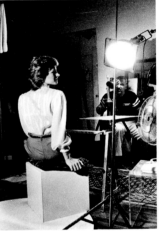

FIG. 2

3. Check the model's makeup and hair before starting the shoot, and make sure that her pose is comfortable.

4. Take an exposure reading, and choose your camera setting. Remember to double-check your exposure if you move the model or the lights during the session.

5. Halo lighting is a technique that could fail if the backlight is improperly placed, so be certain the light casts a bright ring of light around your model but doesn't show in the picture.

6. For a terrific three-quarter shot, have the model sit with one shoulder closer to the camera than the other. Ask her to turn her head until she is at a three-quarter pose, then ask her to hold that position but bring her eyes back to the camera. Eye contact is important in most portraits, and a very glamorous mood can be created simply by turning the head away while maintaining eye contact with the camera. Try a profile shot without changing the lighting (Fig. 4)—it's a beautiful variation.

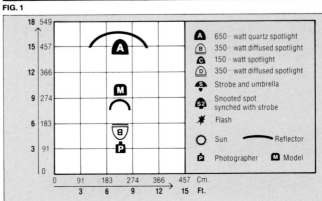

A	650 - watt quartz spotlight
B	350 - watt diffused spotlight
C	150 - watt spotlight
D	350 - watt diffused spotlight
S	Strobe and umbrella
S2	Snooted spot. synched with strobe
✳	Flash
○	Sun
⎯	Reflector
P	Photographer
M	Model

FIG. 3

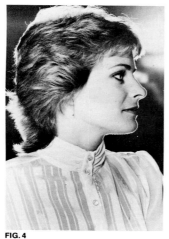

FIG. 4

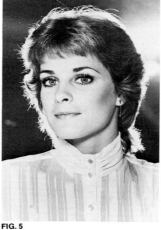

FIG. 5

7. Talk to the model, and explain what you are doing. Point out the halo effect if you have a mirror for the model to watch herself in. Make sure the model doesn't clench her jaw or show any other signs of tension, as nervousness can counteract even the prettiest lighting setup.

CONCLUSIONS

Fig. 3–6 show four lovely variations on the theme of halo lighting. Fig. 4 has an elegant hairline of white light along the model's profile, and the halo continues all around her head, highlighting her blonde hair and pretty haircut. Notice the bright areas in the background—though changing the angle of the suspended backdrop could have removed them, the photographer chose to leave these highlights in the background to balance out the dark areas. Fig. 3 shows the same lighting setup, but the model has turned toward the camera for a frontal portrait. The halo still encircles her entire head, and again, the result is pretty. Though no reflectors were added, the front fill light has adequately filled in the areas that cannot be allowed to become too dark in portraits—the eye area and the area under the nose. Fig. 6 is the shot selected as best from this session. This is exactly the same lighting setup—only the pose is different. The photographer asked the model to turn her head slowly, while looking directly into the lens. There is a certain glamour about this pose that makes it more eye-catching than the others, even though the lighting arrangement is identical.

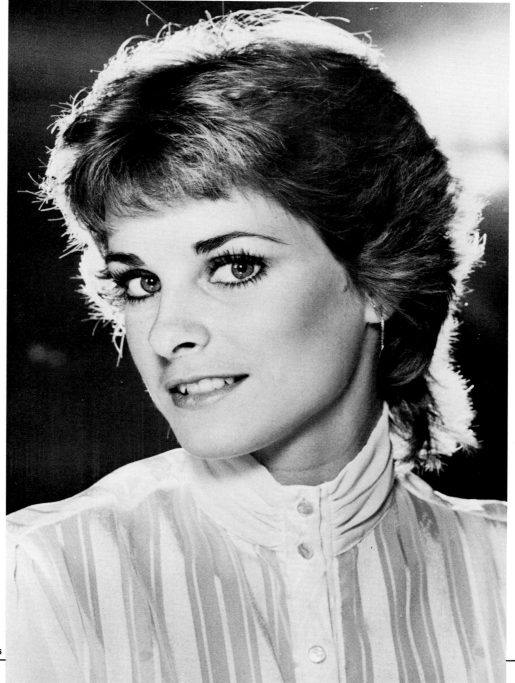

FIG. 6

LIGHTING FOR EYEGLASSES

Producing a fine portrait of an individual who wears eyeglasses requires special care in setting up a good lighting arrangement that does not cause glare on the eyeglasses or frames. Many professional models own a pair of eyeglass frames without any lenses at all, solving the problem in advance for the photographer when they need photographs of themselves wearing glasses. The average portrait client, however, does not want to buy a pair of eyeglass frames just for the purpose of having a picture taken, so it is important to learn how you can photograph eyeglasses without distracting hot spots. Don't rely on retouching to solve this kind of problem—that's the expensive and time-consuming solution. Study this demonstration of the do's and don'ts of lighting for eyeglasses, and practice this technique, without film, on a friend. It's a simple technique to learn, and one that will guarantee that your bespectacled clients are pleased.

EQUIPMENT AND SETUP

This is a standard three-light setup. The 650-watt quartz key light (A) is placed behind the model, about 7 feet (213 cm) back and 7½ feet (229 cm) high. It is directed to light the entire back and top of the head. This light is farther back than normal because the model has gray hair. It is important not to *overlight* gray hair, as it could artificially age the model. The diffused, front, fill light (B) is placed 4 feet (122 cm) to the left of the photographer, and is positioned so that it shines directly on the subject's face. Because this light is raised so high and is within view through the lens, a flag is placed in front of it (Fig. 2). The light is diminished somewhat, but use of the flag helps avoid overlighting, as well as glare in the lens. The hair light (C) is about 2½ feet (76 cm) behind the model and to his left. The hair light is angled downward so that much of its light bounces off three reflective areas behind the model: the aluminum backdrop, the white Formica floor, and the columnar reflector at his left. The model uses the bar to lean on (Fig. 1), as leaning in toward the camera and lowering the head are important for the success of this lighting plan.

PROCEDURE

1. Turn on the key light (A). In this case, the 650-watt quartz light is *behind* the model, fairly high and far back, to provide good illumination without washing out his pale gray hair.

FIG. 1

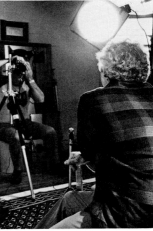

FIG. 2

2. Turn on the 350-watt front, diffused fill light (B), and angle it so that it evenly illuminates the front of the subject, eliminating most of the shadows. Turn on the 150-watt hair light (C).

3. Many subjects need a little makeup—even men. This model was very pale, so a light shading of powdered blush was put around his jawline, at the temples, and under the cheekbones—not enough so that it would look like makeup, but just enough to draw out his features for a black-and-white portrait. Check the collar and hair before going ahead with the session.

4. Take an exposure reading and choose your camera's setting.

5. Check the background. Raise or lower the flag to keep too much light from straying into your lens.

6. Test a reflector. In this case, it was removed, as it caused even more glare on the eyeglasses.

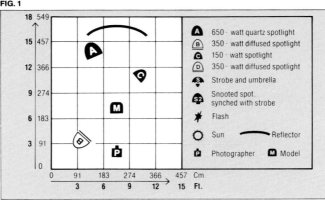

A	650 - watt quartz spotlight
B	350 - watt diffused spotlight
C	150 - watt spotlight
D	350 - watt diffused spotlight
S	Strobe and umbrella
S2	Snooted spot. synched with strobe
✳	Flash
☀	Sun
╱	Reflector
P	Photographer **M** Model

FIG. 3

FIG. 4

FIG. 5

7. Ask the model to lower his chin until the glare disappears from the eyeglasses. Make sure you haven't displaced a hot spot onto the frames—this is just as distracting as glare over the eyes. Ask the model to lean forward if dropping the chin a bit hasn't eliminated the glare. Be careful to maintain a pose where the head is only slightly tilted. Though tilting the head is often pretty in pictures of women, it can weaken a man's portrait.

8. Ask the model to say ''Hello'' and smile naturally. Keep the session relaxed—it will help the pictures.

CONCLUSIONS

Common mistakes that are made when lighting subjects who wear eyeglasses are illustrated in Fig. 3, Fig. 4, and Fig. 5. In Fig. 3, the eyes are nearly obscured by glare on the lenses of the eyeglasses, rendering this portrait wholly unacceptable. In Fig. 4, the glare has been removed from the eyeglasses, but there are hot spots on the frames. This could be removed with retouching, but it is better to correct a shot while you're taking the picture, rather than count on retouching to fix mistakes. Though Fig. 5 is acceptable, Fig. 6 is the subject's favorite from this session. (He changed midway to another pair of glasses in order to see the progress of the shoot better in the mirror.) He chose this portrait because it has no glare whatsoever on the eyeglasses, has a good tonal balance, his face is nicely separated from the even background, and the features are well defined.

FIG. 6

AVAILABLE LIGHT

Beautiful portraits—even close-ups—can be made without a studio, photolamps, or even a flash if you know how to make the most of available light. Natural light can produce some of the most delicate facial modeling imaginable if the subject is properly placed where the light provides sufficient illumination. Since all light-colored surfaces reflect light, creative solutions to the problem of positioning the model can result in as skillful a lighting effect as with the use of several reflectors.

This technique is especially evocative, and looks natural. It is particularly flattering for romantic portraits of young girls, women, dancers, and editorial portraits where the introduction of lighting equipment would undo a mood or setting necessary for the picture. Since many lovely portraits can occur anywhere—and you may have no equipment with you other than a camera—it is worthwhile to practice portraiture using only the light from a single window and a variety of poses.

EQUIPMENT AND SETUP

Only one white reflector was used in this setup. It was propped against the wall, next to the photographer and opposite the model. This window happened to be in a room painted white, and there was a closet whose door was opened to alter the north light coming in from the window (Fig. 1). To enhance the romantic mood of this delicate lighting situation, the photographer chose to use a subtle star filter to soften the effect even more—his aim was to get a very delicate, high-key portrait that stressed the eyes. Since the area was small, the photographer did not use a tripod, despite the long exposures required in such minimal natural light. Instead, he braced himself against the wall to avoid camera motion during the exposure (Fig. 2).

PROCEDURE

1. Locate a window with north light—the same light favored by painters for its even diffused qualities. If the walls around the window are white, they will serve as reflectors. If not, you may want to hang white paper or fabric on them as a backdrop.

2. Investigate what is available to use as reflectors. For instance, if the individual is sitting at a desk near a window, covering the top of the desk with sheets of white paper will help bounce light up into the face and brighten the eyes. In this example, a closet door was opened and positioned so that it bounced light back onto the model, and a white, cardboard reflector was placed opposite her to bounce more light gently back to avoid deep shadows, which would have destroyed the fragile loveliness of the portrait.

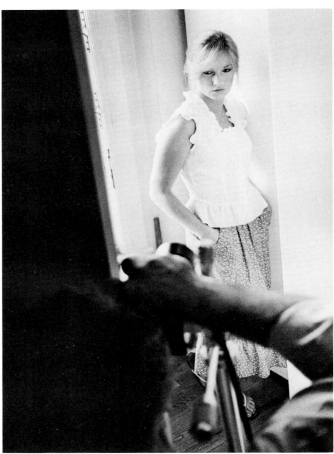

FIG. 1

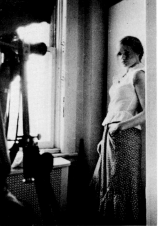

FIG. 2

3. Experiment with poses, angles, and variations within the available light. Move in for a close-up, move back for a head-and-torso shot.

4. Work for an expression that is appropriate to the mood of the picture as you see it through the camera. This is an instance where the photographer did not ask the model to smile, because he wanted a moody shot, feeling it would be more appropriate.

5. It is difficult to make blonde hair retain its tone, even under studio lights. It is even more difficult in available light, but meticulous positioning of the model and deliberate exposure for a high-key picture retained this subject's "blondeness."

6. The photographer used a delicate, crosshatched filter for this shot, not for a star effect, but to make the hair softer and further emphasize the intensity of the eyes in the picture. Once you have taken the shots you intended to take, experiment with a filter or special effect—learn the creative *range* of every technique you employ.

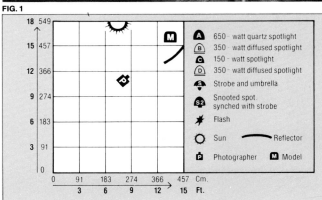

A	650 - watt quartz spotlight
B	350 - watt diffused spotlight
C	150 - watt spotlight
D	350 - watt diffused spotlight
S	Strobe and umbrella
S2	Snooted spot, synched with strobe
✳	Flash
○	Sun ──── Reflector
P	Photographer **M** Model

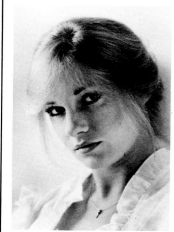

FIG. 3

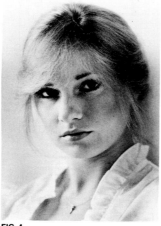

FIG. 4

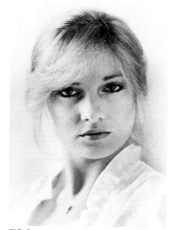

FIG. 5

CONCLUSIONS

Although all of the above are acceptable photographs, Fig. 6, taken with a 105mm lens, is the portrait chosen from the session. It is a good example of the kind of sensitive effects that can result from available light. This portrait conveys softness and thoughtfulness. Its focus is the model's eyes. Imagine the same shot with the same framing photographed with the aid of electronic flash—there would be precise detail, strong shadows, but would there be the evocative qualities and beauty of this shot? This is why the serious photographer needs to learn to understand and work *with* light, not despite it. The art of drawing with light, called photography, offers—even in the age of electronic flash—some of its greatest challenges and rewards as the result of the ''low-tech'' approach: working with only natural light.

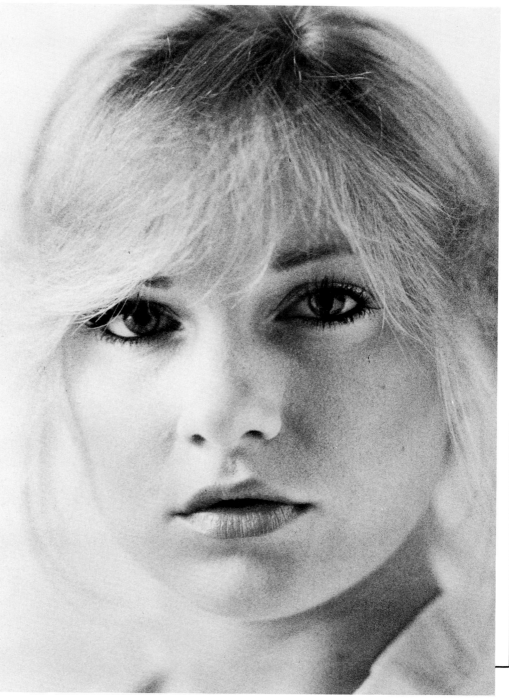

FIG. 6

PHOTOGRAPHING HATS

Hats are among the most ubiquitous of props in photography. In any form, from wedding veils to sporty headwear, special care is needed to light both the hat and the facial features in the hat's shadow. The larger the brim, the more challenging the problem of bouncing light up into the subject's face. Failing to light the face adequately underneath a hat results in a totally unsatisfactory portrait, with the eyes hidden in murky shadows. Since in most portraits the eyes are the feature we look at first, this area needs careful lighting. In this demonstration, two different hats, both straw and fairly opaque, were used to illustrate the problem of learning to bounce light upward, all around the model's head, to keep the hair light in tone and the face satisfactorily illuminated. The lights and reflectors were adjusted to keep the hats at a middle tonal value, so as not to compete with the face. Remember that a hat is an accessory, and must never overwhelm the viewer's experience of the person in the portrait. However, successful lighting can result in a totally charming portrait.

EQUIPMENT AND SETUP

Three lights were used for the portraits with the smaller straw hat. The key or main light (B) in this case is a large, 350-watt diffused light, kept low and located in front of the model. The second light (A) is a 650-watt quartz light placed behind the model and shining directly on her back to bring light *through* the hair as well as the hat. To illuminate the top of the hat, a very high hair light (C) is placed well behind and to the right of the model, and is blocked with a flag to avoid lens flare. The reflector in front of the model and the white, columnar reflector are essential. For the larger hat, hair light (C) is repositioned in front, at a 45-degree angle to the left of the model, to brighten the shadow under the brim (Fig. 4). The strong backlight (A) is brought closer, and angled down to bounce light up off the white floor. For the final portrait, a fifth light (not shown) was added, behind the model and to her left, angled downward to bounce light up from the white floor platform, and to increase the amount of light bounced under the hat's brim from the freestanding, white, columnar reflector placed to her left.

PROCEDURE

1. Turn on and adjust the key (and in this case, 350-watt diffused) front light (B) and lower it for maximum illumination of the face.

2. Turn on the 650-watt high backlight (A) and adjust the flag so that there is no flare in the lens, but the top of the hat is sidelit.

3. Turn on the hair light (C) behind the model, and find its best position for casting light through the hair, and the hat if it is not opaque.

4. Check the model's makeup and hair. Brush the hair to give it a softer, "floatier" look.

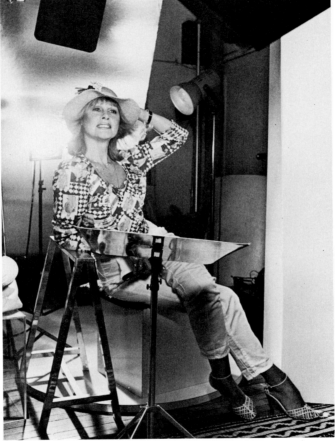

FIG. 1

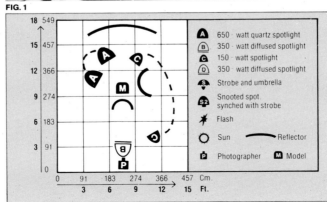

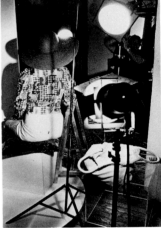

FIG. 2

5. Turn on a fan to keep the model comfortable. Keep a brush nearby, as fans tend to cause hair to separate into strands and lose the windblown look that a fan should provide.

6. If more frontal illumination is essential, move lights (A) and (C) to the positions shown in Fig. 2. These should be placed at the same angle if the brim is large and there are still shadows in the eye area caused by the hat. Move the reflectors in closer, and angle lights precisely onto them to provide maximum lighting.

7. Work with the model—tilting her head, raising or lowering her chin—until the illumination is bright and free of strong shadows. Make sure the hat is neither too light nor too dark.

8. Check the background and be certain there is no flare through the lens before shooting.

Ⓐ	650 - watt quartz spotlight
Ⓑ	350 - watt diffused spotlight
Ⓒ	150 - watt spotlight
Ⓓ	350 - watt diffused spotlight
Ⓢ	Strobe and umbrella
Ⓢ²	Snooted spot, synched with strobe
✳	Flash
◯	Sun
Ⓟ	Photographer
Ⓜ	Model
◠	Reflector

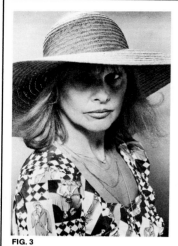

FIG. 3

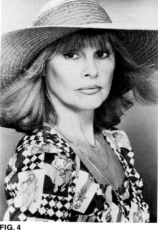

FIG. 4

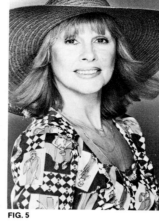

FIG. 5

CONCLUSIONS

Though working with the wide-brimmed hat required far more direct frontal light, successful results were obtained with both hats. Compare Fig. 5 and Fig. 6. Both are good because the face is evenly and attractively lit and remains the focal point of the pictures. The hats are fairly evenly lit, and have middle gray tonal values, which do not compete with the face for attention. The complexity of lighting is demonstrated in Fig. 3 and Fig. 4—a heavy, obscuring shadow covers the eyes and neck in Fig. 3, which is alleviated by the addition of light in front and to the left of the model in Fig. 4. Notice, too, that the model's shoulders are not quite parallel to the film plane. Pretty portraits can benefit from slight variations in a pose. Having the model seated at an angle while turning her face back to the camera adds verve to the image, as long as her effort is not so strenuous as to look uncomfortable in the portrait. Here the model's slight turn of the shoulders adds vitality to a successfully lighted portrait.

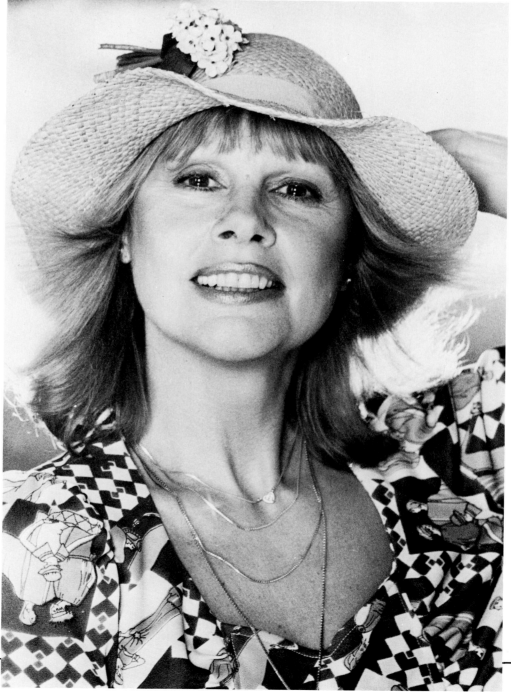

FIG. 6

DIFFUSED LIGHT AND DIFFUSION FILTERS

Light can be adapted in the studio in many ways—its brightness, color, direction, and intensity may all be controlled. The softening of light and lightening of shadows, called *diffusion*, is an effect that can produce many desirable portrait effects. An overly diffused portrait, however, can be totally unsatisfying if it is "soft" overall, and provides no focal points for the viewer to see. Often used for a romantic effect, diffusion is also an important technique that can flatter people with poor complexions or wrinkles. Some photographers automatically use a diffusing filter of some kind for any client over 35. Used delicately, diffusion filters, and even star filters, can produce subtle, beautiful effects. In this demonstration, the photographer uses a star filter in order to produce a halo effect in the hair, and soften the overall image. Think of a star filter as a hair filter in this context, and you will find many fine effects may be obtained with this technique.

EQUIPMENT AND SETUP

The diffused fill light (B) is a large 350-watt spotlight, just above the height of the model's head, located slightly to the left of the photographer. It is directed fully upon the model's face, as the basis of this lighting scheme is to use entirely diffused and/or bounced light on the face, with strong backlighting. The hair light (C) is placed to the model's left, slightly above head height. Notice the extra spotlight (A1) directed at the middle of the model's back. This is the light that produces the "outdoorsy" backlighting in her hair, brightening it and softening the overall outline of the head. Actually, it is used for controlled overexposure on her hair. The backdrop is an aluminized sheet, suspended from the ceiling. To further enhance the outdoor look, a fan was turned on the model and a high, hot light (A) was placed behind her, directed onto her right side to simulate sunlight. The flag is positioned to reduce flare. The entire environment is composed of white and other reflective surfaces—notice the white platform on the floor and the columnar reflectors placed in front of the model at her left and right (Fig. 1). A bar is placed in front of the model to allow her to lean on it for more comfortable posing. Note the careful placement of a reflector on a stand in Fig. 1, located in the direct path of the light from the fill light (B).

PROCEDURE

1. Turn on and adjust the 350-watt diffused fill light (B) in front of the model. It should be slightly to the side, and a reflector should be placed in its path to bounce as much light as possible up into the face and neck area.

FIG. 1

FIG. 2

Ⓐ	650 – watt quartz spotlight
Ⓑ	350 – watt diffused spotlight
Ⓒ	150 – watt spotlight
Ⓓ	350 – watt diffused spotlight
Ⓢ	Strobe and umbrella
Ⓢ2	Snooted spot. synched with strobe
☀	Flash
☉	Sun ⌒ Reflector
Ⓟ	Photographer Ⓜ Model

2. Turn on and adjust the high 650-watt quartz key light (A) behind the model, and pull a flag into position to avoid flare in your lens.

3. Turn on the hair light (C), which is positioned behind the model for a rim lighting effect. Turn on the backlight (A1) behind the model. Test that it is not too hot by passing your hand between the light and your model's back. Check for an even, halo effect through your lens.

4. Check the model's makeup and hair before proceeding. Brush the hair often during the session to avoid separation of the hair into strands. This would undermine the soft halo effect you are trying to build with an environment of diffused and reflected light.

FIG. 3

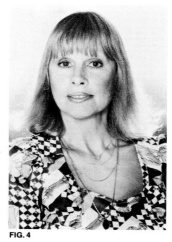

FIG. 4

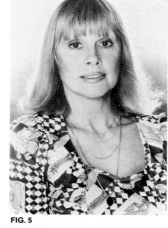

FIG. 5

5. Check the background carefully, and change the angle of your backdrop if necessary to rule out hot spots. Carefully assess the color or tone of your background to make sure that it will be harmonious with the finished portrait.

6. Coach the model through the shooting to keep her relaxed, asking her to speak softly, smile, and tilt her chin down so the eyes are emphasized.

CONCLUSIONS

Fig. 3, Fig. 4, and Fig. 5 are all successful portraits, but the model selected Fig. 6 as her favorite. Fig. 3 is less attractive for two main reasons: the model did not lower her chin enough, and there is too much emphasis on the jawline and nostrils. Also, the lighting on the face is somewhat flat in Fig. 3. This was corrected by adjusting the reflector in front of the model, resulting in the brightening of the face that makes Fig. 4 and Fig. 5 more acceptable. Though the tonal balance is fine in Fig. 4, and the hair is softly diffused, the pose and subject placement within the frame are awkward, and the chin is a bit too high, emphasizing unflattering shadows. Fig. 5 shows the delicate use of diffused light, and meticulous posing—an almost imperceptible lowering of the chin flatters all the model's features, and the corrected placement of a reflector in front of her brightens the eyes, fills in the area under the eyes, and brightens the neck area. The overall effect is pretty without creating too ''soft'' an image.

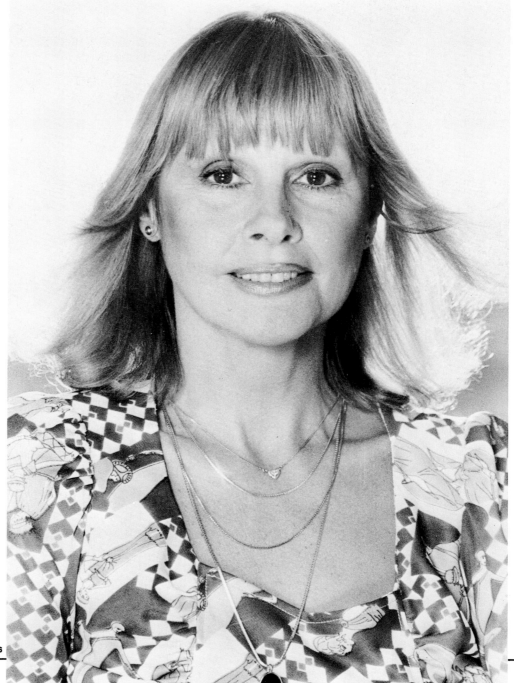

FIG. 6

A STAR FOR A DAY: DIFFUSION LIGHTING

Within everyone is a dream of stardom, a perhaps hidden fascination with bright lights and a life of endless flattering attention. Try the "Star for a Day" technique with your friends and models, and you may discover some surprising beauty and talent in them. This is an occasion for beautiful clothes, jewelry—the best of everything. The mood in the studio has to be upbeat and positive, the pretense impeccable: you are photographing a star! Have fun with this technique—ask your model to project wealth, fame, and talent. Try daring poses, dramatic tilts of the face, the sort of expressions both you and your model have seen stylized in high fashion photography. Keep your ego as the photographer out of the way, and let your model know that she is the star. Many people—even professional models—are tense at being photographed. Take some time before your sessions to find out something about the person, and let the model relax. This will help you draw out hidden sides of the personality—such as the secret star within.

EQUIPMENT AND SETUP

Improvisation proved to be the secret element of this setup. The 350-watt fill light, a large, diffused spot (B) was placed slightly above the height of the model's face, and positioned just over the photographer's head. A second front light, called a *kicker* light (D), was put in place at a 45-degree angle in front of, and to the model's left. Backlighting is provided by the key spot (A), which is directed past a flag to avoid lens flare. The hair light (C) is slightly higher than the model's head, and is positioned behind her, to her left. It is also carefully directed so that it does not cause flare in the lens. Columnar reflectors are used on each side of the model, and the reflector in front of her is not hand-held, but placed directly in the path of the diffused light from the fill light (B). To get a maximum of light bouncing onto the face and jewelry, the photographer put a small, mirrored table into service as a second reflector to bounce light upward into the face. It is resting on the bar, and the model holds it in place with her left elbow. This is an ingenious use of a reflective object that can suggest many variations for the creative photographer.

PROCEDURE

1. Set up and turn on the front diffused fill light (B), making sure you can still readily control your camera and tripod though this light is overhead.

2. Add the front kicker light (D) about 7 feet (213 cm) in front of the model, at a 45-degree angle, and directed at her left side.

3. Position the high, 650-watt key spot (A), and pull the flag in front of it so the light is directed downward onto the model's head, but does not cause flare in your lens.

FIG. 1

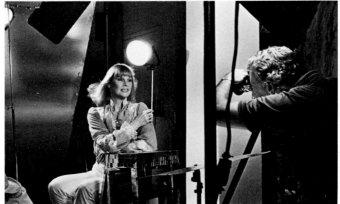

FIG. 2

A	650-watt quartz spotlight
B	350-watt diffused spotlight
C	150-watt spotlight
D	350-watt diffused spotlight
S	Strobe and umbrella
S2	Snooted spot. synched with strobe
	Flash
	Sun — Reflector
P	Photographer **M** Model

4. Add the hair light (C), and test that it is not too hot. Check the model's makeup and hair.

5. Set up your reflectors to the right, left, and in front of the model. Move your hand over them to observe the precise effects they cause.

6. Add a mirror or another highly reflective object in front of the model—but position it so that it does not cause bright spots on the face.

7. Position the bar—in this case, higher than usual so the model can easily maintain a more upright, patrician pose.

8. Determine your exposure.

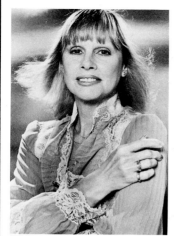

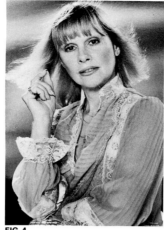

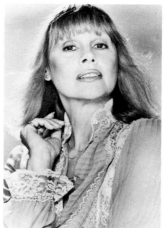

FIG. 3 **FIG. 4** **FIG. 5**

CONCLUSIONS

As is the case in many portrait sessions, all of the examples shown are good portraits. Selecting the best one is a matter of studying each fine detail of the portrait, and determining which is the most perfect. Fig. 3 is lovely, but has emphasized the model's right arm too much through excessive highlighting. Though slight overexposure was intended in the hair, it causes the eye to move away from the center of interest—the face. Fig. 4 is an attractive portrait, but its facial shadows are not adequately filled in. Black-and-white photography emphasizes lines and shadows in the face, which is why skillful fill lighting and use of reflected light are so essential. Fig. 5 and Fig. 6 show better fill light. Fig. 5 shows the model's head raised just a bit too far—giving a haughty look rather than a dignified one. Fig. 6 is the one judged best from this sitting. The facial shadows are filled in with well-balanced direct and reflected light, the hair is well lighted for a delicate effect, and all the elements of the portrait add up to glamour.

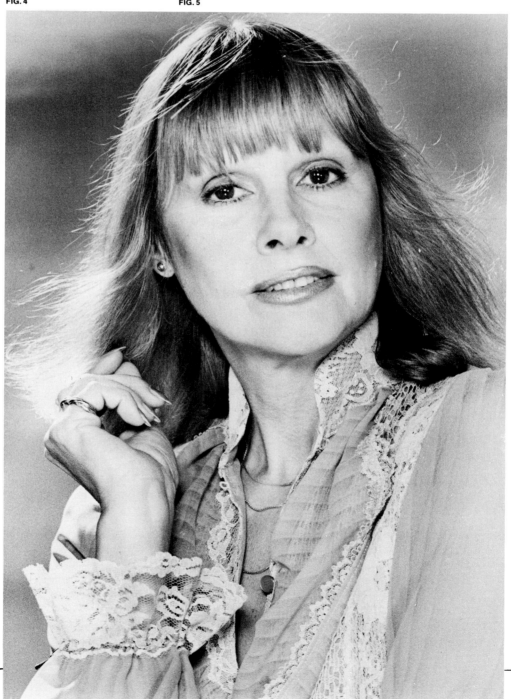

FIG. 6

LIGHTING THE "WET" LOOK

This technique is a terrifically different look for portraits of men or women. However, the "wet" look is best adapted to a younger subject—one between the ages of 18 and 35—because it evokes a casual, youthful mood. It is also a technique that is specifically used as a specialty shot in a model's or actor's portfolio. It would not be used for a formal portrait, as it is too "commercial" (although it might be taken as a very different portrait for a friend). This type of lighting setup is most often used in advertising soft drinks, hair products, toothpaste, etc., as it presents a fresh, athletic, "just out of the shower"

image. As the title suggests, it is a "wet" look—the hair is literally wetted down and the shots can be taken with the hair messed up or slicked back. The lighting should represent a feeling of the sunny outdoors. The portrait should be alive with vitality, the subject surrounded by bright, bouncy light. Some shots can be taken with only the hair wetted down, but for extra emphasis, the face can be sprayed with water as well. This is a refreshing portrait effect, which can be an attractive addition to any professional portfolio.

EQUIPMENT AND SETUP

A rattan peacock chair has been included in this setup to give texture to the background and add a casual, beach club atmosphere to the shot. The main 350-watt diffused fill light (B) is placed very close to the model for maximum brightness. It is positioned directly in front of him, a bit higher than eye level. A 650-watt quartz light (A) is placed behind the model to illuminate his hair. A hair light (C) is positioned at a 45-degree angle, close to the model's left side and slightly above his head, to further illuminate the hair and fill in the shadows. A flag is placed in front of light (A) to prevent lens flare. The reflective background is used to create the effect of a bright, sunny sky. A rectangular metal reflector is adjusted directly in front of his arms, and two large, white, portable reflectors are placed on the left and right sides of the model. The effect in the final portrait is one of the brilliant, light-reflective qualities of a poolside environment.

PROCEDURE

1. Turn on and adjust fill light (B). Turn on key light (A). Adjust the flag to prevent flare in lens.

FIG. 1

FIG. 2

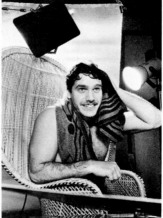

FIG. 3

Ⓐ	650 - watt quartz spotlight
Ⓑ	350 - watt diffused spotlight
Ⓒ	150 - watt spotlight
Ⓓ	350 - watt diffused spotlight
Ⓢ	Strobe and umbrella
S2	Snooted spot synched with strobe
✹	Flash
☀	Sun ⌒ Reflector
Ⓟ	Photographer Ⓜ Model

2. Adjust the metal reflector, which is placed on a swivel stand at waist height between subject and camera.

3. Check model's makeup and hair (which has already been wetted down). Do not spray face yet, but turn on the fan to keep the model comfortable.

4. Turn on and adjust hair light (C).

5. Make sure that background is not reflecting too much light.

6. Take meter reading and check exposure.

7. Spray the model's face with *warm* water.

8. Constantly coach your subject. Since this is a very commercial look, keep the model talking, smiling, or even laughing.

FIG. 4

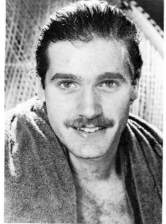

FIG. 5

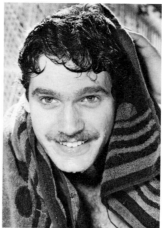

FIG. 6

9. Supply props for your model to work with. Give him a towel, a glass filled with a cold drink, or a can of soft drink (spray these with water too). Always have the spray can ready, as under the hot studio lights, the drops of water will dry up quickly.

CONCLUSIONS

Though the "wet look" was the aim of the session, the model had requested a portrait with sunglasses. As you can see in Fig. 4, portraits with sunglasses are usually not successful because you can not see the subject's eyes. Possibly the only time a subject should be photographed with sunglasses would be in a portrait taken out-of-doors, and in color, so that the viewer can relate to a situation, rather than to the subject. Fig. 5 is more successful. The rattan chair adds to the "beach club" atmosphere, and the towel gives the impression that the model has just stepped out of the pool. The hair has been wetted down and combed straight back for a neat, professional appearance. His face is sprayed with water for even more of a "wet" look. The strong backlighting on the hair augments the idea of a sunlit beach, and the aluminum reflector is placed as close to the face as possible to give the impression of the water shining back from his eyes. Fig. 6 represents a more commercial look. The model adds action to the shot by drying his messed-up hair with a towel. He might be telling you, "This shampoo is great!" The close positioning of the metal reflector keeps his teeth looking *white*. In Fig. 7 all the lighting elements work together to supplement the model's sporty good looks and provide a dynamic shot for his portfolio. His hair was towelled while still wet, his face sprayed with water, and even more intense backlighting, mainlighting, and reflector lighting was used.

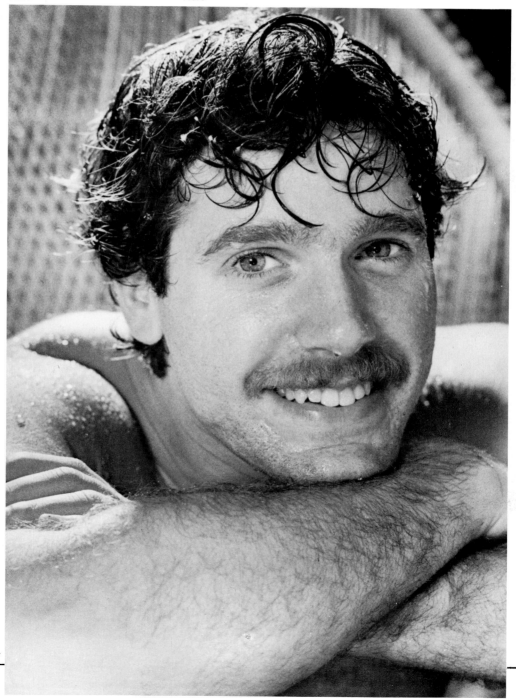

FIG. 7

DIFFUSED OUTDOOR LIGHT

Light may not be what it seems at first glance. Take, for instance, a heavily overcast day. Is such lighting good for outdoor portraits? Probably! Clouds are a peerless diffuser—and although a particular day may look gray and flat, a surprising amount of light is available for outdoor shooting. As an experiment, take an exposure meter, or your camera, and check the kind of exposure you could use the next time it's a gray, overcast day. Or simply look about you—on this kind of gray day, there are almost no natural shadows. This tells you right away that the light is highly diffused, and will be inherently flattering for portraiture. The use of hand-held reflectors can help modify the light for beautiful portrait effects—use reflectors to highlight the eyes, reduce the subtle shadows under the chin, and, as in this demonstration, remove the shadow under the brim of a hat. Keep in mind the *suitability* of a lighting scheme to your subject's personality. The implication of outdoors and of imperfect weather added a great deal to this individual, whose interests are rugged and nautical.

EQUIPMENT AND SETUP
One double-sided reflector was carried along for this session, which took place near the photographer's studio. The actual setting is at a highway exit, a location which allowed a wide expanse of area with no tall buildings or other impediments to the light bouncing from all directions. Notice in Fig. 1 and Fig. 2 that the individuals cast no shadows—this tells you how diffused the noontime light is. The reflector has a white side and an aluminumized side. The white side was used for this session, as the aluminized side cast slightly too hot a glow onto the subject's face. The real challenge in this setup is to place the subject in a pose and position where a maximum of diffused daylight and reflected light illuminate his face, while keeping the background free of obstructions. Notice in Fig. 1 that the subject is facing into the light, but his head is positioned so that none of the distant light poles appear behind his head. Pay extra attention to the background when working outdoors—perfect portraits can be ruined by, for example, a tree behind a person's head. Choose your framing to include or exclude the background, as you prefer.

PROCEDURE
1. Find a location that offers a wide open space with no obstructions to the naturally diffused light.

2. Have your model turn around so that you can observe the effect of the light on his face—find the position that brings a maximum of diffused light. This kind of light softens lines and facial flaws.

3. Show the model how to hold the reflector to bounce light back up into the chin and neck areas, and

FIG. 1

FIG. 2

into the eyes. If the model happens to be wearing a hat, as in this demonstration, try tilting the head and adjusting the reflector until it looks right to you—nearly shadow-free.

4. Take an exposure reading. Check your exposure every time the subject moves into a new pose. Bracket if you're working in color.

5. Double-check your background carefully, and anticipate your framing before you shoot. Determine whether your exposure will allow the background to go sufficiently out-of-focus to avoid being a distraction in the finished portraits.

6. Coach the subject through the session—ask him to say something like "Hi, there!" to give a natural smile and a feeling of dynamic rapport.

Ⓐ	650 - watt quartz spotlight
Ⓑ	350 - watt diffused spotlight
Ⓒ	150 - watt spotlight
Ⓓ	350 - watt diffused spotlight
Ⓢ	Strobe and umbrella
S2	Snooted spot. synched with strobe
✸	Flash
☉	Sun ⌒ Reflector
Ⓟ	Photographer Ⓜ Model

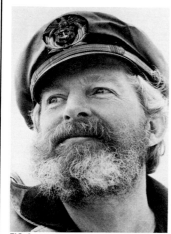

FIG. 3

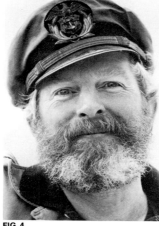

FIG. 4

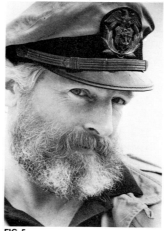

FIG. 5

CONCLUSIONS

It's hard to go wrong in highly diffused, natural lighting—the light filtering through the clouds softens all shadows, and is innately flattering. Here are some examples of the finer points of working in such a positive lighting situation. Notice in Fig. 3 how well the shadow is filled in on the neck, and how a nice highlight appears on the model's right cheek. The problem with this shot is that the eyes are not highlighted, although the rest of the face is. In Fig. 4, direct eye contact gives better impact to the portrait, but the brim of the hat casts a shadow that is just dark enough to lessen the portrait's effectiveness. How to fill in the shadow of the brim? Fig. 5 shows one solution—the model tilted his head and held the reflector closer to hide the shadow, and increase reflector fill. The head, however, is at too much of an angle; in portraits of men, it is important to retain a visual image of strength by keeping the head as close to vertical as possible. So Fig. 6, which solves the brim shadow problem by merely pushing the hat back onto the forehead, is the strongest portrait because it is well illuminated, the brim shadow does not obstruct the eyes, and the head is rendered in a very masculine and personable manner.

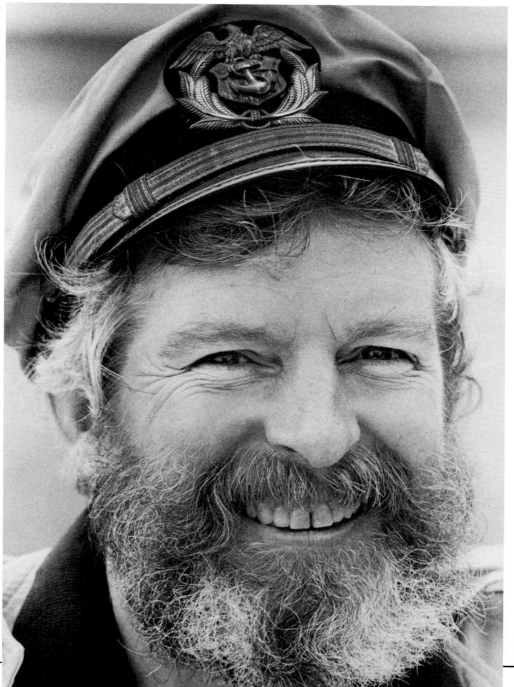

FIG. 6

NATURAL SPOTLIGHTS IN MIDDAY SHADE

Light passing through intertwined branches and other natural objects often creates what to a sharp eye is clearly a *natural spotlight*—a shaft of hot light that can add highlights and a distinctive glow to outdoor portraits. Natural spotlights have effects that are much the same as studio spotlights, but with one major difference: in the studio, you move the spotlights around the model; outdoors, you move the model among the spotlights. A large, white reflector is usually sufficient to provide shadow fill if angled properly, and a gentle

breeze can provide a lovely motion to your model's hair, as a fan does in the studio. Look around while seeking an outdoor location and try to find natural spotlights. Once you've found such a spot, position your model carefully—an outdoor spot can cause the same flaws as a misplaced studio light: glare along the nose and chin, too bright a streak along the part in the model's hair, or overly dark shadows in the eye or neck areas. A slight downward tilt of the model's face while working outdoors will eliminate most of these faults.

EQUIPMENT AND SETUP

A large, white, Styrofoam board, which is easy to carry yet sturdy enough to resist a light to medium breeze, is the only piece of equipment required beyond the camera and lens. The reflector may be held by the subject (Fig. 1), or another person. Fig. 3 and Fig. 4 show a medium brightening effect from the reflector position shown in Fig. 1; and Fig. 5 and Fig. 6 show a more apparent brightening caused by a third person holding the reflector in a more horizontal position, as shown in Fig. 2.

PROCEDURE

1. Scout out a location an hour or so before or after noon that offers fairly brilliant beams of light coming through the branches of a tree. These are your spotlights for the shooting.

2. Position the subject so a natural spotlight brightens the hair, but make sure it doesn't cause glare along the nose, chin, or cheeks. Move the model until her position is perfect.

3. Since the light is quite diffused under a tree, a reflector will be a significant aid in brightening the eyes and filling out the soft roundness of the model's face.

4. Try the reflector in a lengthwise, and then a vertical position; try it parallel to the model, and at various angles. Find the position that most evenly illuminates her face.

5. If the combination of diffused light and reflected light from the natural spotlight are bright enough to cause the model to squint, work out a cue so that you can allow her to close her eyes between shots so that they will appear open and relaxed when you take the picture.

FIG. 1

FIG. 2

Ⓐ	650 - watt quartz spotlight
Ⓑ	350 - watt diffused spotlight
Ⓒ	150 - watt spotlight
Ⓓ	350 - watt diffused spotlight
Ⓢ	Strobe and umbrella
S2	Snooted spot, synched with strobe
✴	Flash
◯	Sun — Reflector
P	Photographer **M** Model

6. Take an exposure reading. You may be surprised at how much light is actually available in the soft, midday shade under a tree.

7. Analyze the background carefully throughout the shooting. Select an aperture that will let it go softly out of focus.

8. Double-check your exposure each time you notice a change in the light level. And shoot quickly—natural spotlights won't sit there waiting for you to turn them off!

FIG. 3

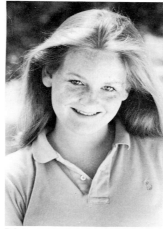

FIG. 4

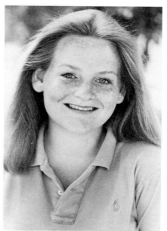

FIG. 5

CONCLUSIONS

Natural spotlights are particularly favorable for outdoor portraits of blondes, whose hair needs a great deal of light to stay blonde-looking, especially in black-and-white portraits. Each portrait from Fig. 3–6 shows a successively brighter image, due to the reflector catching the light from the natural spotlight and bouncing it back onto the face. Though all are acceptable portraits, Fig. 6 was chosen as the one that best expresses the ingenuous beauty of this model. The lighting is lovely, the pose graceful, and the high-key look of this portrait expresses youth and beauty.

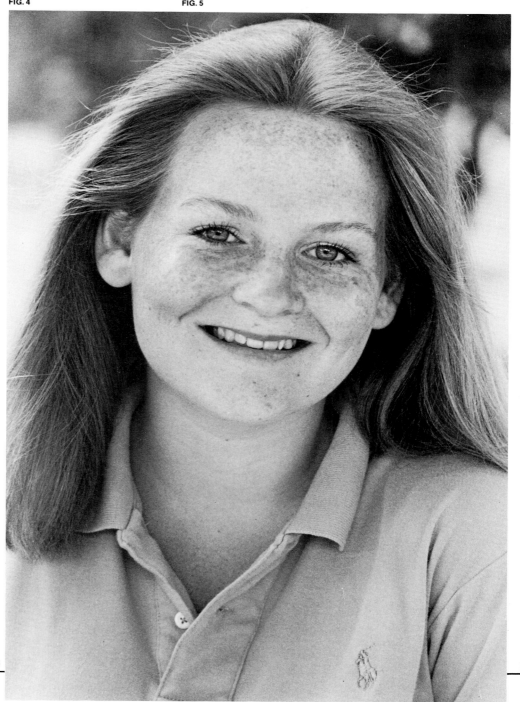

FIG. 6

NATURAL SPOTLIGHTS IN DIRECT SUNLIGHT

Outdoors, the sun is the only major light source, and at certain times of the day, it can be considered as a spotlight—another kind of natural spotlight that you can use to bring out pretty effects. The sun offers innumerable photographic possibilities for portraits. Working in direct sunlight requires as much attention as working with studio lights, for you must position the model in such a way that the natural spotlight effect is evident, but not causing any obvious flaws, such as a hot spot on her nose. Never place a model facing toward direct sun-light. Blue eyes seem to be more sensitive to bright light than brown, so give your model a break from time to time so that portraits will not be ruined by squinting or blinking. A simple cue will let her rest between shots. Using a reflector fills in some of the shadows that arise when the model has her face away from the direct light, but it can also cause a great deal of glare in her eyes. The fine art of posing is especially important in accomplishing perfect lighting when working with this technique.

EQUIPMENT AND SETUP

One double-sided reflector is necessary for this technique. The gold side may cast too hot a glare on the model's face. However, if you take a two-sided reflector along, you have the option of using the gold side in case the sun goes behind a cloud and lowers the level of ambient light. The location is the key to this setup. Choose a spot that offers what appears to be a bright ray of light onto the model's head. Work with her to tilt her head, and tilt her shoulders so that you can see the natural spotlight fall across one side of her face, one side of her hair—or any other highlight that is pleasing. This spotlight is not as easy to see as a studio light, but train your eye to see the highlight and delicate rim lighting it can provide.

PROCEDURE

1. Find a location where a natural spotlight falls on your model. Ideally, her back will be to the bright light, and she can face a darker area, such as the shade of a tree. This will help keep her from squinting and blinking during the shooting.

2. Try the gold side of the reflector, and then the white side. Determine which gives the best effect in bringing out the rounded planes of the model's face.

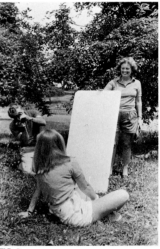

FIG. 2

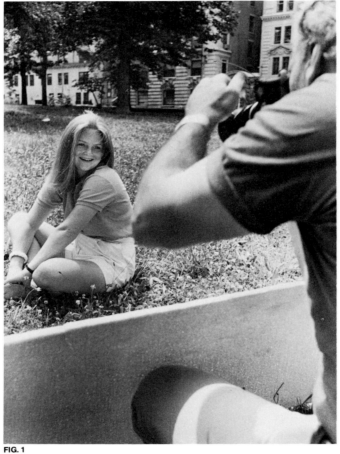

FIG. 1

3. Take exposure readings periodically, especially when you notice a change in the ambient light. If the sun goes behind a cloud, you may want to switch to the gold side of the reflector for more bounced light on her face.

4. Coach the model through the session, asking her to say "Hi!" to give a natural, friendly look. Make sure she keeps her face tilted slightly downward so there is no glare on her nose and let her eyes rest periodically for best results.

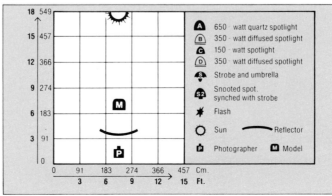

Ⓐ	650 - watt quartz spotlight
Ⓑ	350 - watt diffused spotlight
Ⓒ	150 - watt spotlight
Ⓓ	350 - watt diffused spotlight
Ⓢ	Strobe and umbrella
Ⓢ2	Snooted spot. synched with strobe
✳	Flash
○	Sun
Ⓟ	Photographer
Ⓜ	Model
—	Reflector

FIG. 3

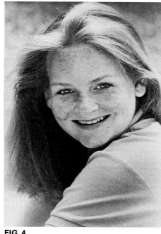

FIG. 4

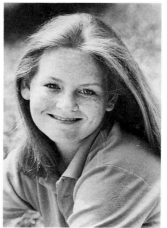

FIG. 5

CONCLUSIONS

Fig. 3, Fig. 4, and Fig. 5 show a natural, midday spotlight filled in with a reflector balanced across the photographer's knees, as shown in Fig. 1. Notice how the dark underside of the hair serves to define the outline of the model's face, emphasizing her pale features through contrast. Fig. 5 shows a bit too much highlight on her nose, though not enough to make the portrait unacceptable. Fig. 6 is the portrait selected from this shooting as the most attractive. It differs from Fig. 3, Fig. 4, and Fig. 5 in that a third person held the reflector, as shown in Fig. 2. The reflector brings a lot of light up onto the face—so much so that the underlighting from the bounced light is as bright as the natural spotlight on her hair. This interesting lighting effect is very natural and outdoorsy, and presents quite a flattering portrait of a lovely girl.

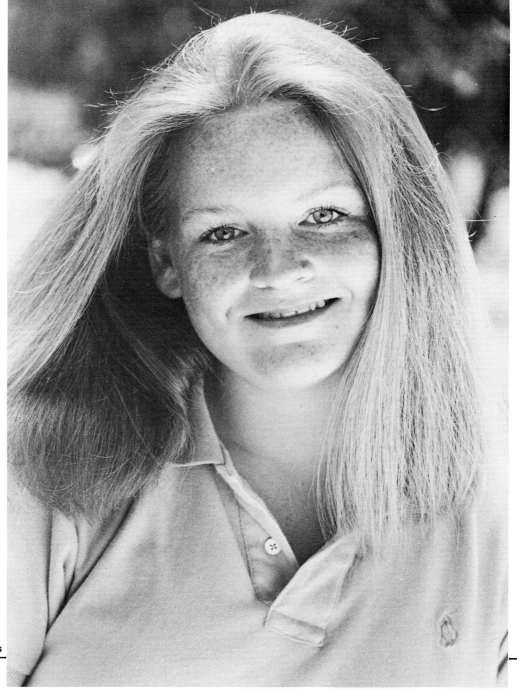

FIG. 6

OUTDOOR PORTRAIT OF TWO PEOPLE AT MIDDAY

Distinctive outdoor portraits of two people can be done in midday sunlight if you skillfully use a reflector. Achieving nonidentical lighting is challenging, but having each person hold a different pose can vary what is fairly fixed lighting. It is doubly challenging to avoid shadows when you have two faces to consider, but a larger reflector can do the job. The key to dynamic double portraits is to achieve a sense of intimacy and to express the relationship of the people. Anything that avoids the stereotypical, side-by-side portrait will add interest. Keeping the two faces, whatever the pose, on the same plane will help ensure equal emphasis and sharpness. Your coaching will have to relax them both and keep both pairs of eyes on the camera. Try to work as close to the models as you can, to nearly fill the frame with their faces. The most common error most photographers make when working outdoors is to stay too far back from their subjects. Even using a 105mm lens, a close photographer-to-subject distance added impact to a sunny, joyous, double portrait.

EQUIPMENT AND SETUP

One large, rectangular, Styrofoam reflector was the only piece of equipment required beyond a camera and 105mm lens. The reflector has to be large enough to more than span both subjects in any given pose, so that there is no line of demarcation of bounced light on either subject in the pictures. To help rest their eyes, the subjects are standing with their backs to bright sunlight, and for some variation in illumination, they pose at various distances from the shade, within the diffused light of a tree at noon. For a maximum of bounced light, both subjects will hold the reflector following the photographer's direction.

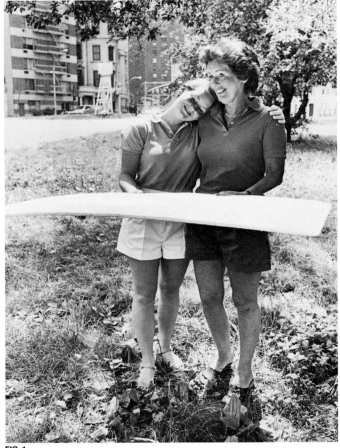

FIG. 1

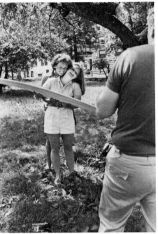

FIG. 2

PROCEDURE

1. Find a location that offers bright midday light, and have your models stand so that their backs are to the bright light, with their eyes looking at a medium shady area.

2. Sporty-looking clothes are important for casual, outdoor portraits. Make sure your models are appropriately dressed.

3. Practice with the reflector. If there is a breeze strong enough to make it flutter, try to turn your models so that the wind as well as the sun strike their backs.

4. Take careful exposure readings, and double-check your exposures each time the light changes. When shooting in color, bracket for best results.

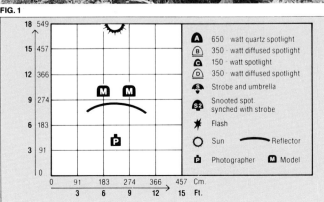

A	650 - watt quartz spotlight	
B	350 - watt diffused spotlight	
C	150 - watt spotlight	
D	350 - watt diffused spotlight	
S	Strobe and umbrella	
S2	Snooted spot. synched with strobe	
✳	Flash	
☼	Sun	Reflector
P	Photographer	M Model

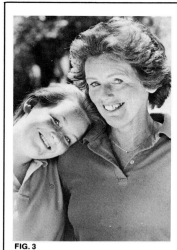

FIG. 3

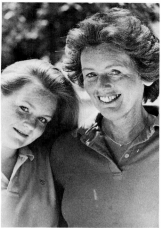

FIG. 4

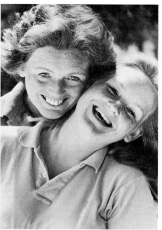

FIG. 5

CONCLUSIONS

Each of the four examples shown here displays excellently filled outdoor light. The reflector is held at a slight tilt so that it gives an equal amount of illumination to both faces, despite the fact that the daughter's face is lower and in front. Fig. 3 shows too much highlight on the right side of the daughter's face because the sun is directly overhead. Fig. 3 also has a tree trunk behind the daughter's head. Fig. 4 is nice, but their closeness is better expressed in Fig. 5 and Fig. 6. Fig. 5 is terrific except that the daughter's mouth is open. Fig. 6 is the best of the series. It is a luminous, joyous, double portrait that this mother and daughter will treasure for years to come.

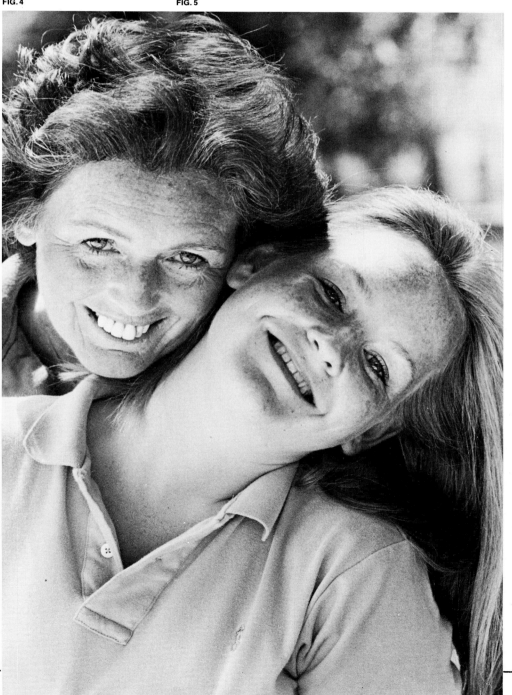

FIG. 6

LIGHTING CHILDREN'S PORTRAITS

Portraits of children, as a matter of course, should be brightly lit, as if they were taken outside. Ideally, their portraits should be taken out-of-doors, on a sunny day, with the use of reflectors. (Review techniques 16 and 17.) If, however, you can't photograph outdoors because of weather conditions or other complications, you should make the studio appear as "outdoorsy" as possible. Children are young, energetic, and vital, and these are the qualities that should be expressed in a child's portrait. The use of any shadows on a child's face should be unthinkable. No one wants to think of their child as being moody and reflective. Of course, children do stop and think occasionally, but a reflective mood in a portrait is not one that you would want to emphasize when photographing a child. Most people would rather look back on their children's youth as a time of buoyant happiness, and this type of portrait can be a pleasant change from the formal, "all dressed up for the party" picture.

EQUIPMENT AND SETUP

Remember that children are very energetic, so try not to keep them sitting still too long. Have them change clothes often (their mothers always bring too many to the studio anyway). Explain to the child and parent the lighting setup you are using, and discuss with them the effect you all want. A parent should be present to help with clothing changes and hair, but don't let the parent play director! For a diffused, outdoor feeling, begin by setting up the 350-watt diffused fill light (B) at eye level, in front and to the right side of the subject. A 650-watt quartz key light (A) is added behind her and to her right. The key light (A) is raised to a height of 6 feet (183 cm), and pointed down at her at a 45-degree angle. A metal reflector is placed directly in front of the bar, which she leans on, and at waist level between the subject and the camera. A hair light (C) is placed behind her left shoulder. It is raised to a height of 4 feet (122 cm), and tilted toward her at a 45-degree angle. The flag covers light (A) to prevent lens flare. A fan is used to keep the child comfortable under the hot lights, and to blow her hair gently. A softer, more diffused piece of Mylar is used here as the background.

PROCEDURE

1. Place light (B) at a slight angle to the left of the subject's face, raised to about eye level. Make sure there are no shadows falling on her face.

2. Add makeup as needed. A little pink blush is always good on a child's face, but avoid anything that looks overdone. Make sure clothing and hair are neat, but natural looking.

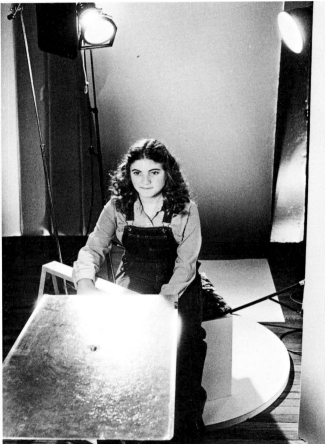

FIG. 1

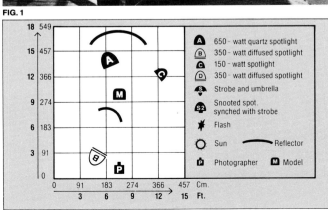

Ⓐ	650 – watt quartz spotlight	
Ⓑ	350 – watt diffused spotlight	
Ⓒ	150 – watt spotlight	
Ⓓ	350 – watt diffused spotlight	
Ⓢ	Strobe and umbrella	
Ⓢ2	Snooted spot, synched with strobe	
✳	Flash	
☀	Sun ⌒ Reflector	
Ⓟ	Photographer Ⓜ Model	

FIG. 2

3. Add hair light (C), along with key light (A), to create the sunny, outdoors effect. Position a flag in front of (A).

4. Have the subject adjust the metal reflector with her hand occasionally for maximum brightness and bounced light. This also helps to make the child part of the action. Be sure to check your meter reading each time a part of the setup is changed.

5. Keep talking about what you are doing. When working with children, it is always best to keep them interested and to try to be as entertaining as possible.

6. Similarly, remember that children like to keep active. Have different props available for their use, and move them into various poses. Allow them to change costumes for different shots as well.

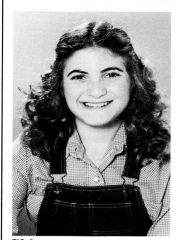

FIG. 3

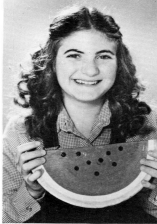

FIG. 4

FIG. 5

CONCLUSIONS

It is evident from these portraits that the model, though young, knows how to work with the photographer to achieve specific looks. She is a young actress who has done some television commercials already, and her experience shows. Fig. 3 is a straight head-and-shoulders portrait—she gives the impression that she *has* been playing outside and suddenly stopped in to say "Hi!" The use of the overalls with the suspenders adds to the "down on the farm" look that was wanted. Fig. 4 shows how effectively props can be used when working with young models. The prop gives the child the extra feeling of a real situation. The lighting in this shot continues to project an outdoors mood with its light background and the hair lights imitating sunlight. Fig. 5 shows the value of a continual flow of conversation to keep the child relaxed and natural. Ask them a question and photograph their response. As you can see, this will usually result in a thoroughly charming facial expression. Fig. 6 is the shot selected from this session. All of the elements work together to successfully evoke a sunny, natural portrait of a charming young girl.

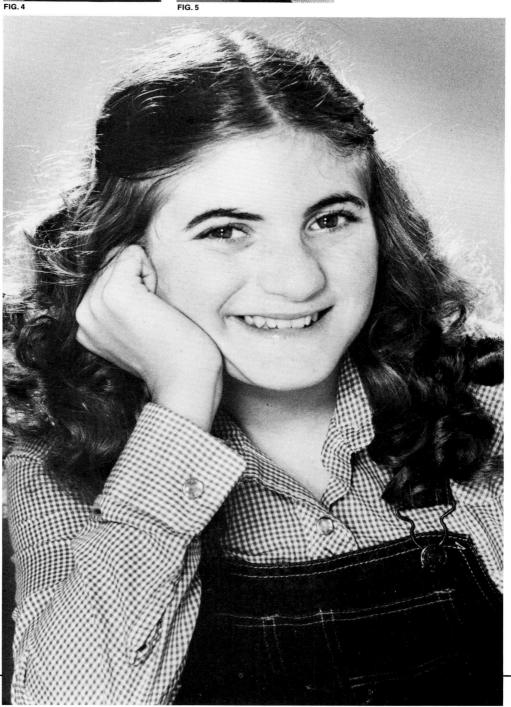

FIG. 6

TELEVISION LIGHTING

Everyone wants to be a television star, and by telling your subjects that you are going to make them look like their favorite newscaster or soap opera personality, they will immediately become more than a little interested in the portrait session. Creating the effect of a television lighting setup is not difficult at all. If you observe any personality appearing on television, you will note that they are very brightly and sharply lit. Usually, one or two intense spotlights and a strong backlight are used. Have your subjects pretend that they are their favorite local news personality. This gives them a specific image to keep in mind, as well as a natural reason to connect with the camera. Besides, nearly everyone likes to imagine him or herself in this type of role. This technique of having a brightly lit subject "speaking" directly to the camera is one that can work well with anyone. It is excellent for commercial portfolio shots, and can create an attractive formal portrait as well.

EQUIPMENT AND SETUP
Most television lighting is brightly and sharply lit. A 50-watt diffused fill light (B) is placed directly in front of the subject at eye level. A 50-watt kicker light (D) is also placed on the tripod directly in front of the model for highlights in the eyes. Fill light in this setup is provided by three white reflectors. One is placed at table height for the model to lean on, with two more positioned directly on each side of her. The 650-watt key light (A) is positioned about 4 feet (122 cm) behind her right shoulder, and raised to a height of 7 feet (213 cm) to add sufficient modeling to her dark hair. A metal flag is placed in front of the key light (A) to prevent lens flare. The background reflector is angled forward 45 degrees to prevent light from bouncing into the camera lens. A hair light (C) is placed 2 feet (61 cm) behind the left shoulder, at a height of 5 feet (152 cm) for modeling of the subject's hair on the left side. A secondary metal reflector is placed between the waist-high, white reflector and the camera to add more light to the dark complexion.

PROCEDURE
1. The fill light (B) will be the main light from which you will take your basic meter reading.

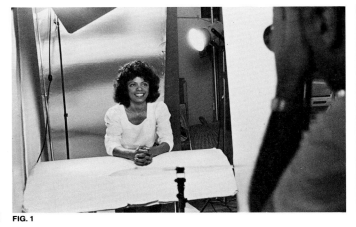

FIG. 1

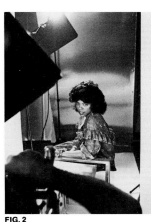

FIG. 2

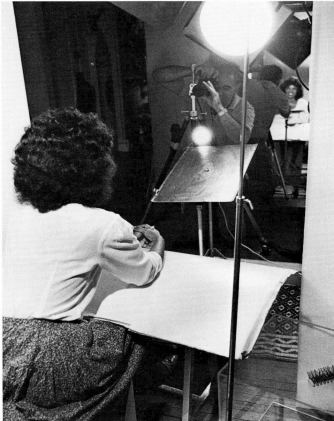

FIG. 3

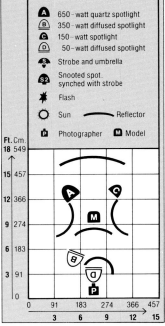

Ⓐ	650 - watt quartz spotlight
Ⓑ	350 - watt diffused spotlight
Ⓒ	150 - watt spotlight
Ⓓ	50 - watt diffused spotlight
Ⓢ	Strobe and umbrella
S2	Snooted spot. synched with strobe
✳	Flash
☼	Sun ⌒ Reflector
Ⓟ	Photographer Ⓜ Model

2. The kicker light (D) is placed on the camera tripod for extra eye highlighting.

3. Check the clothes and the hair for neatness, and the makeup for clarity and appearance. Remember to check these continuously throughout the session.

4. Add hair light (C) for light modeling on the hair. Turn on key light (A) and adjust the metal flag in front of it to prevent lens flare.

5. Tilt the background reflector to the right angle to prevent light from bouncing directly into your lens. If you are using a plain paper background, try to avoid having shadows from the subject falling onto it. (This is why reflective Mylar backgrounds are preferable for portraits, as they give a feeling of depth behind the subject and also absorb shadows.)

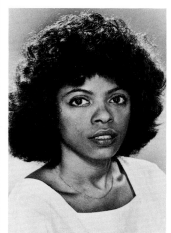

FIG. 4

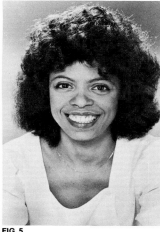

FIG. 5

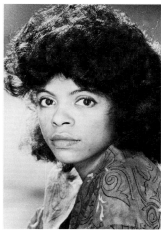

FIG. 6

6. Recheck your meter reading.

7. Play the ''television director'' throughout the session. Ask your subjects questions and keep them talking so that expressions remain animated.

8. Reposition the model occasionally and change lighting setups and clothes too for variable portraits.

CONCLUSIONS

In Fig. 4 you can see how the added use of the kicker light (D), plus multiple reflectors, give the impression of a well-lit television studio. Although in this shot the model is slightly relaxed, her rapport with the camera is still strong. In contrast, you can see how the model's mood perked up in Fig. 5. This is a look that could sell any product. This lighting technique must be augmented by the subject's personality, and that's where the photographer's role as director becomes important—it's your job to keep the energy up. In Fig. 6, the lighting and clothing are adapted to suit a more quiet mood. While the model is still brightly lit, there is a subdued tone present that suits her expression. Every photo session should include a variety of expressions; continually vary the activities of your model so that they can have a good selection of portraits to choose from. Always avoid monotony in your photo sessions. Fig. 7 is the portrait selected from this session, because of the model's attractive smile. She has an irrepressible charm that bursts through on occasion, and this shot captured her spontaneity. The lights and reflectors surround her on all sides, and the reflective background gives space and light behind her, keeping her sharp image dominant in the foreground plane.

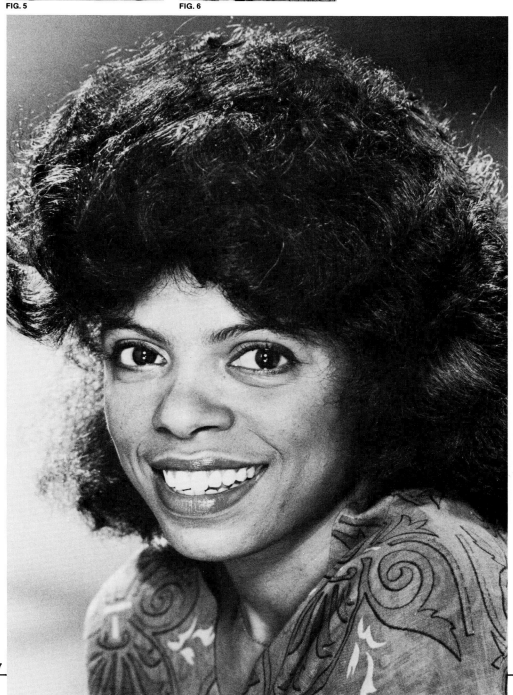

FIG. 7

HIGH FASHION I (BLACK-AND-WHITE)

Although most advertisements one sees today are in color, there is still a significant amount of fashion photography, commercial headshots, and product advertisements shot in black-and-white. Even if you aren't shooting for a commercial client, you can make good use of the technique detailed below to make any subject look like a high-fashion model. It's a matter of sleek lighting, a fan blowing the hair, and a kind of sophisticated pose that conveys elegance, style, and *savoir faire*. This demonstration shows how much a good

lighting setup has to do with making a very pretty girl look utterly spectacular. Accomplishing results such as those shown on the opposite page is also the result of a terrific photographer-model rapport. It takes a real interest in the model to draw out hidden glamour, and to bring out even more sophisticated beauty with each successive frame. Think about all the uses of a shot such as the one opposite: it could be a lovely framed portrait for the home, or a commercial shot for a model—the options are unlimited.

EQUIPMENT AND SETUP

Professional-looking makeup is an essential ingredient of this look. Ask your model to have her makeup done professionally if possible. If she does it herself, ask her to avoid extremes, especially heavy, dark, eye shadows—earth colors are best for this kind of session. It is a good practice to have models bring their own makeup kits to the studio, so if touchups are needed, you can do them with the model's own colors and brushes. The high-fashion look involves lots of strong light, particularly if your model has stunning blonde hair, as shown here. Three lights are sufficient, plus a fan to emphasize the hair, and a metallic, pedestal-mounted reflector. The keylight (A) is placed behind the model, to her right side. The front fill light (B) is positioned to the photographer's left and angled toward the white columnar reflector at the left side of the model. The hair light (C) is placed over the model's left shoulder, and a pedestal-mounted reflector is positioned horizontally in front of the model for additional fill light. Keep a hairbrush and makeup handy throughout the session for touchups, and keep up a mood that says this model is the most beautiful on earth. The mood of the shooting will help to bring out a sophisticated look as much as your studio lights and reflectors!

FIG. 1

FIG. 2

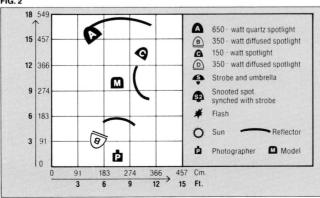

PROCEDURE

1. Set up your 650-watt quartz key light (A)—about 8-feet (244 cm) high, directed onto the top and sides of the model's hair.

2. Add a hot hair light (C) slightly behind the model on the side opposite the main spot.

3. Turn on a large, diffused front spot (B) and check that it fills in all the shadows in the face and neck areas.

4. Check the model's makeup. Add more blush in a triangle *under* the cheekbones, shaded back toward the ear.

5. Turn on a fan and move it close enough to make her hair lift somewhat—but don't make it too strong. The fan should be in front of the model so that it blows her hair back, *away* from her face.

6. Take some time to work with the model and determine exactly how to best use the aluminized reflector in front of her. The ideal position is one that casts a sexy, even sheen across her entire face.

7. Talk about expressions with the model. Big, ingenuous smiles are less common in high-fashion portraits than intense, ''cool'' facial expressions. Ask the model to practice in a mirror the expressions she's seen in fashion magazines, and work with her until they look natural and expressive.

8. Take an exposure reading.

9. Check your background—in this case it's a simple aluminized sheet hanging from the ceiling, chosen to be noncompetitive with the model's beautiful face.

10. Coach the model through the session to draw out her beauty and a full range of expressions.

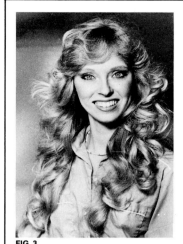

FIG. 3

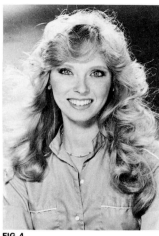

FIG. 4

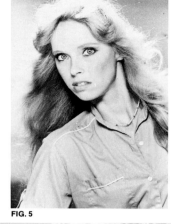

FIG. 5

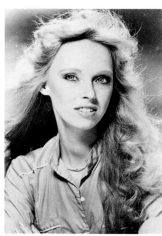

FIG. 6

CONCLUSIONS

Glance quickly over Fig. 3–7. They are terrific examples of the range of expressions, from innocent to sophisticated, that a talented photographer can draw out of a model. Fig. 3 is a simple shot using only the diffused, front spot (B) with no backlight of any kind. Fig. 4 shows the addition of the back light (A) and hair light (C), and demonstrates how enough light will keep a blonde's hair light in tone. Fig. 5 shows that the model has warmed up to a sophisticated mood—the tilt of the head and lovely hair approach a high-fashion look. With Fig. 6 the model has relaxed into a smooth, elegant look, greatly enhanced by reflected light for a portrait of timeless beauty. Fig. 7 is the one chosen at the end of the session. It could be an ad, a commercial headshot, or a portrait to frame and treasure, for what this portrait expresses is sheer beauty.

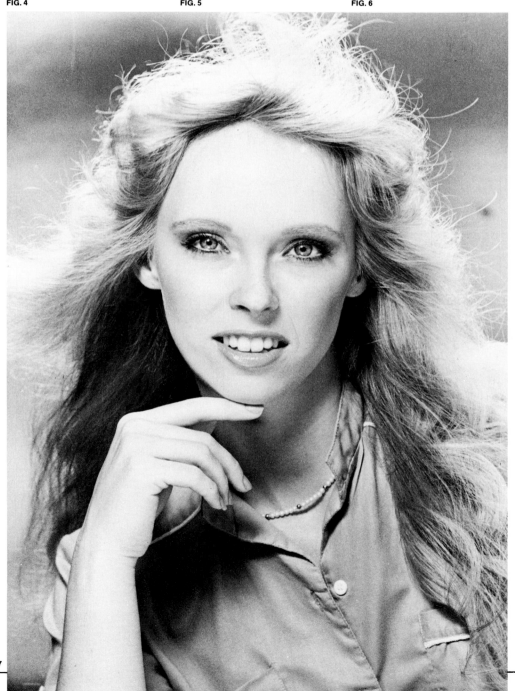

FIG. 7

HIGH FASHION II (COLOR)

The high fashion look that you see in magazines and on television is an effect that you can easily re-create in portraiture. It involves a maximum of reflected light, and the softening of all direct light except that which falls on the hair. When working in color, the beauty of the subject is the most important element. Proper makeup and styling are essential for a fashion look. If you study fashion magazines, you will find that the models look utterly impeccable, but equal—if not more—emphasis is placed on the clothes they wear.

Good lighting can make a subject's hair become a stunning element in a picture. Add a fan for a touch of motion in the hair and outfit; the outcome should be spectacular. Grace and pose are just as important as lighting for this style of portrait. Try to determine the subject's best feature—hands? eyes? lips? smile? perfect teeth? Emphasize the best features of your client through lighting and choice of pose. Make the most of what is naturally best in your model, and your portraits will be successful.

EQUIPMENT AND SETUP

A highly reflective environment composed of a number of shiny, mirror-like surfaces is the lighting secret for this high-fashion look. For this session, the model sits or stands on a piece of Mylar, which has been kept covered to avoid scratches. Before each session such material needs to be carefully cleaned so that there are no marks to ruin the images in situations where the mirrored surface would show. Pieces of shiny aluminized board have been put in place on three sides to complete the reflective environment for the portrait session. A 350-watt diffused spot (B) is placed just over the photographer's head as he works to fill in the reflective environment with soft frontal fill light. The 650-watt main light (A) is placed about seven feet (213 cm) from the model, and about three feet (91 cm) to the right of the photographer. It adds strong frontal light and also lights the hair, thanks to the high reflectivity inherent in the setup. An assistant holds another reflector just in front of the model when deemed necessary.

PROCEDURE

1. Position the mirrored Mylar floor reflector. Clean it with an appropriate solution. Ask the model to remove her shoes to avoid marring the surface.

2. Position the back and side reflector panels, and angle them to maximize the amount of light that will bounce from the main light (A).

3. Position the main light (A) to your right, about seven feet (213 cm) from the model. Turn it on and check for hot spots in the background. Move it until it lights the hair sufficiently, as it is also serving as your hair light in this instance.

FIG. 1

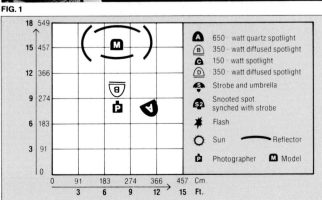

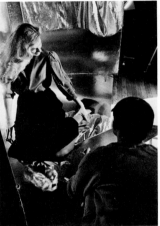

FIG. 2

4. Turn on the diffused front fill light (B), and position it so that it provides a maximum of softened light on the model's face and clothing.

5. Place a fan in front of the model, set at a moderate speed sufficient to gently lift her hair and make the clothes move a bit, but do mot place it too close. Keep a brush handy for the model's use, as a fan tends to make the hair separate and lose its ephemeral look after awhile.

6. Check the model's hair and makeup, and make sure there are no visible flaws in the outfit. Her cheekbones should be properly emphasized for the high-fashion look by using an earth-colored blusher applied under the cheekbones in an appropriate shade for her skin. Professional looking eye makeup is essential, but avoid strong or unusual colors. Stick to colors you naturally find in the model's own coloring. Avoid blue eye shadow and thick eye liner (both tend to darken the eye area and cause reflected shadows under the eyes). Make sure her complexion looks naturally beautiful—not painted.

A	650 - watt quartz spotlight
B	350 - watt diffused spotlight
C	150 - watt spotlight
D	350 - watt diffused spotlight
S	Strobe and umbrella
S2	Snooted spot. synched with strobe
✳	Flash
☼	Sun — Reflector
P	Photographer **M** Model

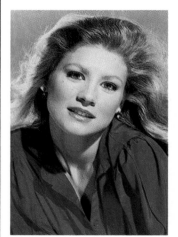

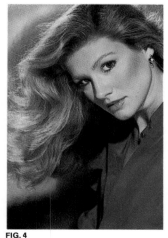

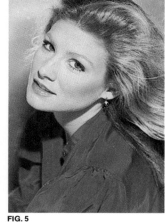

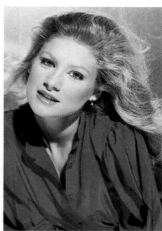

FIG. 3

FIG. 4

FIG. 5

FIG. 6

7. Check that you are using an appropriate indoor film.

8. Take an exposure reading and set your camera. Bracket for best results.

9. Coach the model through a series of poses and expressions, suggesting effects that will make the most of her beauty and charm.

CONCLUSIONS
The photographs on this page show the variety of totally glamorous and shimmering effects that this lighting setup can produce. Fig. 3 is a wonderfully sensual and seductive portrait. Notice the effect of the fan gently blowing her hair. However, the angle of the reflectors caused distracting shadows on her neckline. Fig. 4 shows the same pose as the final selection, Fig. 7, but it does not contain enough highlight on her face and hair. Fig. 5 is a beautiful three-quarter shot, with a delicate hairline of light outlining her right cheek. Fig. 6 is lighted well, but the model's expression and the angle of her face seem awkward. Fig. 7 is the portrait chosen from this session. It contains all the best qualities of the lighting setup—bright, shining highlights on the model's face and hair, no distracting shadows on the face or neck area, and a glowing expression and natural pose on the part of the model.

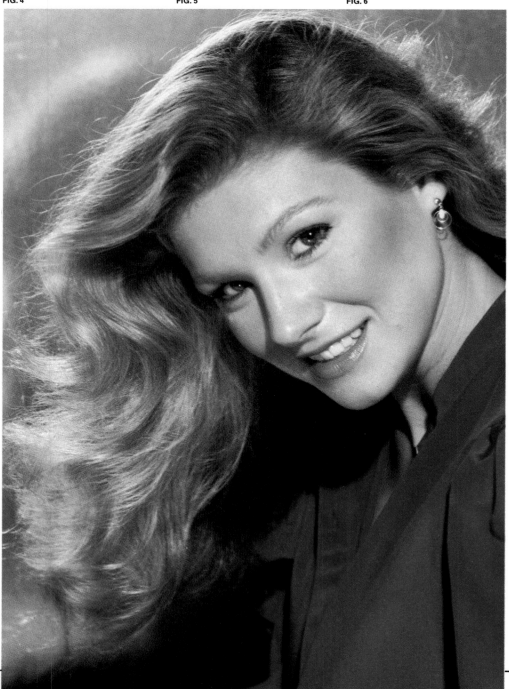

FIG. 7

OUTDOOR PORTRAIT OF TWO PEOPLE—NORMAL LIGHTING

Portraits are a unique form of photography in that they not only give us a permanent, two-dimensional representation of a person or persons, they also express intangible qualities about the subject's personality or nature. When taking portraits of couples or other duos, think about the *conceptual* aspect of the picture. How are you going to express togetherness, affection, and the combination of personalities that any couple is? Yes, this has something to do with lighting. It is possible, and even desirable, to pose a couple so that each is lighted differently, in a way that highlights his or her special qualities. The choice of a pose can express a great deal, also. Though it may seem the simplest thing in the world to pose two people outdoors at midday with a single reflector, study this demonstration to see the difference a shadow or pose can make. Each time a new pose is introduced, the reflector has to be repositioned. Each time the sun moves behind a cloud, your exposure is altered. These are the contingencies of outdoor portraiture—and the opportunities for you to show your skill!

EQUIPMENT AND SETUP

The equipment required for this double portrait taken outdoors is simple: daylight-balanced color film, your camera and lens (in this case, 105mm), and a single reflector. Since this portrait required lighting two people well, a larger reflector was used. It is a sheet of white Styrofoam board with a smooth surface, which in hot sunlight casts a great deal of light. Remember when working with reflectors that light bouncing into the subjects' eyes can be too bright, so to avoid squinting, ask them to close their eyes from time to time during the session. Positioning the couple and selecting their pose are worth serious study. Move them until they are brightly lit by the sun, but without strong shadows under the eyes, glare on their noses, or too much shadow on their faces. Then observe how many different effects you can achieve by moving the reflector around and at different angles.

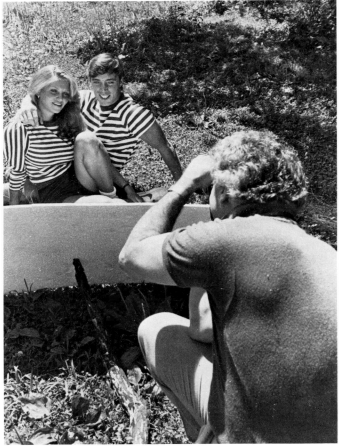

FIG. 1

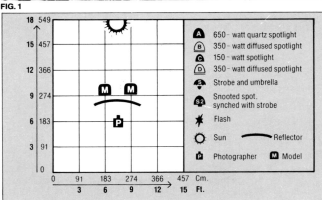

Ⓐ	650 - watt quartz spotlight
Ⓑ	350 - watt diffused spotlight
Ⓒ	150 - watt spotlight
Ⓓ	350 - watt diffused spotlight
🔦	Strobe and umbrella
Ⓢ2	Snooted spot. synched with strobe
✳	Flash
☼	Sun Reflector
Ⓟ	Photographer Ⓜ Model

PROCEDURE

1. Above all, try to break the trite, side-by-side type of portrait. Work out a series of cozy poses that will express the concept that these two people are a couple. Place one person behind the other; have them stand, sit, kneel, or lean over the shoulder. Switch positions and try poses with the other person in front. The variations in poses will produce a series of pictures that conveys much of the intangible dynamics of the relationship.

2. After deciding on a group of poses, work with positioning the reflector. Tell your subjects to close their eyes between frames (give them a cue so they know when to open them!) so you won't have a series of squinting expressions in the pictures.

3. Take an exposure reading with each change of pose.

4. Be aware of changes in the sunlight—if the sun passes behind a cloud, either wait until it shines again, or take a new exposure reading.

5. Bracket to make sure you've got the best available exposure.

6. Get your models to talk, to interact. Ask them to say something to each other. The most lively portraits are not the result of asking them to say "Cheese," despite the popular photographic habit. Ask them to say "Hey, I feel great today!" and you'll find the portraits that result are completely natural and charming.

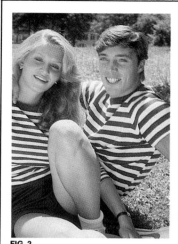

FIG. 2

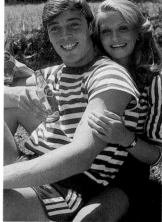

FIG. 3

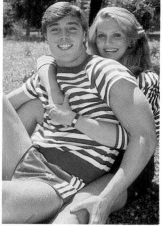

FIG. 4

CONCLUSIONS

Fig. 2–5 are studies both in poses and outdoor lighting. Take a moment to consider how each pose "reads"—what does each one convey about the couple? Do they look at ease, affectionate, comfortable, or uncomfortable? These are the questions you have to ask yourself about posing a couple. Now study the lighting. Fig. 2 shows the girl squinting, and her knee is too commanding an element in the overall composition. The people do not look comfortable, which undoes the casualness the portrait is aiming for. Fig. 3 reversed the lighting balance—the faces are darkened, while their arms and legs are brighter, which minimizes the interest of the portrait. Fig. 4 is lighted better (the reflector was corrected), but the pose looks downright uncomfortable. Fig. 5 is the portrait chosen by the couple for its attractive lighting, absence of harsh shadows, open eyes despite the brilliant light, good color, and comfortable pose. This is the picture that best expresses their "togetherness."

FIG. 5

DOUBLE-STROBE STUDIO LIGHTING

Strobe lights, used skillfully, can produce incomparably sharp, textural photographs. Used poorly, however, they can produce flat images with no character or energy. This demonstration involves the use of two strobes directed into aluminized umbrellas, which are both directed to the back wall of the studio. They bounce again off an aluminized backdrop to illuminate the middle area between subject and backdrop. A painting, chosen for its softly swirling colors, provided a mottled background to suggest the outdoors. The model's green t-shirt complements her flaming red hair and green eyes. The lighting that resulted from a double strobe setup proved to be even and flattering. Because of the fine detail this lighting setup provides, it is best for subjects with perfect complexions and features. Even the slightest of facial flaws looks a bit redder on color film, and strobe lighting, as compared to spot lighting, will render everything in very sharp focus.

EQUIPMENT AND SETUP

Two strobe units and aluminized umbrellas are the heart of this setup. The first strobe (S) is close behind the model's head, bouncing onto both the painting, which is just behind her, and the aluminized backdrop at the back wall of the studio. The second strobe (S1) is at the front of the studio, to the photographer's left, raised to a lower edge height of about 5½ feet (168 cm), and directed toward the back of the studio. An additional "snooted spot" (S2) was clipped to the upper center of the backdrop, and synched with the strobes. A modeling light (a large diffused frontal light (B), not shown) was kept on, in the front of the studio to the left of the front umbrella, mostly for safety reasons. It was a very dark day, and the soft light made it easier to work in the studio. When working with strobes, a good photographer has to make sure that no one trips over a cord or stand. The pedestal-mounted, aluminized reflector in front of the model is a key element of this setup. The model leans forward, following the photographer's directions, to get a maximum of bounced light to fill in around the eyes, under the chin, and under the nose. Don't forget to use reflectors with strobe lighting—though the flash of light is too fast to study through the viewfinder, it still moves and bounces just as still light does. Two additional reflectors are used—a pair of white, free-standing, columnar pillars, one just to the model's left, and the other in the rear corner near the backdrop on her right side. One other piece of improvised equipment was used for this session—the photographer taped a white index card on the end of his lens to reduce any possible lens flare from the umbrella next to him.

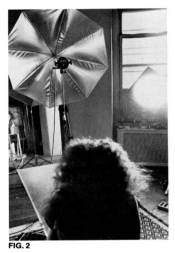

FIG. 2

PROCEDURE

1. Set up two strobe units and umbrellas, one in the front of the studio (S1) to the photographer's left, and one in the rear (S) on the same side of the model. Direct both umbrellas toward the back wall of the studio. Add a synched snoot light (S2) if desired.

2. Test everything before starting the shooting. Check your cords and connections, and ensure that your camera is on flash synch, your film is the right type, and that the ready light is flashing on your strobe system.

3. Set up an aluminized reflector on a pedestal in front of the model, and explain to her how to lean forward on the bar, and into the reflected light.

4. Check that the painting or any other object used as a backdrop is properly positioned, and has no edges or other defects showing in the picture.

5. Take an exposure reading and set your camera. Be absolutely certain that your PC cord is properly seated.

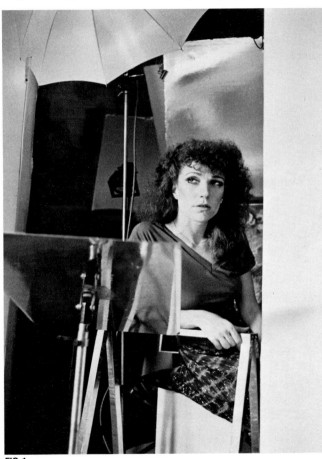

FIG. 1

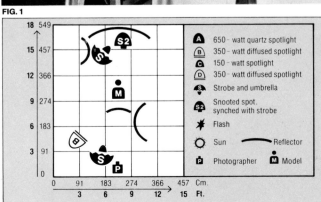

A	650 - watt quartz spotlight	
B	350 - watt diffused spotlight	
C	150 - watt spotlight	
D	350 - watt diffused spotlight	
S	Strobe and umbrella	
S2	Snooted spot. synched with strobe	
✳	Flash	
☼	Sun	
P	Photographer	
M	Model	
	Reflector	

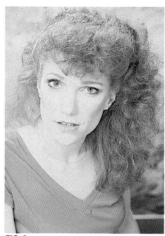

FIG. 3

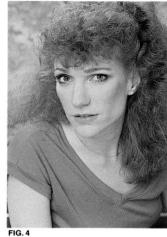

FIG. 4

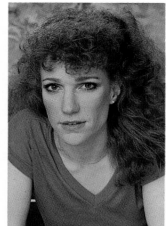

FIG. 5

6. Coach the model through the session, trying different poses and expressions, aiming at the most naturally beautiful look possible.

7. Bracket your exposures.

CONCLUSIONS

Though it is often distracting for models to work under the flashing brilliance of strobes, this model remained relaxed and comfortable, and nearly every shot was successful. A three *f*-stop bracket made some of the slides unusable, but all the rest showed excellent lighting, good color, and interesting composition. The backdrop is muted and complementary to the model's rich, red hair. Leaning in toward the camera and into light bouncing up off the reflector gave flattering facial modeling and pretty poses. Fig. 3, Fig. 4, and Fig. 5 show the bracketing series, and how critical exposure is when working with color film. Fig. 6 is a beautiful color portrait, useful as a portrait to frame for the home or as a commercial headshot. It has good eye contact, and flatters all of the model's good features.

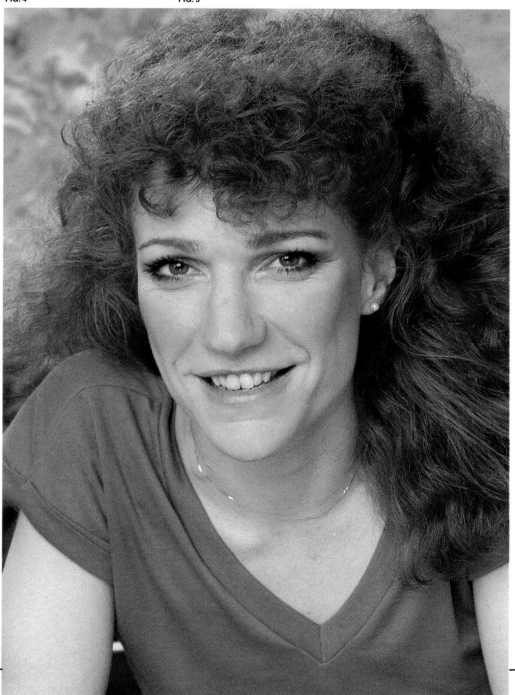

FIG. 6

GOLDEN-TONED STUDIO LIGHTING

People who have become expert in understanding the color of light know that they can "warm" or "cool" it to suit their taste. For example, to warm a room, a downward-directed light shining onto a red book jacket will cast a red glow. This colored light is said to have a *color cast*. Outdoor reflectors, usually white or silver, bounce light with a hue that would be called a *color cast* if the reflectors were any other color. You can use this quality of light to achieve portraits in color that are quite unusual. Think about the color of every element in your color portrait, and study each one in terms of what, if any, color cast it might contribute to the eventual pictures. In this demonstration, warm, golden-toned light is achieved by setting up a lighting arrangement that bounces off a gold Mylar background. The color of the light is, in effect, a very positive use of color cast in that it simulates the warm light of the sun early or late in the day, and flatters the individual. Good lighting is generally *natural-looking* lighting, whether produced by the sun or by studio lights.

EQUIPMENT AND SETUP

Creating a golden look in the studio involves a three-light setup. First, a high 650-watt quartz key light (A) is placed behind the model's right shoulder to give maximum illumination to the background, in this case bouncing off a sheet of gold Mylar attached to the suspended aluminized backdrop. To the left side of the model, a hair light (C) is directed both at his hair, to keep its blonde highlights, and onto the floor, so that light bouncing from the floor will in turn bounce back off the gold Mylar. The third light used for this setup is a large, diffused fill light (B) positioned directly above the camera, shining evenly on the subject's face for shadow fill. In front of the subject there is an aluminized reflector for shadow fill (this could be gold as well, to increase the effect, though a silver surface proved to be best in this session). Tall, standing columnar reflectors are placed about 2 feet (61 cm) from each shoulder to complete an arrangement that bounces light in a 360-degree area around the subject. When trying to maximize the effect of reflectors, slight changes in the position of the subject's head can make a great difference. A good rule of thumb in portraiture is to ask the subject to *drop his chin slightly*. This will improve eye contact, reduce shadows in the eye area, keep the nostrils from being too evident, and allow light from a reflector placed in front of the model, at waist level, to produce a maximum of reflected light onto the facial structure.

PROCEDURE

1. When the sheet of gold Mylar has been positioned as a backdrop, place the fill light (B) in front of the model so that it illuminates the background, and the side and top of the model's head. Turn on key light (A).

FIG. 1

FIG. 2

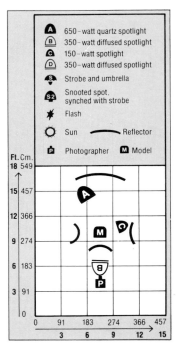

A	650-watt quartz spotlight
B	350-watt diffused spotlight
C	150-watt spotlight
D	350-watt diffused spotlight
S	Strobe and umbrella
S2	Snooted spot, synched with strobe
✳	Flash
☼	Sun
P	Photographer
M	Model

2. Place a flag in front of light (A) to avoid flare in your lens, but move it until it reduces lens flare without cutting back on background or hair illumination.

3. Position the hair light (C) to the model's left, and angle it basically downward. There is a white Formica platform on the floor in this studio setup, which helps bounce light back up onto the background. The background is not perpendicular to the floor—it is angled farther back at the bottom and nearer at the top to accommodate light bouncing up onto the gold Mylar.

4. Check the model's hair, makeup, and clothing. (In this case, rather than using makeup on the subject's healthy complexion, the photographer asked the subject to pinch his cheeks a few times to heighten the color!)

5. Adjust all the reflectors, trying to

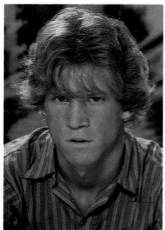

FIG. 3

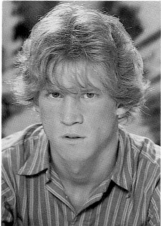

FIG. 4

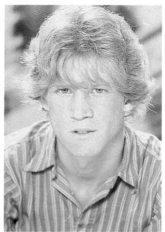

FIG. 5

achieve the best possible bounced lighting in a full circle around the subject. Show the model how to tilt the reflector, which is mounted on a pedestal in front, if a better angle can be achieved that way. Position the two columnar reflectors at each side, and adjust them for maximum effect—this may mean that they are not on the same line parallel to the film plane, so adjust them carefully.

6. Check the background through your lens. If there are folds in the Mylar that you don't like, try using a fan to keep it "flowing." Mylar is a thin and fluid material. Don't let its gleam compete with your subject's face for attention.

7. Take an exposure reading, and bracket when working in color.

8. Coach the model through the sitting to get expressions and poses you both like.

CONCLUSIONS

These images demonstrate the importance of bracketing when doing color portraits. This series shows the results of a bracket at $f/4$, $f/5.6$, $f/8$, and $f/11$ (Fig. 6). There are two reasons for bracketing even the most carefully controlled lighting arrangement: to get the most desirable exposure, and to produce the slight variations that some clients may prefer. Compare Fig. 5 and Fig. 6—either one might be the portrait your client chooses, depending on his particular taste. The skin tone is acceptable in each one, though they vary a great deal. The color portrait succeeds or fails given its skin tone, so remember to bracket to give yourself the best opportunity of having a perfect color portrait. The healthy glow in the subject's face is a result of having given the bounced light a golden color tone. This is a good technique to try during the winter months—it's almost an instant suntan for your subjects, and cannot fail to delight them.

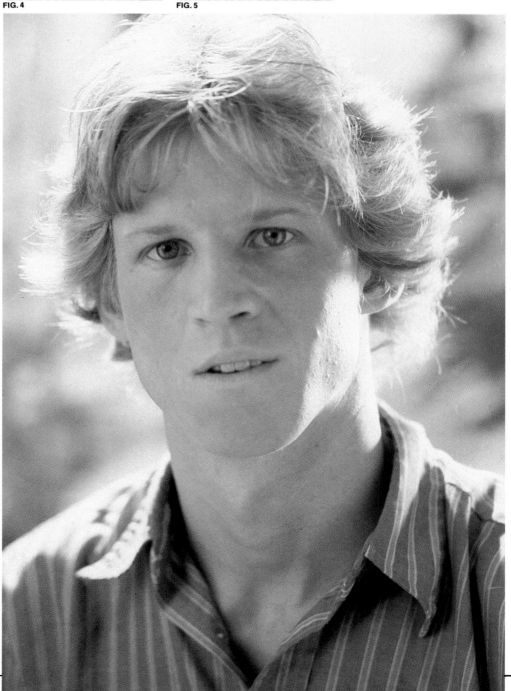

FIG. 6

SHOOTING THE "OUTDOORS" LOOK—INDOORS

Take a good look at the large portrait on the opposite page (Fig. 6). Was it taken indoors or outdoors? If you didn't already know from the title of this technique, it might be difficult to be certain. (It was taken indoors, using a gold Mylar backdrop, lots of back and hair light, a 360-degree environment of reflectors, and a lucky slow exposure on a wide bracketing range. If you like working in color, and enjoy producing natural-looking lighting that flatters your subject to the utmost, this tech-

nique is a good one for you. It will teach you how well you understand and can control light, your camera, and color film. Many different backgrounds may be substituted for an outdoor look. This demonstration used gold Mylar for its gold tone and high reflectivity. Other variations can include hand-painted, mottled panels on a reflective panel, or even a designer shower curtain with leaves or plants. Use your imagination to set up a shot that no one will ever be sure was shot in your studio!

EQUIPMENT AND SETUP

The photographer started out working with a three-light setup. The key light (A) is a 650-watt quartz spot elevated above the Mylar panel, and directed downward between the model and the backdrop so that the light serves a dual purpose: it casts a lot of light on the reflective background, and provides almost a halo around the model's head. A flag is positioned to cut back glare in the lens. During the beginning of the session, a large, 350-watt diffused frontal light (B) was positioned directly over the camera, but this was turned off to enhance the late afternoon, golden, backlit effect that was chosen as the final portrait. A 150-watt hair light (C) was used in all cases, lowered to about neck level on the model, and directed across his back. A fan was turned on to keep the model comfortable, but it was moved so that it wouldn't blow his hair around too much. Since the final portrait effect will employ no frontal light at all, reflectors are the key to this setup. If you study Fig. 1 and Fig. 2, you will see that the subject is surrounded by reflective surfaces: the highly reflective background, and the aluminized board the Mylar is attached to, angled forward at the top; white Formica on the floor; a pair of freestanding, columnar reflectors on either side; and a pedestal-mounted, aluminized reflector at waist level. Study how the light is reflected in Fig. 1 and Fig. 2—this, together with a long exposure, is the secret of the "outdoor" portrait (Fig. 6).

PROCEDURE

1. Turn on the key spot (A) between the subject and the backdrop. Raise it high enough so that it provides almost a halo of light around the subject, and rim lights the shoulders. Position a flag to reduce flare in your lens.

FIG. 1

FIG. 2

2. Adjust the hair light (C). Test that it is not too hot by moving your hand between it and your model's back after it has been on for a minute or so. If it is too hot, move it away slightly, and turn on a fan to keep your subject comfortable. When using a fan, make sure it doesn't blow the hair into the subject's eyes.

3. Turn on a diffused fill spot (B), located above the camera, and determine whether it adds to the outdoor effect or not by studying the setup through your lens. If you're aiming for a glowing, late-afternoon look, as shown in Fig. 6, turn this diffused spot off, and work with backlight only.

4. Check the position and effectiveness of your reflectors. In particular, experiment with the aluminized one at waist level in front of the model, as this will be the only source of frontal, fill-in light. Check the background through your lens as well. Make sure the main light between the subject and the background doesn't cause so much glare that the outline of the model's head is lost.

Figure legend:
- **A** 650 – watt quartz spotlight
- **B** 350 – watt diffused spotlight
- **C** 150 – watt spotlight
- **D** 350 – watt diffused spotlight
- **S** Strobe and umbrella
- **S2** Snooted spot. synched with strobe
- **✳** Flash
- **☼** Sun — Reflector
- **P** Photographer **M** Model

FIG. 3

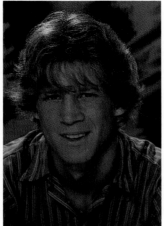

FIG. 4

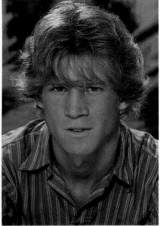

FIG. 5

5. Work with your model to find the best pose and use of the reflectors.

6. Take an exposure reading, and determine how wide a bracketed series you are going to do. In this case, the photographer chose to bracket across four f-stops to give himself the best chance at a perfect result. (Doublecheck that you're using the right kind of film for studio lighting, as well).

7. Coach the model through the shooting, and experiment with different poses.

CONCLUSIONS

Photographic instinct was the key element in this session. Take a look at Fig. 3–6. The first three were bracketed attempts to produce a high-key, outdoor effect using three lights. After Fig. 5, however, the photographer chose to try a photographic ''long shot''—he turned off the diffused front spot, chose an appropriately slow exposure, asked the model to hold perfectly still—and got exactly the shot he wanted. Fig. 6 is practically indistinguishable from a picture taken outdoors late in the day. The warm-toned lighting ''looks like'' late afternoon sunlight, and thanks to a long exposure and absolute stillness on the part of the subject, this was a creative solution for a shooting on a rainy day, which delighted the subject—and the photographer! Fig. 6 has many qualities that are the result of much camera experience. The face is modeled in a very masculine way—in men's faces, angularity and bone structure must be emphasized strongly. *Strength* is the major quality a man's portrait should show, as well as good lighting, beautiful color, good composition, and good eye contact.

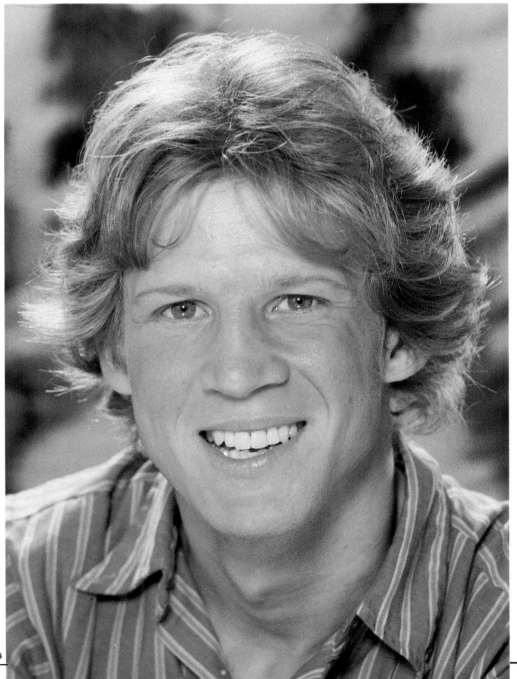

FIG. 6

THE "COVER GIRL" LOOK

There is a kind of secret glamour in many young women, which, if drawn out and caught on film, can make them look like the faces shown in fashion magazines. It takes a skillful lighting setup and careful attention to color to succeed at the sexy perfection cover girls have. This technique requires almost shadow-free lighting, perfect makeup and hair, a beguiling pose, and real skill on the part of the photographer as the director at the shooting. Even professional models need rapport with the photographer so that each is at his best. Style is important in a cover girl shot—the model's clothes have to be striking and trendy, and every element of the picture has to add up to a vision of healthy, alluring beauty. If you are working with someone who is not a professional model, have her take a look at a few current fashion magazines, and study the makeup, clothing, and poses of the models shown there. Without too much ado, your model can, with your skillful direction, look just as spectacular! This is a technique that can present a portrait that shows the subject (and the photographer) at their best.

EQUIPMENT AND SETUP

Three basic studio lights are necessary for this setup. All of them are fairly close to the model to maximize the light, and to eliminate all shadows on her face, except for a very fashionable shadow under the cheekbones. The large, diffused 350-watt fill spot (B) is located above the photographer's head, and is directed squarely upon the model's face. Behind and to her right is a 650-watt quartz spotlight (A) raised to about 7 feet (213 cm) and directed down onto the hair and the pedestal-mounted aluminized reflector in front of her. This light has a flag in front of it to avoid flare in the lens. The 150-watt hair light (C) is just behind her left shoulder, at about head height. To give the warmest look possible, a gold Mylar panel is used as a backdrop. This bounces light with a subtle gold cast, which helps flatter the model's blonde good looks. A fan is essential both to keep the model cool under the heat of such intense lights, and to move her hair around for a sexy look. Her makeup is professional, restrained, and totally suitable to a "cover girl" look. There is no shine on her face—just a perfect, poreless complexion with the right amount of emphasis of her eyes, cheekbones, and lips.

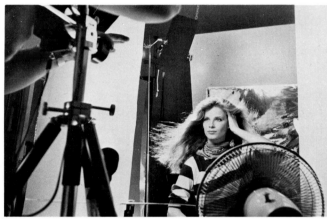

FIG. 1

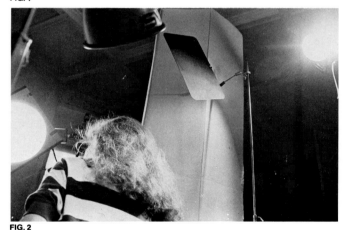

FIG. 2

PROCEDURE

1. Select a backdrop that is both highly reflective to maximize the studio lighting, and gold so that it will imperceptibly "warm" the photographs.

2. Turn on the 350-watt diffused front fill spot (B) and direct it for maximum shadow reduction on the model's face and throat.

3. Turn on the high 650-watt quartz spotlight (A), which will illuminate the hair and background, and move a flag in front of it so that you will not have flare in the lens. It is also good practice to keep your left hand extended on top of your lens while shooting in such a brilliant environment, as shown in Fig. 1, to further avoid light flare.

4. Position the hair light (C), and test that it is not too hot for your model.

5. Turn on a fan in front and to one side of the model so that it blows her hair back away from her face.

6. Keep her makeup and hairbrush handy on a nearby table. Since the fan will cause her hair to separate into strands she will need to brush her hair from time to time. Keep some tissues there to blot her face if necessary, as it will be hot under those lights.

7. Talk to the model, direct her as if you were doing the most chic commercial ever made. Draw the glamour out, and capture it on film. Remember to bracket to get the best possible results.

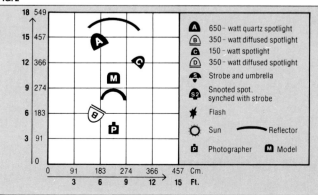

Ⓐ	650 – watt quartz spotlight	
Ⓑ	350 – watt diffused spotlight	
Ⓒ	150 – watt spotlight	
Ⓓ	350 – watt diffused spotlight	
Ⓢ	Strobe and umbrella	
S2	Snooted spot, synched with strobe	
☀	Flash	
☼	Sun	⌒ Reflector
Ⓟ	Photographer	Ⓜ Model

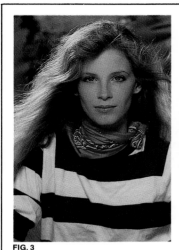

FIG. 3

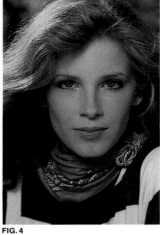

FIG. 4

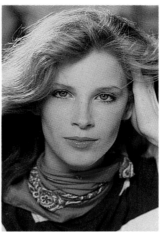

FIG. 5

CONCLUSIONS

Here are four shots from this session, each showing a stunning and glamorous girl who could adorn the cover of any top magazine in the world. Fig. 3 and Fig. 4 differ in framing, and both show that not quite enough light is on her hair—it looks dark rather than sun-touched blonde. Fig. 5 and Fig. 6 show good highlights in the hair and a luminous, high-fashion quality of lighting on the face. Fig. 6 is the portrait selected at the end of the session because of its graceful, winsome pose. It is a golden, radiant image that makes a beautiful model a real "cover girl."

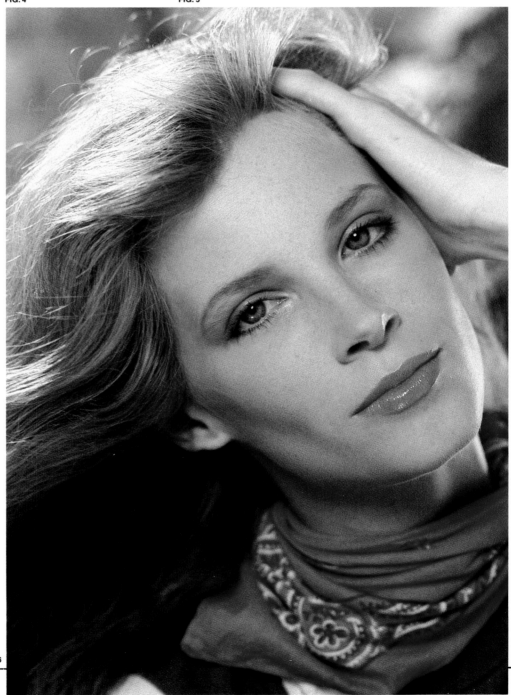

FIG. 6

PORTFOLIO I: THE HEADSHOT

The most important element of a model's or actor's portfolio is a good commercial headshot. In recent years, large color prints have made their way into these portfolios, which means that the portrait photographer who hopes to maintain a number of commercial clients, with their continual need to update their portfolios, should be quite adept at good color headshots. The qualities to aim for are: good color, sharpness, appropriate background, a vital expression on the subject's face, and direct eye contact. These are the same aims as those for a good casual portrait taken outdoors. This technique can be used for subjects who want a naturalistic rather than a more formal portrait. The clothing must coordinate with a casual atmosphere, and the lighting must flatter the subject. In this technique you will see that clothing can not only serve as a reflector in its own right, but as shown here, it can serve as a tinted reflector, casting highlights complementary to the outfit. Not all subjects want a portrait so original that it models their face with colored "shadows." In this lesson you will learn how to control reflected light with color cast, and to use it creatively.

EQUIPMENT AND SETUP

These headshots were done in a park close to the studio. Because of its proximity, most portrait sessions for commercial portfolios take place for one hour indoors and one hour outdoors. One white reflector is the only additional equipment needed, and of course it is helpful if an assistant can come along to help hold it in an ideal position. If you do not have an assistant available, the model can hold the reflector himself. Having a third person hold the reflector may help relax the subject, however, aiding in achieving a dynamic outdoor look. Try to avoid contrasty, mid-day sunlight, as it can create harsh shadows even skillful reflector work cannot undo. Remember, too, that very early and very late in the day sunlight has a much warmer tone, which may contribute to a healthy, casual look for your subject. When working in daylight, have your subject stand or sit so that his back is to the sun. Make sure the reflector fills in light well without casting any shadows in the subject area.

PROCEDURE

1. Scout out a location that offers good natural light. Either naturally diffused light near the edge of the shade under a tree or in direct sunlight, with the subject's back to the sun, will be ideal.

2. Work with the reflector to find its best position. Try it at various distances to see what works best.

3. Give your subject a cue so he can rest his eyes between shots. Sunlight can cause sensitive eyes to squint, adding a disturbing element to a casual portrait.

4. Ask your model to lower his chin somewhat to avoid glare along his nose. Lowering the chin also helps maximize eye contact.

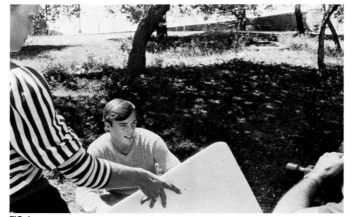
FIG. 1

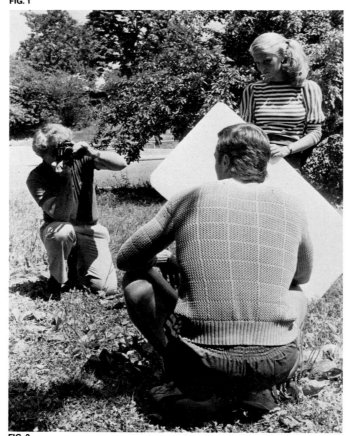
FIG. 2

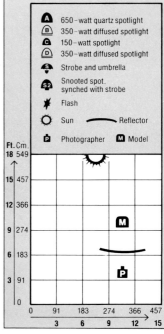

Ⓐ	650-watt quartz spotlight
Ⓑ	350-watt diffused spotlight
Ⓒ	150-watt spotlight
Ⓓ	350-watt diffused spotlight
Ⓢ	Strobe and umbrella
Ⓢ2	Snooted spot. synched with strobe
✹	Flash
☼	Sun — Reflector
Ⓟ	Photographer Ⓜ Model

5. Check your background carefully. In such bright light, it will not soften to a mottled look, and could provide unfortunate surprises in the final pictures.

6. Make sure you have daylight-balanced color film and that your ISO setting is correct. Take an exposure reading.

7. Coach your client through the session. Ask him to talk, say "Hello," or, if he's not relaxed, suggest that he pretend he's doing a commercial, and have him talk about golf clubs or tennis racquets or something. It is important that every aspect of the portrait convey a coordinated feeling—a casual portrait should be casual and comfortable in all respects.

FIG. 3

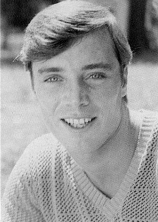

FIG. 4

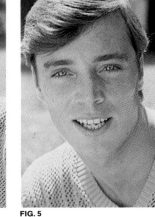

FIG. 5

CONCLUSIONS

Fig. 3–6 all show good head-and-shoulders views of a young actor / model. Fig. 3 is overexposed—the result of bracketing. Though it is often difficult for some photographers to bracket, as they feel they are wasting precious frames, it is a professional technique in its own right. This is how you can guarantee you'll have exactly the right exposure. Failing to bracket and having to reshoot a session is annoying, and often the second time doesn't work as well. Try to get the best the first time! Fig. 4 and Fig. 5 are pretty good headshots, but they all have a rather overpowering background. Fig. 6 is a marvelous outdoor portrait, and ideal for a model's portfolio. It shows the person to his best advantage, has good, direct eye contact, and also has a green-tinted highlight caused by reflected light on the left side of his jaw. Though tastes differ and many people do not like any color cast in a portrait, this client and his agent felt the shot was unusual, and thus a good addition to a portfolio for modeling use. The background is attractive, and the tight framing emphasizes the subject handsomely.

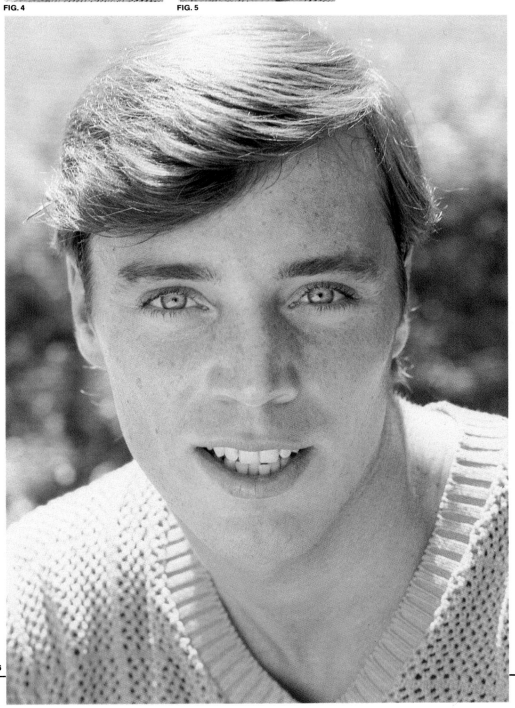

FIG. 6

PORTFOLIO II: THE ACTION SHOT

Though the vast majority of portraits are of motionless individuals, either seated or standing, there is no reason why a portrait can't be of a person doing something, showing how he or she looks while accomplishing a characteristic task. Even in a commercial model's portfolio, action shots are a good addition. Agents responsible for selecting people for television commercials, films, and print work are interested in how people look when they are *involved* with something. You don't have to set up a simulated commercial to give the idea that a model can be a good choice for one, but it helps to show him or her in real life situations that give agents and others an indication of how the model will look on the set. Any sports facility, health club, or similar location can give you ideas for expressing the physical fitness of a client. In this location, an iron railing provided an easy "hurdle" that the model could vault over for some stunning shots to express his physical fitness in action.

EQUIPMENT AND SETUP

Only the camera was used—no reflectors or other equipment. This is straightforward action photography, and the lighting setup involves making the best possible use of a found location. This session occurred near noon on a summer day. This meant the photographer had to anticipate how and where the client would be jumping or running, in order to avoid harsh direct sunlight and deep shadows as much as possible. Knowing that the asphalt would reflect a certain amount of light upward, it was decided that the subject would jump over the wall and run toward the photographer. The model and the photographer practiced both series of actions several times so both knew exactly what to expect during the shooting. Take a look at Fig. 1. Why is the model running toward the fence at an angle rather than squarely up to it? Because this angle illuminated his face better, and allowed some sky in the background. Analyzing the background is very important when working outdoors, especially when shooting action. It is very easy to become caught up in the excitement of the action, and to forget to look at the background. Study all of this in advance. Look at Fig. 2. There is a built-in flaw in this location (the light pole) and if the photographer shoots from a poorly chosen angle, it will appear to come from right behind the model's head.

PROCEDURE

1. Have your model warm up a bit while you scout out a location. Consider the height of the sun, the shadows it causes, and the background. Anticipate sporty activities your client can exhibit well in that location.

FIG. 1

FIG. 2

A	650-watt quartz spotlight
B	350-watt diffused spotlight
C	150-watt spotlight
D	350-watt diffused spotlight
S	Strobe and umbrella
S2	Snooted spot, synched with strobe
✳	Flash
○	Sun ⌒ Reflector
P	Photographer **M** Model

2. Practice the activities several times, so you can anticipate when you'll shoot. Remember to prepare for composition and framing in advance, because you'll be too busy watching the subject move during the shoot to try to think it all through later.

3. Check your background carefully for distracting elements.

4. Make sure you have the right type of color film, and choose your exposure well. Remember that you have to shoot quickly and at a high shutter speed to stop your subject in motion.

FIG. 3

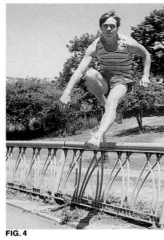

FIG. 4

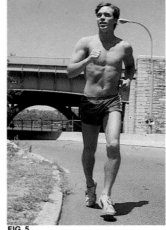

FIG. 5

CONCLUSIONS

Fig. 3 and Fig. 4 are the partial results of a bracketed series of shots of the model vaulting over a wall. Though Fig. 3 is underexposed, both it and Fig. 4 show exciting motion, good eye contact, and a good selection of background. Fig. 3 shows a hot spot of light on the subject's nose—a common fault of outdoors shots. Changing his angle slightly helped illuminate the face and body better in Fig. 4. Fig. 5 and Fig. 6 show the model running toward the photographer along a short stretch of a highway through the park location. Fig. 5 is a good action shot—except for the light pole behind the subject's head. Noticing this, the photographer then asked the subject to run past him, for a non-competitive background as seen in Fig. 6. All of these shots show good photographic decisions in addition to good use of harsh, direct sunlight. One important quality of these shots is that the photographer chose to shoot from a low angle—variation of the angle from photographer to subject can add meaning to portraits. In this case, a kind of strength and sculptural quality was added to the portraits because the camera looks *up at the subject*, subtly exaggerating his body and height. Keeping the subject out of the exact center of the frame is another sophisticated touch that makes these good additions to a commercial portfolio.

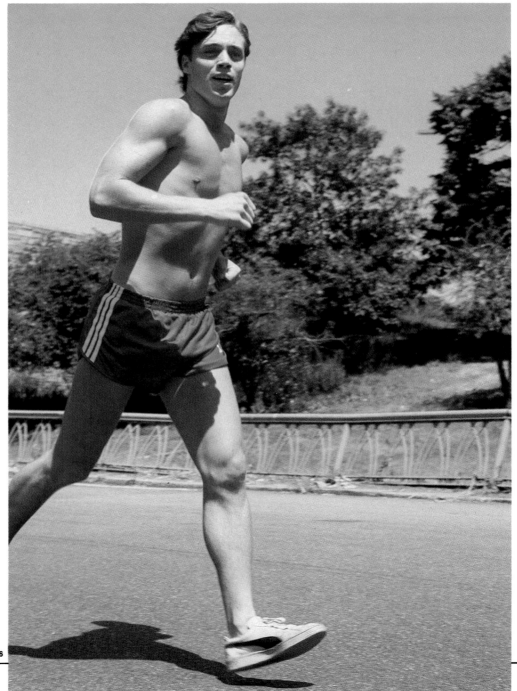

FIG. 6

PORTFOLIO III: FRONTLIGHTING

Studio sessions for commercial portfolios offer a nearly unlimited range of opportunities for setups that express any number of aspects of your model. Sophisticated setups are fun to do, and will add a great deal to any model's, actor's, or actress's portfolio. When planning shots for a portfolio, take an hour before the session is scheduled to sit down and work out with your client exactly what is needed to fill in a preexisting portfolio, or to do a first professional "book." Anyone aiming at fashion or commercials needs elegant shots such as the ones shown on the opposite page. They not only show that this model could look good in an ad for men's clothing, but he might just be the right "type" for a wine company's promotion, for example. Including a second model to add to a "country club" ambience gives a unique touch to his portfolio. Setting up a scenario full of props and the suggestion of opulence is fun, and a good challenge for the studio photographer. This is the art of illusion used to its best advantage!

EQUIPMENT AND SETUP

Four studio lights are required for this setup, plus a number of reflectors. The aim is to set up a romantic, elegant scene, while lighting the models as much as possible so the pictures will be good choices for a portfolio. A large, 350-watt diffused fill spotlight (D) is positioned to the photographer's right, and is aimed at the models' faces, encompassing both when one is standing. When both models are standing, it is raised higher. At the photographer's left the customary large, 350-watt diffused fill spot (B) is in place. Above the photographer's head, slightly to the right but varying in position (it was later moved nearer the models) is a 650-watt spotlight (A) to add to the strong frontlighting of this setup. The fourth light is a 150-watt hair light (C) that is placed at the right of the models, directed onto a pedestal-mounted reflector in front of the models.

PROCEDURE

1. Put together a set that will complement your model's evening clothes. A country club look was desired for this session, so a rattan chair, a large plant, and champagne glasses were made part of the overall design.

2. Only frontlighting is used for these shots, to achieve a high contrast look that brings the viewer's attention to the faces and gestures of the models. Set up the two large, diffused "fill" lights (B) and (D) one on the right and one on the left, and angle them so they provide a maximum amount of strong light on the subjects. Adjust these each time the subjects change to a position that moves them out of the maximum light path.

3. Turn on the "key" spotlight (A), which will be just about over your

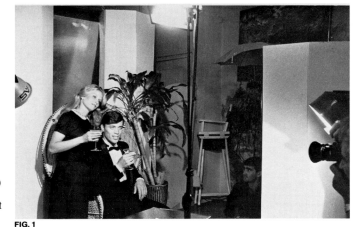

FIG. 1

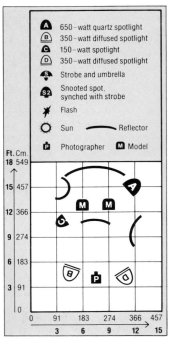

Ⓐ	650-watt quartz spotlight
Ⓑ	350-watt diffused spotlight
Ⓒ	150-watt spotlight
Ⓓ	350-watt diffused spotlight
Ⓢ	Strobe and umbrella
Ⓢ2	Snooted spot, synched with strobe
✳	Flash
☼	Sun ⌒ Reflector
Ⓟ	Photographer Ⓜ Model

head as you shoot, raise it to just about the height of the model's heads, and angle it downward onto both of them.

4. Turn on the hair light (C), which is positioned at the models' right sides, midway between you and the set. Angle it onto a pedestal-mounted, aluminized reflector.

5. Check the effect of so much frontlight on your background. An aluminized board, suspended from the ceiling, is used in this session, and though the frontlight causes areas of glare, these are creatively used as devices to focus the attention on the models in many of the final pictures. However, if you notice any glare that you find objectionable, change the angle of your backdrop to the floor.

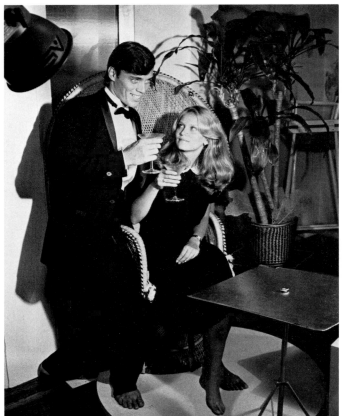

FIG. 2

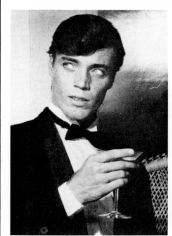

FIG. 3

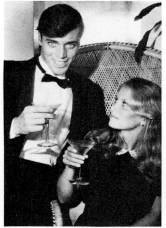

FIG. 4

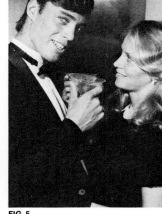

FIG. 5

FIG. 6

6. Position two freestanding, white, columnar reflectors to help bounce light in toward the subjects—as walls would in a room. One is used initially behind the models at their right in this session, one between them and the photographer on the right. Later in the session you can move both columnar reflectors to parallel positions behind the models for an effect of large pillars.

7. Check the scene through your lens, and check for glare on any area—the plant, the backdrop, the glasses. Remember that the emphasis has to be on the models.

8. Coach them through the session, having them talk to each other and vary their poses.

CONCLUSIONS

These shots have brought a lot of good attention to the male model shown, as they draw out the sophisticated side of his personality, and are well suited to expressing his appropriateness for commercials and print ads. Fig. 3 is half of a shot—the model's agent realized that it worked better showing him alone, so this area was isolated from a double headshot much like Fig. 4. Sometimes this technique can provide good single headshots for each of the two models, and is a good thing to keep in mind to get the most out of the shooting. Fig. 5 is a charming shot, but shows a hot area on the backdrop, which rules it out as the best shot from the session. Fig. 6 is a classic headshot done during the same session—another realistic, but stylized, look that is good for a portfolio. Fig. 7 is a classic double portrait with good lighting, equal emphasis on each model, good poses (the hands, in particular, are well posed) and is a successful portfolio addition for each of the models.

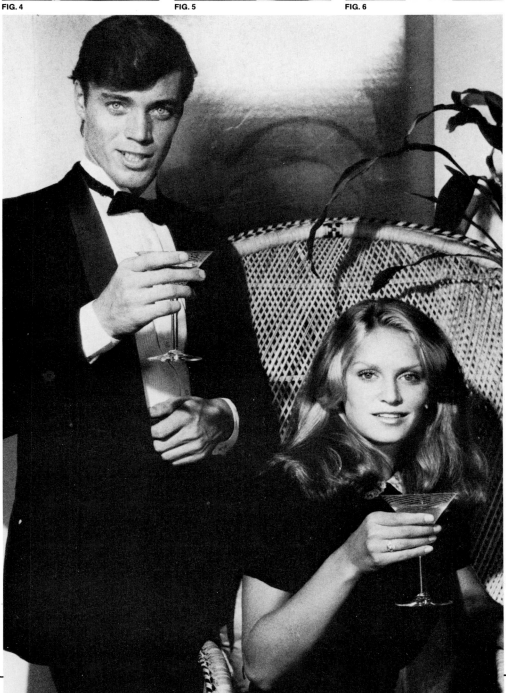

FIG. 7

PORTFOLIO IV: FASHION LIGHTING

Excitement may be added to a model's portfolio with one or two shots using a spectacular effect, though such shots must be balanced with more traditional, unmanipulated looks. A hand-held sheet of thin, gold Mylar film was used to create spectacular star-like highlights in this setup. Star filters could also be used to add a special sparkle to commercial shots, with an intent to show how the model can wear clothes well for fashion work. Classic clothes, in particular sweaters and tweed jackets, are ideal for a fashion look—they have texture that good lighting will emphasize, and good clothes will, of course, make your model look good. This technique involves the concept that fashion work is, in essence, a matter of showing clothes more than an individual. Sporty clothes require sporty poses and ingenuous smiles; formal clothes require refined poses and cool, aristocratic expressions. Shooting commercial shots for fashion models can teach you a great deal about expressing a "type" in a portrait, while at the same time flattering each individual subject.

EQUIPMENT AND SETUP
An end of a roll of gold Mylar film was held in place as a unique background for these shots. Two assistants were on hand to hold the roll of Mylar. Two large, 350-watt front diffused fill lights (B) and (D) were used, each at one side of the photographer, directed at just below face level on the model. A 650-watt quartz key light (A) was added, in front and to the left of the photographer, directed on the right side of the model's face. A hair light (C) is placed in position on the model's right, just slightly behind his shoulder. At times during the session it was turned off, as the gold Mylar bounced enough light forward to illuminate his silhouette, and the pedestal-mounted, aluminized reflector served to bounce light up onto his torso and face.

PROCEDURE
1. Select a shimmering, glowing background such as the large roll of Mylar film shown here. To get starburst effects, two assistants held it at an angle to the film plane, and a fan kept the Mylar moving so the bright spots would move across it.

2. Turn on the two large, diffused fill lights (B) and (D). Position them so that both focus directly on the model's midsection and face. These are the lights that will bring out the detail of the textured sweater, and will give this shot its fashionable emphasis.

FIG. 1

FIG. 2

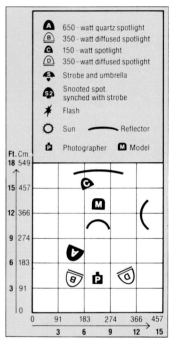

Ⓐ	650-watt quartz spotlight
Ⓑ	350-watt diffused spotlight
Ⓒ	150-watt spotlight
Ⓓ	350-watt diffused spotlight
Ⓢ	Strobe and umbrella
Ⓢ2	Snooted spot, synched with strobe
✳	Flash
☼	Sun
⌒	Reflector
Ⓟ	Photographer
Ⓜ	Model

3. Turn on the 650-watt key light (A), located at the photographer's left. Direct it onto the model's face and torso as well. Adjust this light when he changes position.

4. Turn on the hair light (C), and check that it properly illuminates the backdrop, as well as the pedestal-mounted reflector in front of the model.

5. Show the assistants how to hold the Mylar at an angle, and make sure they raise it high enough so that the upper edge doesn't show in the shots.

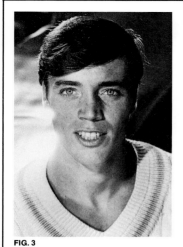

FIG. 3

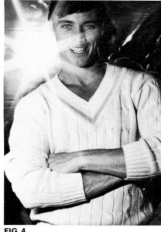

FIG. 4

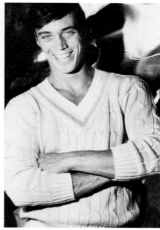

FIG. 5

CONCLUSIONS

Though using such a highly re-
flective background caused some
problems of flare in the lens, and at
times obliterated part of the shot as
the Mylar moved, there were a
number of portraits for this model
to include in his portfolio that are
nothing short of spectacular. Fig. 3
shows a headshot flawed by too
much glare off the Mylar. Fig. 4,
while acceptable in that it shows
the sweater wonderfully, does
cover up the model's face with a
star effect. With a shot such as this
one, the model's agent should
choose whether to use it or not.
Fig. 5 shows a lesser star effect in
the upper right corner, a good
comfortable pose, and a sweater
that is well lighted. Fig. 6 is the shot
finally selected for the portfolio for
its overall harmony of lighting,
composition, pose, expression,
and rendition of the sweater.

FIG. 6

PORTFOLIO IV: FASHION LIGHTING

Probably the most wide-ranging portrait effort is producing a professional-looking portfolio (called a "book" in the modeling business) for a beginning model, actor, or actress. It takes careful planning and input from the subject's agent and other experienced professionals to determine what group of 10 to 20 shots will show that the subject is exactly the right person for a particular TV commercial, part in a play or film, or advertising modeling job. Though there are what could be called the expected "traditional" types of shots that go into a commercial portfolio (see technique #3 concerning the standard commercial headshot), variety and well-stylized, imaginative efforts can be a plus. Find out what your subject wants, and shoot a series of images that express how well that person can look in situations close to the work he or she dreams of having. On these two pages are seven different variations shot for the portfolio of a young man who is starting out in the right way for a career in acting and modeling.

EQUIPMENT AND SETUP

Three basic studio lights, a pedestal-mounted, aluminized reflector, a backdrop, two freestanding, columnar reflectors, and two sheets of aluminized board are the basics for all the shots shown here. Since these are all variations on lighting schemes already explained, study them until you can "see" in each image exactly how the lighting was arranged each time to show the same individual in a new way.

Fig. 1: Men's fashion in recent years has adopted a more relaxed, naturally sexy look. This shot involves a simple set of an aluminized panel laid on the floor, and behind it, another similar board. This, like many fashion shots, uses only two lights—to keep emphasis on the *clothing*, more than the model. This textured shirt is a good choice for a fashion-oriented shot.

Fig. 2: Using the same set as Fig. 1, the model is now standing. Behind him the background sharply cuts from luminous gray to a flat gray. Using one main light, and working from a lower angle to lend strength to the image, you too can add this contemporary look to a portfolio.

Fig. 3: White shirts serve as reflectors in their own right and have a classic appeal. Reclining in the same set as in Fig. 1 and Fig. 2, the model is illuminated both by a high frontal spot and a diffused frontal spot. When posing men, instruct them to keep their fingers together, clasped in a comfortable fist, as in Fig. 3, or with the fingers extended but touching. Poor hand posing and the unfortunate shadows that result can ruin an otherwise terrific shot.

FIG. 1

FIG. 2

FIG. 3

Fig. 4: This is a classic commercial headshot. It is evenly lit, all features are realistically shown, and the subject has a good, winning smile. Remember that what an agent wants to see in a headshot is how this person really looks—don't go to extremes.

Fig. 5: Here's a creative, "instant" set that implies high fashion—two columnar reflectors are placed close together, just behind the model, with the gap between them extending back to an unlit aluminized backdrop. One strong frontal spot is directed at the midpoint

of the *jacket*, not the model's face. This and Fig. 6 and Fig. 7 show how clothes have to be emphasized more than the model's face, and lighting is the best way to do this. Make sure the clothes are classic, well tailored, and in perfect repair.

Fig. 6: Using the same twin pillar set as in Fig. 5, the photographer has moved in for a tightly composed midshot (from head to waist). Remember to include headshots, midshots, and full-length views in a model's portfolio. This holds true for women's portfolios, too.

Fig. 7: This is another variation on a fashion-oriented midshot. Notice how the lighting highlights the jacket.

FORMULA FOR A MODEL'S PORTFOLIO

1. Two or three headshots with balanced, bright lighting, direct eye contact, and comfortable big smiles. Indoor and outdoor shots. Black-and-white is fine, but include color if your client prefers.

2. Two or three full-length shots in classic clothing, ranging from formal to recreational. Indoors and outdoors; in black-and-white and color.

3. Two or three midshots in a variety of clothes. You may want to introduce a product to suggest a commercial advertisement if the model has no tearsheets of prior jobs to show.

4. Variations that show talents, hobbies, or special abilities of the model such as playing tennis, singing or dancing, etc.

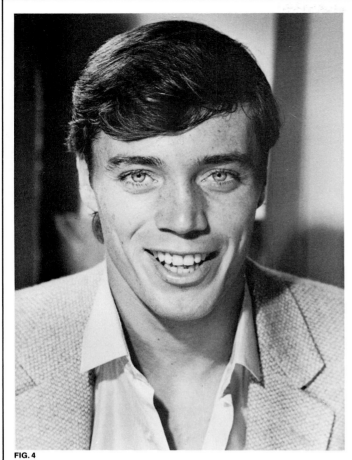

FIG. 4

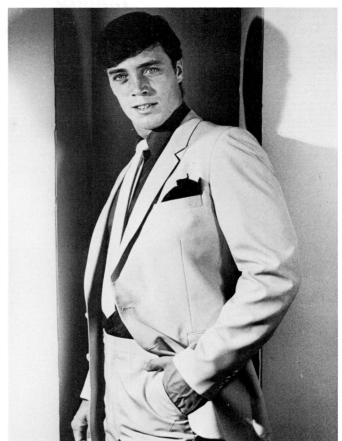

FIG. 5

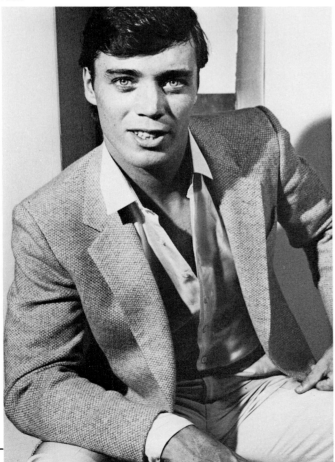

FIG. 6

FIG. 7

LOW-CONTRAST BOUNCED LIGHTING WITH ONE STROBE

Light carefully bounced off a strobe unit can produce very effective studio portraits. When the light bounces off the umbrella, it diffuses somewhat, and produces a lower contrast, which can be very effective. This is a good approach to take for models with dark complexions, as it averages out their facial tones. When working with a strobe, a fine-grained film is a good choice, as the strobe allows for fine detail and sharpness, which increases the impact of the portrait. Part of the challenge of this technique is that you cannot see the precise ef-

fect you're getting, as you would with a setup of lights, so you must anticipate each aspect of the portrait beforehand: the exposure, the amount of detail you want to flatter your subject, the background (as it will be in fairly sharp focus as well, due to stopping down for the flash unit), the pose, and the overall light and dark design. If you're working in black-and-white, study the outcome of lights and darks in your mind's eye before you shoot. Bounced lighting lowers contrast and can limit tonal range.

EQUIPMENT AND SETUP

A combination of studio lights and strobe was used for this setup. The predominant light source is the strobe unit (S), placed almost directly in front of the model and bounced directly into an aluminized umbrella. The backdrop is a large sheet of aluminized material suspended from the ceiling, which will bounce the light it receives back onto the model. To add some sparkle and brighten the background somewhat, a 650-watt key light (A) was added—placed very high and aimed at the aluminum backdrop. It is blocked by the flag so that its light causes no flare in the lens and no hot spots in the background. It is there to bring out the sheen of the model's hair. A 350-watt diffused front fill light (B) was added to delicately highlight one side of the model. Just as the two sides of a face are never exactly symmetrical, thus providing much of its interest, so a lighting setup should not be entirely symmetrical, either. The aluminized reflector on a stand in front of the model is not hand-held, as the use of props is anticipated. It is placed so that it, too, will bounce light from the strobe upward to fill in the eye area, and help avoid accidental shadows. The model's white dress is a reflector in its own right, though a subtle one. One folding, columnar reflector is placed at her left, to fill in the light from that side. This is one of the subtle touches that results in a delicate, asymmetrical lighting, which does the most for her face.

PROCEDURE

1. Position the strobe unit (S) and umbrella. Check that the ready light is blinking.

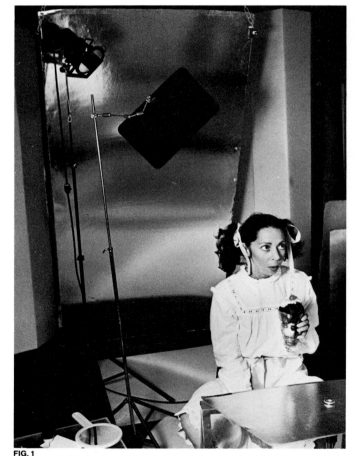

FIG. 1

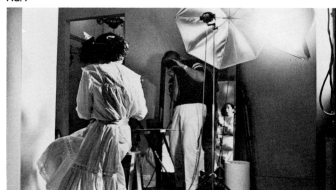

FIG. 2

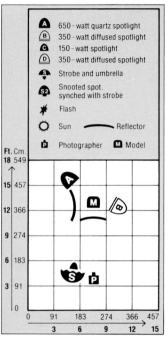

Ⓐ	650-watt quartz spotlight
Ⓑ	350-watt diffused spotlight
Ⓒ	150-watt spotlight
Ⓓ	350-watt diffused spotlight
Ⓢ	Strobe and umbrella
Ⓢ2	Snooted spot, synched with strobe
✶	Flash
○	Sun
━	Reflector
Ⓟ	Photographer
Ⓜ	Model

2. Position the key light (A), and move the flag in front to cut the light back so that it only brightens the model's hair.

3. Check and correct the model's makeup, hair, and pose.

4. Turn on the diffused front fill light (B). Position it to one side of the model's face.

5. Position the fixed reflector in front of the model, and the columnar reflector to the side, opposite the main thrust of the diffused light. This completes a balanced, yet slightly asymmetrical, lighting arrangement.

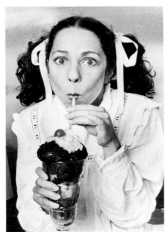

FIG. 3

FIG. 4

FIG. 5

FIG. 6

6. Check the background, and move the key light (A) if it is causing hot spots on the background. Remember that your background will be fairly sharp when working with a strobe.

7. Take an exposure reading, and set your camera to flash synch when you determine the best exposure. Be sure to bracket when working in color.

8. Coach the model through the sitting to maintain good eye contact with the lens. Vary the pose and the props if desired; try a variety of expressions.

CONCLUSIONS

Notice the extra sharpness in these portraits, and the excellent separation of subject from background. This is a special quality of strobe effects that can be used well for many types of portraits. Compare the facial tones of Fig. 4–6. Now study the balance of tones from light to dark. You can see that the contrast range is somewhat limited in Fig. 3 and Fig. 4. To show the subtle, yet unmistakable, influence of reflectors, the model changed her pose, which changed the bounced light falling on her. Notice the successive brightening of her face in Fig. 4–7. Fig. 7 is the portrait chosen from this session. It is a fairly high-key portrait, beautifully contained within the frame. This portrait is both pretty and sensitive, as it expresses the individuality of the subject.

FIG. 7

USING A STROBE TO STOP MOTION

One of the most exciting options a portrait photographer has is to use a strobe to stop a subject in motion. This can be used effectively for photographs of children at play, people involved in their hobbies or work, or subjects such as this one, who wanted a portrait of herself leaping in the air to express her natural tendency toward sheer exuberance. This technique can make ultradynamic portraits, which surpass the often staid images people expect from a portrait session. There are numerous challenges for the photographer while working with motion: keeping the picture sharp, establishing a lighting arrangement that will adequately illuminate the person in the course of motion, and keeping the image well framed. Knowing this technique well can heighten your photographic talent by increasing your knowledge of the kind of "decisive moment" that arrives in portraiture. In this case it's not a fleeting, special expression, but a split second of motion that expresses an entire personality. Try this with subjects who are naturally energetic—they'll love the results!

EQUIPMENT AND SETUP

One strobe unit and two lights make up the lighting arrangement for this setup. The strobe unit (S) is just to the left of the subject-photographer axis, and is pointed directly into an aluminized umbrella to diffuse the light and even out contrast. The 350-watt diffused fill spotlight (B) is placed nearer to the model than the strobe, at her right, to serve as fill light. A snooted spot (S2) is synched with the flash unit, and is clipped to the suspended, aluminized backdrop to act as a hair light. The photographer has introduced a prop for this session to justify the model's leaps into the air. In order to express joy and exuberance, she holds a small, gift-wrapped box, and says "Hey, thank-you!" as she jumps up, to contribute to the effect that this is a moment of action, as if it were a frame from a film. The only major reflectors in this case are the background itself, which bounces light onto the top of the model's head and the background area, and one large, white, columnar reflector at her left. This columnar reflector is about 9 feet (274 cm) tall, and in this case, its height is essential, as it functions just as well while she is at the top of her jump as it would were she sitting on the platform for a still shot.

PROCEDURE

1. Set up your strobe unit (S). Make sure the ready light is on.

2. Turn on and adjust the diffused front light (B), positioned slightly to the right of the model as she looks at the camera.

3. Adjust the white, columnar reflector on the model's left as she looks at the mirror.

4. Attach the snooted spot (S2) to the backdrop, or use a high hair light if you prefer.

FIG. 1

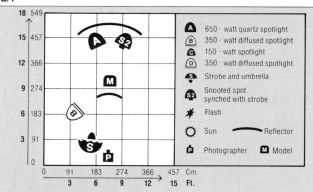

Ⓐ	650 – watt quartz spotlight
Ⓑ	350 – watt diffused spotlight
Ⓒ	150 – watt spotlight
Ⓓ	350 – watt diffused spotlight
Ⓢ	Strobe and umbrella
Ⓢ2	Snooted spot, synched with strobe
✴	Flash
☼	Sun
	Reflector
Ⓟ	Photographer
Ⓜ	Model

FIG. 2

5. Check the model's hair and makeup, and practice the motions to be photographed so that you'll know what to anticipate in order to frame the portrait well. Make sure the model jumps high enough and in the place you expect so the hair light doesn't show in the portrait.

6. Have the model move, and check the background. Don't let an unfortunate background happen. Anticipate it, through the whole range of movement, and adjust the background, if necessary, before you shoot.

7. Take an exposure reading and set your camera to flash synch.

8. Coach the model through the session. Tell her something to say while moving, to add more realism to the activity. When we see people in real life, we see them talking and moving. Make sure your model's face and body language fits the body language of the activity.

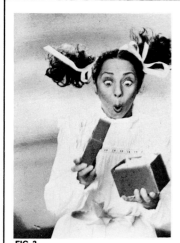

FIG. 3

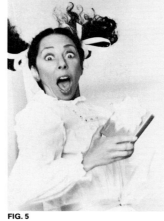

FIG. 4

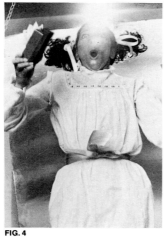

FIG. 5

CONCLUSIONS

The contact sheets that resulted from this session are most amusing—far from a "postage stamp" kind of sheet full of nearly identical shots, this sheet was full of hilarious leaping and laughing pictures of a very dynamic girl. Fig. 3 shows a framing problem. The leap was somewhat off center, and the photographer was unable to move his camera and tripod fast enough to improve the composition of the picture. Fig. 4 shows a picture taken a fraction of a second too early—the model is not high enough to block out the snooted hair light behind her. Notice the lens flare this caused. Fig. 5 has quite a bit of charm, but the real story is that the model jumped up and slipped as she came down. She ended up on her feet, but it is a reminder that you have to anticipate such problems, and make sure your model can't get hurt in your studio. Fig. 6 is the portrait chosen as the final one from many terrific action shots from this session. It has a good tonal range, good separation from the background, and exciting composition. It's sharp and the model looks as exuberant as she possibly could.

FIG. 6

UNDERLIGHTING

Strong underlighting is the type of lighting often used in horror movies, as it is completely opposite most natural lighting, which has made us accustomed to seeing people with light coming from above, not below. This kind of light shows a person's face in a very different way than we are used to seeing them, and use of this technique requires a creative touch and skillful use of reflectors to result in a good portrait. The very dark shadow created behind the subject's head with underlighting can become an interesting element in the over-all composition. This is a technique that can bring out the whimsy and acting ability of a subject. With underlighting you can express a number of powerful qualities in a personality: strength, humor, even dominance. This contrasty kind of portrait requires skill at showing the desired aspects of the person, as improper use could be simply unflattering. This is a portrait lighting variation that is rarely used, though with the right subject, flattering and irresistible images can be produced.

EQUIPMENT AND SETUP

This setup, as with any strongly chiaroscuric lighting arrangement, derives its high contrast and powerful effect from the use of only a few lights. In this case, one 650-watt key light (A) is used to create the underlighting. It is placed low, and bounces directly off the aluminized reflector in front of the model. The aim is to bounce as much light as possible from a single source *upward* onto the face. The model holds the reflector at the proper angle, and often through the session closes his eyes between shots, as 650 watts of bounced light in a dark room is strenuous for his eyes. A hair light (C) is used as well, placed high and to the model's left. The purpose of the hair light is both to put some gleam into the hair, and also to subtly alter one side of the face. Again, asymmetry is a part of portrait lighting. The background is an aluminized sheet, which appears to have a matte finish as almost no light shines on it in this setup. This helps establish depth in the portrait, and adds to the three-dimensional effect in a two-dimensional medium. There is a dominant foreground (the face), a strong, graphic middle area (the shadow), and the background is a complementary pale gray.

PROCEDURE

1. Turn on the key spot (A) in front and to the left of the model.

2. Position the aluminized reflector so that a maximum quantity of light is bounced directly onto the subject's face from below. Tell the subject to close his eyes from time to time, as the glare can be stressful for his eyes.

3. Turn on the hair light (C). Position it so that it casts light on the hair, but move it so that it doesn't

FIG. 1

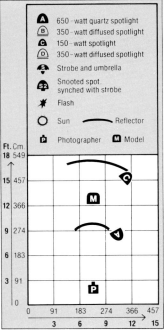

A	650-watt quartz spotlight
B	350-watt diffused spotlight
C	150-watt spotlight
D	350-watt diffused spotlight
S	Strobe and umbrella
S2	Snooted spot, synched with strobe
✳	Flash
O	Sun
P	Photographer
M	Model
	Reflector

FIG. 2

cause hot spots on the background. Check this through your camera lens.

4. Tilt the background sheet of aluminized board so that it gives a tone that suits the effect you desire. In this case, it is not perfectly flat but not obtrusive, either.

5. Take an exposure reading.

6. Vary the framing during the session—use the shadow cast by the subject's head as a compositional element.

7. Coach the model to talk, smile, laugh, and "ham it up" for the camera—try out a variety of expressions. Try the combination of a humorous expression with the natural sobriety and darkness of the lighting.

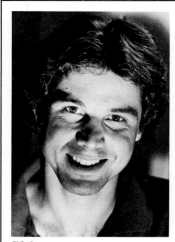

FIG. 3

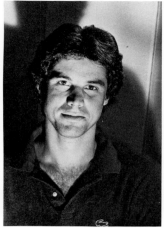

FIG. 4

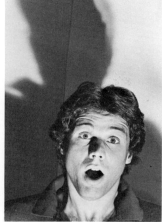

FIG. 5

CONCLUSIONS

Fig. 3–6 show some remarkably interesting results of what could have been a very unflattering setup. Fig. 3 is a close-up, with most of the shadow behind the head cropped out of the frame. The reflector is well positioned, and the lighting is fairly even. The eye area can go too dark in under-lighting, but careful use of the reflector, as shown, can make the picture succeed. Fig. 4 and Fig. 5 show successively greater areas of shadow, and different expressions on the subject's face. Fig. 4 also shows an unfortunate area in the background, which was difficult to see in the dark studio. Fig. 5 is interesting but a bit too close to a "horror movie" kind of image. The subject preferred the expression and combination of Fig. 6, as it expressed a side of his character that was unique. Compositionally, Fig. 6 is successful, as the strong shadow and the face combine to form a strong line of diagonal force in the image, which adds to the power of the picture. Though this is not the most "attractive" portrait that could have been done of this subject, it certainly is unique. Non-conventional approaches sometimes produce remarkable portraits, so remember to try some experimental shots when the subject is interested in a portrait that is attention-getting and out of the ordinary.

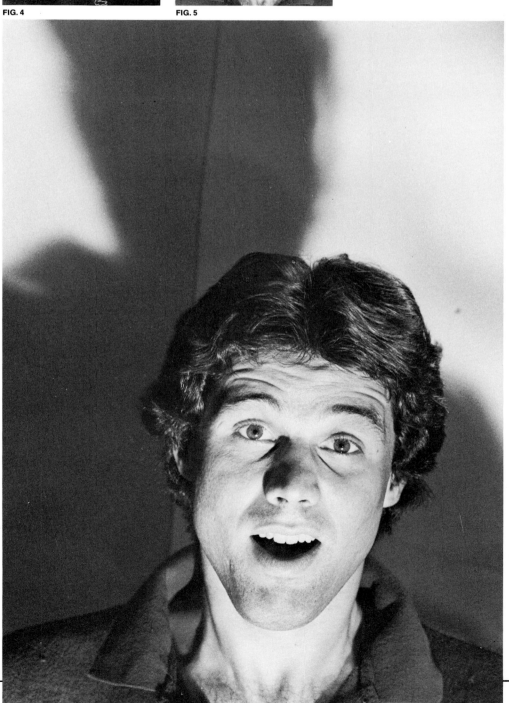

FIG. 6

INDOOR POOLSIDE LIGHTING

Though natural light normally falls on us from its single light source, the sun, and is diffused by trees and objects in its path, there are two occasions when underlighting occurs naturally: at water surfaces, and when people sit around campfires. This kind of lighting can be simulated indoors by combining a wet look with a re-created lighting setup that imitates light bouncing up off water, or from a campfire below the level of a subject's head. This is an interesting technique to try when the subject wants an outdoor-type portrait and the weather doesn't allow working outside, and is a variation many subjects will like. Actors and models could use a shot like this for their commercial portfolios, because with the simple addition of a product, this lighting setup could simulate a commercial for shampoo or suntan lotion, beach towels, or any of a number of products made for use at the beach. This variation of underlighting fills in more of the face by having the model tilt his face forward into the bounced light of the reflector, which imitates the kind of shot where someone is at the edge of the pool, with lots of light bouncing up onto his chin.

EQUIPMENT AND SETUP

Two main lights are used for this setup. Most important is a 650-watt quartz key spotlight (A) in front and to the left of the model, directed onto an aluminized reflector from a distance of about 4 feet (122 cm). Though this is a kind of underlighting, it is not extreme underlighting, so the bounced light source is moved back to minimize it somewhat. The model holds the reflector at the proper angle with his hands or knees, or it is held in position by an assistant, depending on the pose. A hair light (C) is placed slightly behind the model and to his left, to serve both as a hair light, and to cast light on the left side of his face. To add to the poolside effect, the model is wet and drapes a towel around his neck. A spray bottle of water is kept handy, as the lights dry the water quickly, and the photographer has to stop between shots to "wet down" his model. Props are very helpful to express a location—in this case the use of a large rattan chair added to the ambience of a beach club. The hair light helps keep the area of the chair bright in the image, and brings out its texture. Strong lighting is best used to bring out texture. In this demonstration the towel, chair, and the strength of the model's face are all enhanced by the strong lighting arrangement.

PROCEDURE

1. Position the key spot (A) and angle it onto an aluminized reflector in front of the model. Pass your hand in the path of the bounced light to test its brilliance (watch the shadow of your hand pass across the subject) and move the light to the position you determine is best.

FIG. 1

FIG. 2

2. Instruct the model how to hold the reflector for the best effect. Double-check the position of your front light.

3. Position the hair light (C). Move it until it highlights the hair and the side of your subject. If you are using a backdrop (in this case, the rattan chair), make sure the texture is strongly highlighted.

4. Check the background through the lens, and determine how you will frame the picture.

5. Check the eye area through your lens as it is difficult to light the eyes evenly when working with bounced light. Coach your model while looking through the lens until the effect is right.

6. Spray water all over your model's hair, face, and shoulders. Wait a moment and wipe off any accumulation under the end of the nose, but leave as many droplets as you can elsewhere to heighten the poolside effect.

Ⓐ	650 - watt quartz spotlight
Ⓑ	350 - watt diffused spotlight
Ⓒ	150 - watt spotlight
Ⓓ	350 - watt diffused spotlight
S	Strobe and umbrella
S2	Snooted spot. synched with strobe
✳	Flash
☼	Sun
⌒	Reflector
Ⓟ	Photographer
Ⓜ	Model

FIG. 3

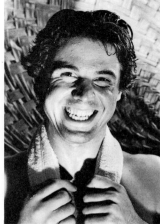

FIG. 4

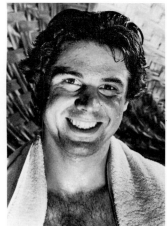

FIG. 5

7. Ask the model to lean forward into the bounced light so that it brightens his face fairly evenly and keeps his eyes bright. Keep a sharp eye out for shadows as you photograph, especially if you change the pose.

8. Coach the model through the session, trying to get as relaxed a look as you can, to complement the recreational mood of this type of portrait.

9. Spray water on the model's face and shoulders periodically throughout the session.

CONCLUSIONS

Study the changes in the reflected light caused by slight changes in the angle of the model's head in Fig. 3–6. Though the portraits are interesting in Fig. 3–5, one eye is highlighted far more than the other, which gives a somewhat lopsided effect. Fig. 5 shows an interesting use of the strong lighting—the fists become a very graphic element due to the shadows separating the fingers. The hands do compete with the face, however, so this was not chosen as the final portrait of the session. Fig. 6 is the portrait selected from the contact sheets as the best from the model's point of view. It has modified underlighting, but both eyes are satisfactorily bright, and all the textures in the image are highlighted. The water glistens, and the mood is relaxed and happy, resulting in a good portrait.

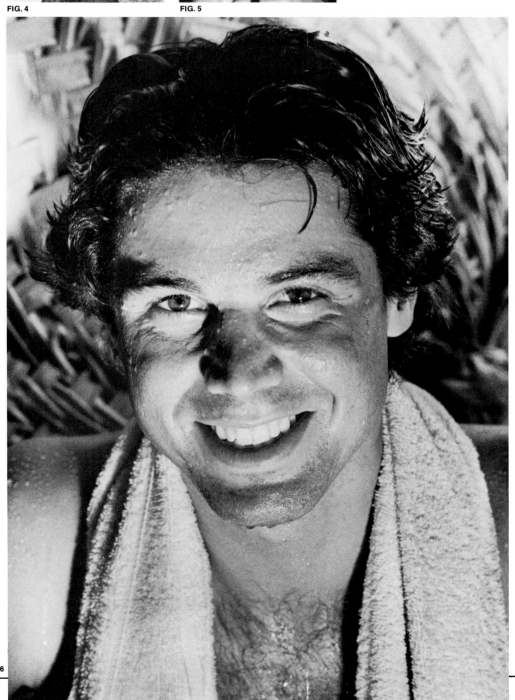

FIG. 6

HOLLYWOOD GLAMOUR LIGHTING

Images of Hollywood and glamour excite everyone—especially your professional clients. Hollywood glamour lighting gives the portrait photographer a chance to re-create the best of the Hollywood studio portraiture that was done in the 1930s and 40s in the glamour capital of the world. Being able to emulate this style is a special thrill for the photographer, as it is a style that greatly influenced our concept of portrait photography. It took the portrait out of the available light situation and gave it a sophistication it had not known before. Lighting a Hollywood movie set, in itself, caused many new lighting situations and instruments to be developed. These new lighting instruments were adapted and used in the portrait studios that were built especially to photograph the stars. These photographs of people such as Greta Garbo, Marlene Dietrich, Joan Crawford, Gary Cooper, Clark Gable, and Henry Fonda had to speak of their glamorous image to the public. This was the image that the fans were used to seeing on the screen. By using Hollywood's lighting techniques in your own studio, you can give your clients a touch of glamour that will make them look like the stars they have always wanted to be.

EQUIPMENT AND SETUP

To imitate a Hollywood glamour portrait, the photographer based the lighting setup on a 650-watt key light (A), positioned a bit closer to the model than usual for a more intense light. The model was fortunate enough to have a good complexion that could take such bright lighting. Because you will be using intense lighting in this technique, always have a fan on to cool the model's face. It does not have to blow her hair away from her face. Also remember to give the model frequent breaks from the lights. The diffused fill light (B) is placed directly in front of the model at a distance of 6 feet (183 cm). An aluminum reflector is placed at waist level, about 2 feet (61 cm) away from the model. A 150-watt hair light (C) is added, raised to a height of 7 feet (213 cm) and tilted down at a 45-degree angle. (The use of (C) is optional and therefore shown not in use in Fig. 2.) A portable reflecting screen was added for shadow fill, placed 1 foot (30 cm) away from the model's left shoulder. A background reflector board was tilted forward at a 45-degree angle to avoid light flaring back into the lens. Have the model try different poses for variety, but remember to make lighting adjustments accordingly, and always check your meter readings.

PROCEDURE

1. Set up the 650-watt key light (A) 4 feet (122 cm) behind the subject. Raise it to a height of 7 feet (213 cm) to avoid shadows.

2. With such intensly hot lighting placed so close to the model, remember to make sure that the makeup is especially well blended and her hair particularly neat. When showing only bare shoulders, try to avoid (by proper placement of lighting) any overly hot light falling on the shoulders from behind, as this can be distracting in a final portrait.

FIG. 1

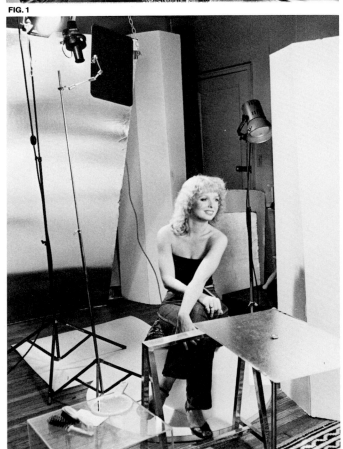

FIG. 2

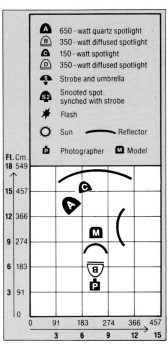

Ⓐ	650-watt quartz spotlight
Ⓑ	350-watt diffused spotlight
Ⓒ	150-watt spotlight
Ⓓ	350-watt diffused spotlight
Ⓢ	Strobe and umbrella
Ⓢ²	Snooted spot, synched with strobe
✳	Flash
☼	Sun Reflector
Ⓟ	Photographer Ⓜ Model

3. The hair light (C) is directed at the hair from behind the subject, raised to a height of 5 feet (152 cm). The spot itself is aimed down at the back of the head at a 45-degree angle.

4. A 350-watt diffused fill light (B) is placed at waist height directly in front of the model to eliminate the shadows and add sparkle to the eyes.

5. An aluminum "horse" is placed between the model and reflector.

6. Remember to shade your lens to avoid lens flare from the strong backlighting. You can do this with your left hand—rest it atop your lens as a lens shade would.

7. Always remember to check your meter reading as more lights are added.

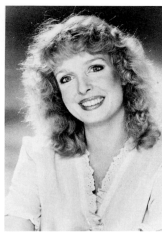

FIG. 3

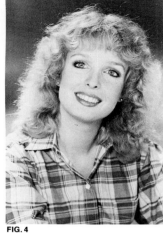

FIG. 4

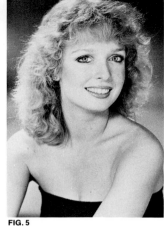

FIG. 5

8. Coach the model throughout the session—make sure she relates to the camera as if it had a personality of its own.

9. Have the model vary her poses, look over her shoulder, and lean into the camera. These are interesting poses that say "Glamour."

CONCLUSION

With strong main lighting and backlighting, together with the added diffusion and reflectors, Fig. 3 is a terrific "Hollywood" shot that could be commercial as well. This lighting setup is close to harsh lighting, so don't try to use it on "bumpy" complexions. Glamour is present in this portrait, but it is a relaxed, self-assured glamour. In Fig. 4 the model continued playing the ingenue or "starlet" role, and changed into a pastel plaid shirt. But because of her own glamourous good looks and the lighting, she manages to dominate the costume. The model is not squinting in these because she looks away from the bright lights as soon as the shot is taken. In Fig. 5 the model has changed into an off-the-shoulder top and is getting closer to the ultimate Hollywood image. Strong lighting is maintained, and since this look often dictates many different angles of the head and shoulders, she has turned her head a bit to her left while keeping eye contact with the camera. By leaning back a bit, she has given more interest to her pose in Fig. 6. This shot imparts a healthy sexuality to the image without trying too hard. This is a perfect Hollywood glamour portrait that could be cropped to a head-and-shoulders shot or left full frame.

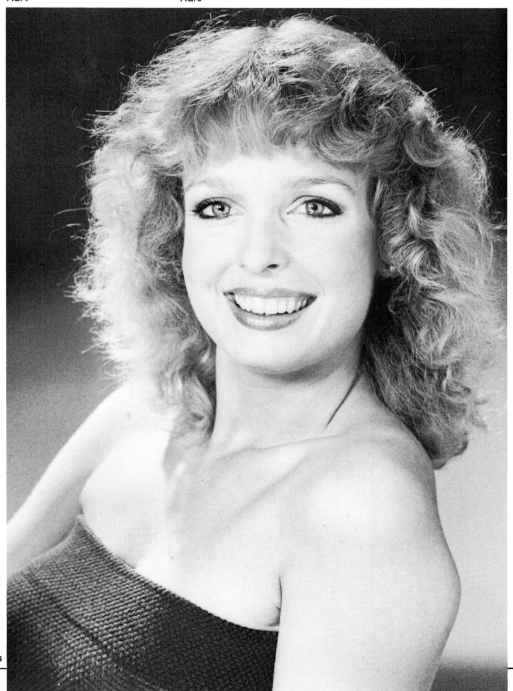

FIG. 6

SIDELIGHTING FOR WOMEN

Sidelighting is a technique often used for portraits of men because it enhances the planes of the face. Although it can impart more strength to the face and give it more character, sidelighting for women should be used very carefully. Sidelighting can add a strong effect to a portrait, but only when used with discretion. This is especially true when photographing older women, where softness should be an important element. However, this technique can add drama to a portrait, and depending on the strength of the lights being used, it can give a deep shadow to the right or left side of the face, or give a soft, gray-toned shadow to either side of the face. By experimenting with flexible key lights, you can arrive at the best solution for your client. Sidelighting can sculpture the face a bit more, and separate the head from the background. This gives the face a three-dimensional quality that adds to the impression of reality. The addition of spot lights, whether full-strength or diffused, will always cause some shadow to fall off on either side of the face.

EQUIPMENT AND SETUP

The key light (A) is placed at the photographer's left at a height of 7 feet (213 cm). (A) and (B), a 300-watt fill light located below and to the photographer's left, provided the three-quarter shadows desired for sidelighting. A 150-watt hair light (C) is used. It is placed 8 feet (244 cm) opposite the key light (A) and raised to a height of 5 feet (152 cm), angled toward her at a 45-degree angle. An aluminum reflector is placed directly below the model's face to fill in the shadows and add some sparkle to the eyes.

PROCEDURE

1. Place the key light (A) 5 feet (152 cm) away from the model and slightly to her right.

2. Add a diffused fill light (B) for extra light and sharpness.

3. Adjust the hair light (C), making sure that the heat from this light does not cause the model to be uncomfortable. Place it directly behind and to the left of the model.

4. Place the aluminum reflector at waist level for sparkling eyes and shadow fill.

5. Have the model move about to the left and right for an over-the-shoulder adjustment and lighting alignment.

6. Align lights (A) and (C) so that the shadows they cause do not conflict or become too harsh.

FIG. 1

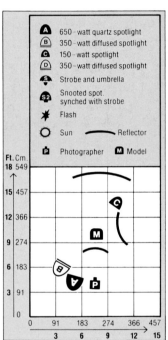

A	650-watt quartz spotlight
B	350-watt diffused spotlight
C	150-watt spotlight
D	350-watt diffused spotlight
S	Strobe and umbrella
S2	Snooted spot. synched with strobe
✳	Flash
○	Sun
⌒	Reflector
P	Photographer
M	Model

7. Make sure the reflective background is angled so it does not bounce light back into your lens.

8. Remember to check your meter reading as more lights are added to the setup.

9. Keep a fan blowing softly on the model's face, and give her frequent breaks from the heat of the lights.

FIG. 2

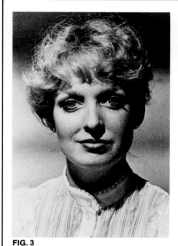

FIG. 3

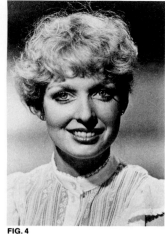

FIG. 4

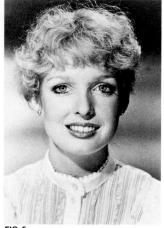

FIG. 5

CONCLUSIONS

In Fig. 3, the key light (A) is angled slightly to the model's right side to give darkest shadow to the left side of her face. Note the interesting bounce light under her chin. Its source is her light-colored blouse. In Fig. 4 the shadow area on the right side of her face has been lightened by moving the key light (A) a bit more to the model's right and having her twist her head slightly. The shadows in the eyes are lighter as well, but the shadow under the nose is still a bit too long and deep. By lowering the key light (A) and adding the reflectors to fill in the dark shadows, the face has been given a softer look in Fig. 5 while still retaining the strength of the sidelighting. Notice how the shadow on the neck has moved from a frontal position to the side. Fig. 6 is a more interesting ''over-the-shoulder'' shot. With the slight turn of the shoulders, conscious front lighting and the addition of backlighting to accentuate her blonde hair, the strength of the sidelighting on her left is still maintained, but it has been kept in proportion. There are no distracting shadows under her nose or in her eyes. The finished effect is a fresh, yet sculptured, image.

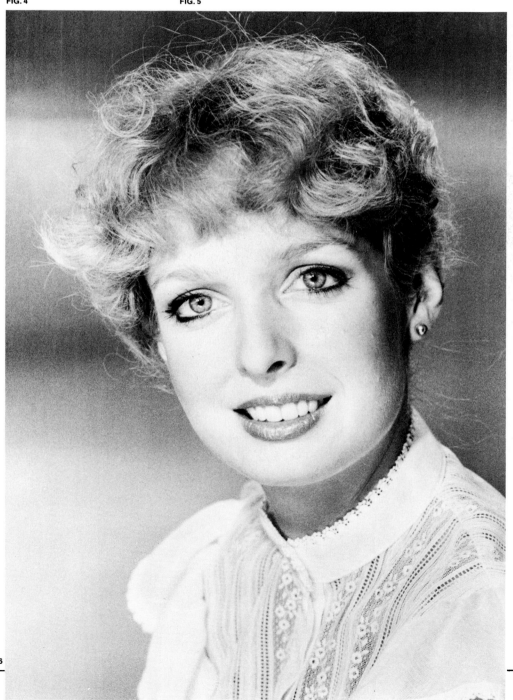

FIG. 6

FRAMING THE FACE

For an effect that goes beyond the ordinary, try having your subject wear a hat, hood, scarf, or piece of drapery. This can add extra drama to a portrait, and is especially effective for portfolio purposes. It is necessary to work close to your subject with this technique and with this idea, you'll find it's fun to zero in on the model. This shot will be sharp and intense, so don't try it on someone with a bad complexion. You can create a fun feeling in a portrait by using a silly hat, a sporty effect with a hooded jacket, or, for something really dramatic, try us-

ing silk or wool fabric draped interestingly over the head. Even a child peeking out from under a blanket or quilt would be a dynamic shot. Lighting can be used to enhance the subject for whatever mood you want to create: bright, diffused lighting for a sporty look, or dark, contrasting lighting for dramatic expression. By framing the face you are creating an impact shot that has a truly outstanding graphic simplicity. Experiment with this technique—neither you nor your clients will be disappointed.

EQUIPMENT AND SETUP

A large, diffused 650-watt key light (A) is placed to the model's right, a bit higher than eye level. Front fill is provided by a 350-watt diffused light (B). The back of the hood is lighted with a 150-watt hair light (C). It is raised to a height of 7 feet (213 cm), and several backgrounds are used for variety. A rectangular reflector is placed at arm's length from the subject. A white reflector background is added in Fig. 2, with an extra reflector below and to the left of the model's arm for added bounce. A black background with white stripes is also used.

FIG. 1

FIG. 3

PROCEDURE

1. Turn on the key light (A) and experiment with the best angle to bring out the facial qualities of your subject. Turn on front fill light (B).

2. Adjust the rectangular reflector to fill in any harsh shadows.

3. Add a secondary reflector to fill in any shadows that will fall on either side of the subject's face.

4. Check that the model's makeup is smooth, as the framing is very close on his face.

5. Adjust the hair light (C), which is kept at a height of 7 feet (213 cm) and angled slightly away from the hair to prevent overexposure.

6. Use a fan to keep the model cool under the hot studio lights.

7. Check your exposure reading.

8. Always frame your model so that he is centered with the backdrop as your position changes. You don't want to see the edges of the backdrop in your finished pictures.

A	650-watt quartz spotlight
B	350-watt diffused spotlight
C	150-watt spotlight
D	350-watt diffused spotlight
S	Strobe and umbrella
S2	Snooted spot, synched with strobe
✳	Flash
☉	Sun — Reflector
P	Photographer **M** Model

FIG. 2

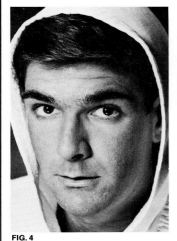

FIG. 4

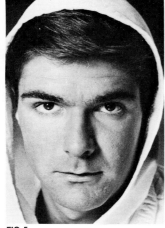

FIG. 5

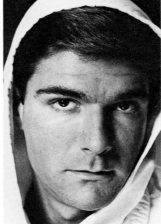

FIG. 6

CONCLUSIONS

In Fig. 4, we can see the advantages of sidelighting in men's portraits. By working very close up and framing the face with a white sport hood, the simplicity of a totally graphic design (very simple areas of lights and darks with no distractions) is achieved. The strong backlight on the hair is not used in this portrait as the emphasis is only wanted on the face. In Fig. 5 the model has turned his head straighter into the camera, giving the sidelighting more power. The bounce of light from the white hood onto the shaded side of his face gives the portrait added dimension. The model's direct gaze augments the basic strength of this technique. In Fig. 6 the subject has turned his head even more to the right, but although the strength of the shadows has been increased, the shot itself is weakened slightly by this added angle. In Fig. 7 the model took off the white hood, but the graphic impact of a face that is tightly framed by the lens and the lighting is maintained. For added variety, a black-and-white sunburst shower curtain was used as a background and gives the impression of the sun's rays. The strong planes in this model's face are emphasized in this portrait by the intense main light on his right side and the close cropping of the image.

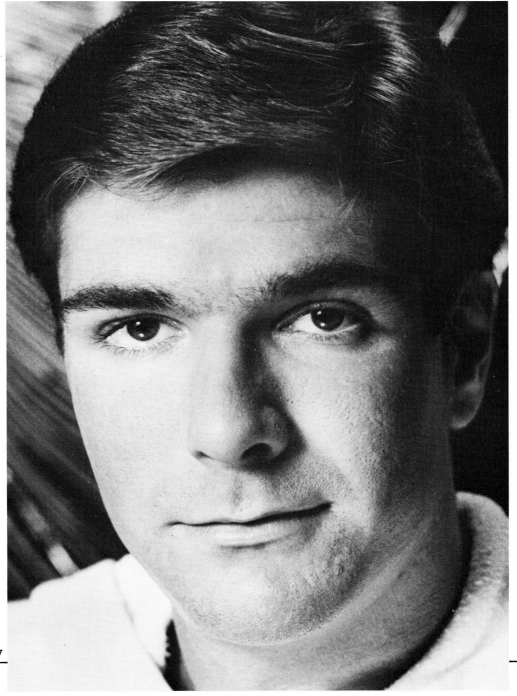

FIG. 7

DOUBLE EXPOSURE

This lighting setup, although technically difficult, can be a lot of fun for the subject and the photographer. This technique really brings out the photographer's imagination—and the results are unlimited. Imagine putting your subject into two different settings in the same portrait, or having them express two different moods. For the illustration shown here we created two different moods—one happy, one sad—to emulate the actor's masks of tragedy and comedy. Effects of this kind can often contain a sense of humor, as shown here, and the results can be truly magical. This is a technique that is much more satisfying than simply sandwiching two negatives together. The double exposure that exists on the same negative has an integrity and a wholeness that is all its own. The double-exposure effect can also be used to express motion by having the subject pose in two different figure positions. It is an unusual means of artistic expression for the creative photographer.

EQUIPMENT AND SETUP

A large, 350-watt fill light (B) is placed to the photographer's left, slight above eye level. A 650-watt key light (A) is placed behind the model, raised to a height of 5 feet (152 cm) and angled toward the left side of his head. In Fig. 1 the frame is held by the model and anchored on an aluminum horse. In Fig. 2 you can see a box placed on top of the horse for added height and to allow the model to move easily from one position to another. The setup is kept simple, using only two lights and no reflectors to avoid complications with the double exposure.

FIG. 1

FIG. 3

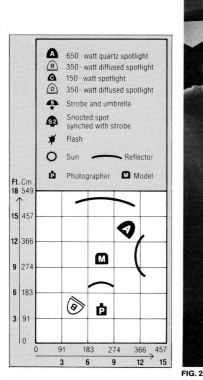

FIG. 2

Legend:
- **A** 650 - watt quartz spotlight
- **B** 350 - watt diffused spotlight
- **C** 150 - watt spotlight
- **D** 350 - watt diffused spotlight
- **S** Strobe and umbrella
- **S2** Snooted spot synched with strobe
- ✷ Flash
- ○ Sun ⌒ Reflector
- **P** Photographer **M** Model

PROCEDURE

1. Place the fill light (B) directly in front of, and slightly above, the model's face. It is angled slightly to his right to achieve some shadows on the left side of his face.

2. Place the key light (A) behind and to the left of the model. It is raised to a height of 5 feet (152 cm) and angled slightly behind the head to avoid too hot a backlight.

3. A Mylar background is used, but it remains dark as not enough lights are used to brighten it.

4. Double-check the meter reading, as proper exposure is essential to the first and second exposures.

5. The model will move twice, or make two different facial expressions. Coach your subject not only for proper and exact positioning, but also for achieving the two different emotions.

6. Take at least a half a roll of shots if you wish, then rewind carefully as indicated in the conclusion.

7. Various angles and points of view should be experimented with. By using only the two-light setup, you have ample room for lots of creative expression.

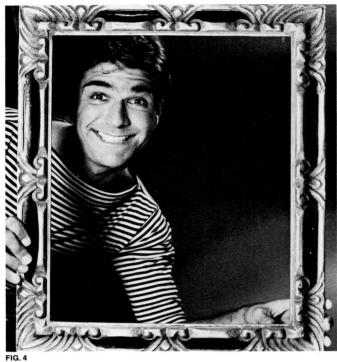

FIG. 4

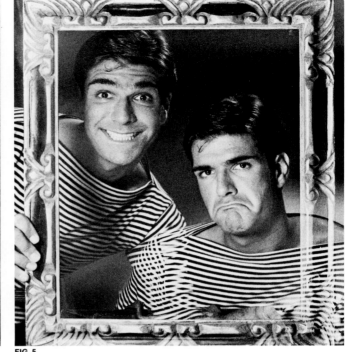

FIG. 5

CONCLUSIONS

Fig. 5 and Fig. 6 show that double exposure gives results that can be truly imaginative and creative. Double exposure can also be a lot of fun for the photographer who wants to experiment—and experiment is the key word, because it is a tricky business and you have to be willing to take chances. Once the idea of the tragedy and comedy mask was decided on, a frame-within-a-frame concept was introduced to ensure accuracy. This kept the faces in exactly the right spot by making sure the picture frame itself stayed stationary. In Fig. 4 the model was positioned in the upper left-hand corner of the frame and told to try to keep his left arm from going too far into the space that his alter image would occupy. To avoid complications with backlighting, and since he would be moving slightly, a very soft, 150-watt hair light was used to separate him from the background. Six frames were shot of the model in this position, and then the camera was rewound—counting approximately 1½ turns per frame—by pressing the release button. The model then repositioned himself in the lower right-hand portion of the picture frame and the six shots were rephotographed. Fig. 6 shows the best results of the double exposure. By cropping the photograph right to the inner frame and leaving only the surrealistic fingers, the result is a very imaginative example of double exposure.

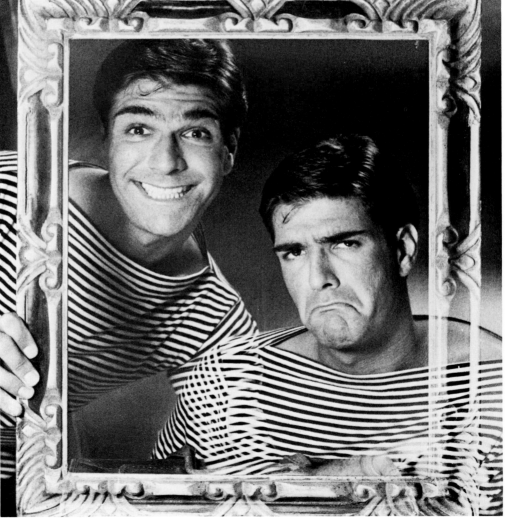

FIG. 6

FLASH FOR OUTDOOR HEADSHOTS

Since headshots for an actor's or model's portfolio have to show the individual as he or she really looks in real life as well as under bright lights, using flash fill in daylight is a good technique for one of the several headshots that the professional will carry in his or her portfolio. A helpful professional tip to keep in mind when using this technique is to position the model so that the face is in shadow, and that bright light highlights the hair and shoulders. It also adds to the image if the background does not contain objects rendered in fairly

sharp focus by the small aperture a flash unit allows. For this demonstration, the photographer asked the model to sit on a slight rise so that he would be shooting from an angle slightly lower than her eyes. This is what allowed the attractive pattern of light and shadow on the grass behind her to serve as a good, undistracting background. Outdoor portraits have an innately casual, recreational look, with the wind blowing the hair softly, and obviously natural interplay of light and shade that can make the most of fresh good looks.

EQUIPMENT AND SETUP

A flash unit freshly recharged or with new batteries and a camera are the only equipment required for this setup, though selecting the location among the infinite number of ''studio settings'' nature offers is a key step in accomplishing this technique. Look for a spot with soft, natural shadow, and seat your model at the edge, so her face is not struck by harsh, overhead illumination. Make sure there is no glare on her nose, as strong highlights will not be erased in the flash's burst of bright light.

PROCEDURE

1. Find an appropriate location in natural shade, and position your model with her face in shadow.

2. Check that your flash unit is properly seated, and that your camera is set to flash synch.

3. Take an exposure reading and choose an appropriate setting for the flash unit. Make sure to watch the shifting quality of daylight, and adjust exposure when necessary.

4. Let the model rest her eyes often, as the flash will be very bright and tough on eyes that are already beginning to squint from daylight. Keep the session short to keep the model's eyes from becoming too fatigued.

5. Keep the mood of the session casual and cheerful. Ask the model to say ''Hi'' to get a natural, dynamic smile.

FIG. 1

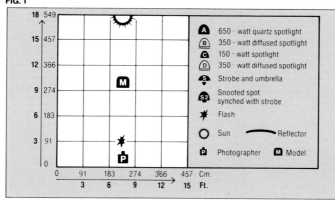

A	650 - watt quartz spotlight
B	350 - watt diffused spotlight
C	150 - watt spotlight
D	350 - watt diffused spotlight
S	Strobe and umbrella
S2	Snooted spot synched with strobe
✳	Flash
☼	Sun — Reflector
P	Photographer **M** Model

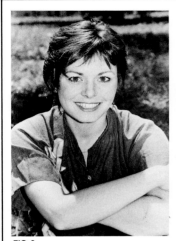

FIG. 2

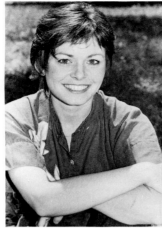

FIG. 3

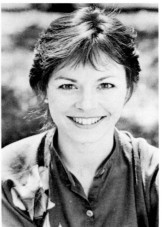

FIG. 4

CONCLUSIONS

Fig. 2–5 show a succession of exposures using direct, on-camera flash at midday that range from unacceptably washed out (Fig. 4) to a terrific and flattering exposure (Fig. 5). These variations in exposure occurred for two reasons, one of which the photographer could control, and one he couldn't. Changing levels of daylight as the sun moved behind the clouds changed the lighting sharply—and sudden bursts of sunlight as the sun reappeared from behind a cloud added enough light to cause overexposure, as in Fig. 3 and Fig. 4. Fig. 2 and Fig. 5 show flash that is well balanced with daylight, resulting in good commercial headshots for this model. Despite the brightness, her eyes are open and she is communicating directly with the camera—a skill all professional models must perfect.

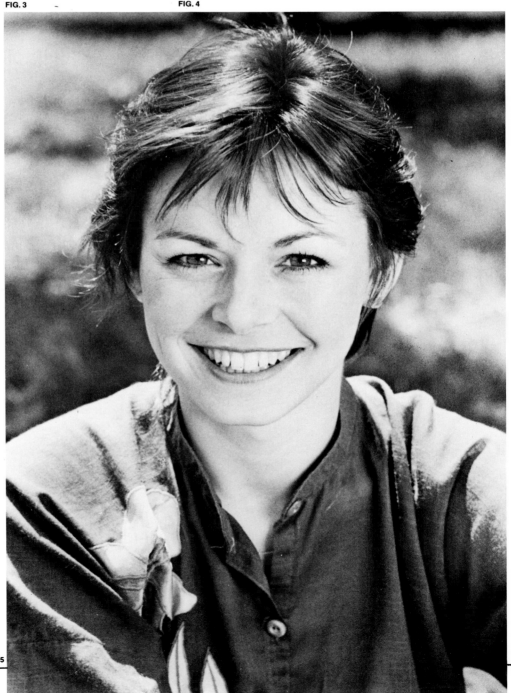

FIG. 5

GOLD REFLECTOR FOR OUTDOOR HEADSHOT

A gold reflector is equally useful for color or black-and-white portraits taken outdoors, and adds a luminous glow to a portrait that is hard to beat. Having an assistant to hold the reflector frees both the subject and the photographer to do their best in their respective roles, and allows bounced light to be accurately directed without the model having to lean into it or assume what could be a tiring pose. A gold reflector is troublesome for the eyes, so a session such as this one should be planned well in advance to cut down on the amount of time the subject must be exposed to glaring light. Reflectors work in the same way a flash unit does, to add light specifically for the purpose of filling in shadows—but reflectors accomplish this in a gentler manner. Bounced light from a reflector seems to round out a face, whereas flash fill gives a flat, stark look to an outdoor headshot. This session was aimed at getting a good new portfolio shot for the model to show him in a casual environment. He, like most models and actors, regularly updates the shots in his "book."

EQUIPMENT AND SETUP
A gold-toned, metallic reflector is the only piece of equipment needed for this technique, other than a camera and portrait lens. The model sits with his back to the sun, and an assistant holds the reflector at head height for warm-toned, bounced light to fill out natural shade.

PROCEDURE
1. Find a location that offers slight shade to be balanced by reflected light from the gold reflector.

2. Position the model, keeping in mind that having his face in the shade will avoid highlights on his nose, though some highlight in the hair is desirable.

3. Show the assistant how to hold the reflector. Because a metallic reflector bounces such strong light, move the assistant at least 10 feet (305 cm) away from the subject to reduce the chance that he might blink. Instruct the assistant to drop the reflector between shots, to rest the subject's eyes, and to raise it again to exactly the same position for each shot.

FIG. 1

A	650 - watt quartz spotlight
B	350 - watt diffused spotlight
C	150 - watt spotlight
D	350 - watt diffused spotlight
S	Strobe and umbrella
S2	Snooted spot. synched with strobe
✳	Flash
☼	Sun Reflector
P	Photographer **M** Model

4. Take an exposure reading and check that the background is clear, and that it will not provide surprising elements when working with small f-stops in bright daylight.

5. Keep a male model's face straight up and down, and coach him so that he presents a good, personable smile, as this is what agents will look for in his headshot: an attractive, persuasive visual identity.

FIG. 2

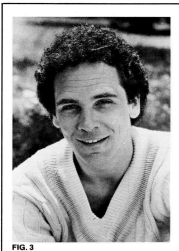

FIG. 3

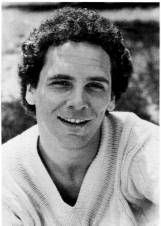

FIG. 4

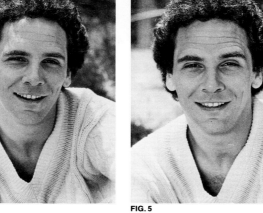

FIG. 5

CONCLUSIONS

Fig. 3 shows a lot of light reflected onto the subject between his chin and eyebrows—and it also shows that he found it impossible to keep his eyes wide open in such bright light. In Fig. 4 he has tilted his head to reduce the amount of light in his eyes, but the portrait loses strength with his head at this angle. Fig. 5 shows how the reflector was used to give most of its fill light to the left side of the model's face, but the stress of the illumination shows on his face, in lines of tension on the forehead and in his eyes. Fig. 6 is the most successful shot from this session. The model looks comfortable, the reflected fill light works well, sunlight is high-lighting his hair, and he has a terrific smile and easy manner—qualities agents should appreciate when he shows his headshots.

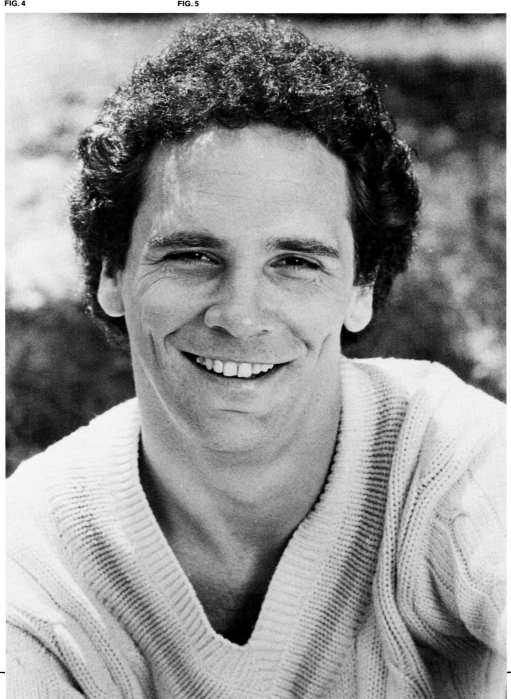

FIG. 6

USING FLASH FOR OUTDOOR HEADSHOTS IN MIDDAY SHADE

Flash may be combined with natural lighting to produce bright, sharp outdoor portraits. It is most effective when used to illuminate subjects in a medium to dark shady area, as flash can tend to wash out pictures in broad daylight, giving them a pale and insubstantial appearance. This is a technique that is best used for young models with impeccable complexions, as using flash outdoors allows you to stop your lens down to a small aperture, which will bring out the most delicate of de-

tails. Since black-and-white photography already tends to make lines and wrinkles a bit darker than they appear to us in real life, the use of flash in midday light will not flatter everyone. One of the techniques you can use to soften a flash's blast of light is to bounce it off the reflector in its path. This demonstration shows how a white reflector card mounted on the camera can soften the flash's output to a large degree, providing overall fill light. Many flash units can be fitted with a card holder.

EQUIPMENT AND SETUP

A good flash unit with fresh batteries is essential to this technique. If it is a recharging model, remember to plug it in the day before your shoot so it will function reliably when you're outside shooting. Take along a white reflector attachment, or find a way to fasten a stiff piece of white cardboard to one side of your flash unit so that the light will become somewhat diffused as it bounces off the white surface.

PROCEDURE

1. Find a location that offers medium to dark midday shade, and a reasonably clear background. Remember that using a flash allows you to stop down, and your background will be very sharp, not soft and indistinct.

2. Check your flash unit before the shoot. Test its recycling time, and remember to wait for the ready light before each frame. Make sure your camera is set to flash synch.

3. When working with a couple, use a series of interesting poses. Also explain that they can rest their eyes from time to time, as the brilliant flash of light combined with a high level of natural ambient light will cause them to squint or blink.

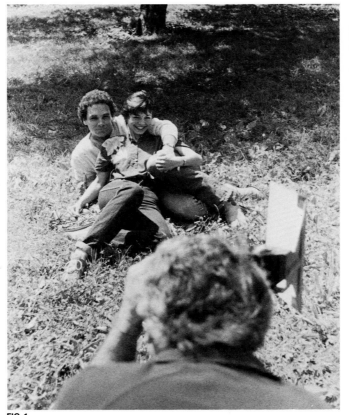

FIG. 1

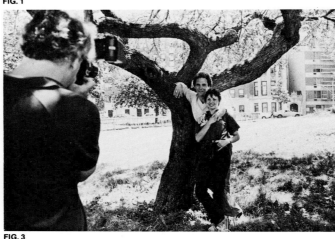

FIG. 3

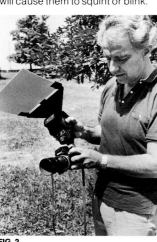

FIG. 2

Ⓐ	650-watt quartz spotlight
Ⓑ	350-watt diffused spotlight
Ⓒ	150-watt spotlight
Ⓓ	350-watt diffused spotlight
Ⓢ	Strobe and umbrella
Ⓢ²	Snooted spot. synched with strobe
✳	Flash
◯	Sun ⌒ Reflector
Ⓟ	Photographer Ⓜ Model

4. Take an exposure reading, and set your flash unit to an appropriate setting.

5. Coach the models while you shoot, and get them to relax. Work to maintain good eye contact.

FIG. 4

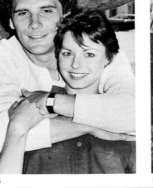

FIG. 5

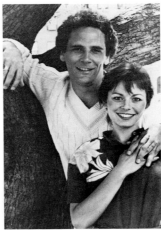

FIG. 6

CONCLUSIONS

Compare Fig. 4 and Fig. 5—both are the result of flash used outdoors, but the illumination is very different in each one. Fig. 4 shows a softer variety of flash fill caused by bouncing the flash's output off a white card. Fig. 5 shows the same shot without the use of the white card to diffuse the flash's blast of light. Notice how washed out the young man's sweater is in Fig. 5. This demonstrates a kind of "overkill" illumination you can obtain with straight flash aimed directly at the subjects. In Fig. 5 the flash failed to fire because it had jiggled loose. Make sure to check periodically that the unit is well seated. Fig. 6 shows the couple standing in deeper shade than in Fig. 5. The flash has created a shadow behind their heads and rendered the background in fairly sharp focus, but this somewhat stark effect is, nonetheless, an effective double portrait. The two faces stand out, and are the focus of the portrait.

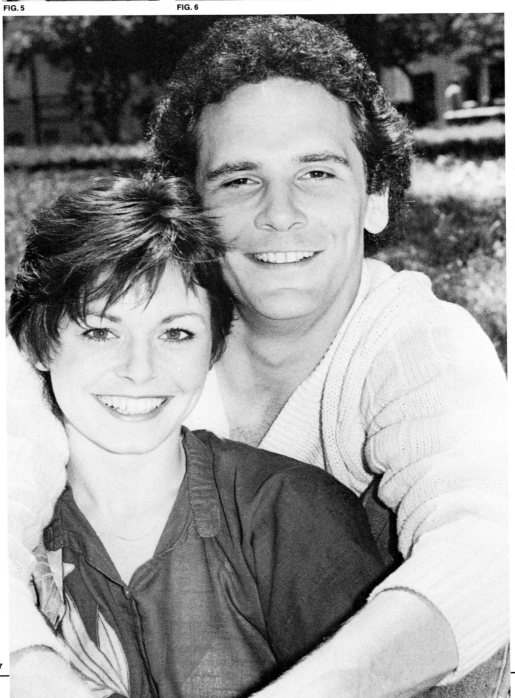

FIG. 7

SOFTLY DIFFUSED LIGHTING

Diffusion is a technique that has often been overworked in portraiture, but it remains a special way of rendering a softened image, and of giving a portrait a dreamlike quality. General diffusion can be accomplished by using lights that are softened by passing them through or onto a diffusing surface. In this demonstration, only frontlighting (a combination of direct and diffused) was used in conjunction with a delicate star filter to bring out the gleam of the silver lamé backdrop, pearls, rhinestones, lacy gown, and the model's pretty features. This is diffusion used at its most subtle extreme—the aim is to keep the portrait sharp and concrete while subtly emphasizing the gleam of all the sparkling and shining elements it contains. A statue was added as a prop to give the idea of a romantic vision of the subject. Setting a scene and including props are good methods of making the most of lighting setups. A good studio maintains a supply of background materials, props, and even clothing for special sessions such as this one. They are the "little extras" that can turn a good portrait into a spectacular one.

EQUIPMENT AND SETUP

This setup involves a careful arrangement of textures and reflective surfaces, anticipating the soft, glamorous glow of the final portrait. The metallic silver fabric used as a backdrop is a key element. It is simply a length of fabric draped over the standard aluminized backdrop. The fabric reflects a remarkable amount of light, and because of this, the two frontal lights used for the setup are much farther away from the model than for most other studio setups. This is almost a re-creation of a type of stage lighting, as the light sources are very high, and are directed at a wide area. Notice in Fig. 2 that both frontal lights are to the left of the photographer, and that the key 650-watt quartz spotlight (A) is raised to a height of about 9½ feet (289 cm). These two lights cast an even, soft glow across the room. Observe in both Fig. 1 and Fig. 2 how high the pedestal-mounted reflector has been raised. This is necessary as the model is standing, and light must be bounced up to brighten the eyes. A pair of white, columnar reflectors are placed at each side of the model; the one on the same side as the lights is about 3 feet (91 cm) closer to the photographer than its twin.

PROCEDURE

1. Put together your set: a shiny, metallic fabric background, a pedestal for a prop such as this terracotta statue, and a model glamorously dressed in a sparkling outfit with lots of jewelry. Anticipate the outcome in black-and-white—judge the gray tones of all the objects you place in the scene. When working in color, design the colors of the environment carefully and harmoniously.

FIG. 1

FIG. 2

Ⓐ	650 - watt quartz spotlight
Ⓑ	350 - watt diffused spotlight
Ⓒ	150 - watt spotlight
Ⓓ	350 - watt diffused spotlight
S1	Strobe and umbrella
S2	Snooted spot. synched with strobe
✴	Flash
◯	Sun ⌒ Reflector
P	Photographer M Model

2. Turn on the key 650-watt spotlight (A) located about 14 feet (427 cm) from the model, to the photographer's left, and raise it until it casts a fairly even, general illumination all across your set.

3. Turn on the 350-watt diffused fill light (B), which is positioned 3 feet (91 cm) to the left of the main spot. Direct it straight forward so it causes an almost undetectable asymmetry in lighting on the model's face. This helps keep the face three-dimensional in the final photographs.

4. Raise and adjust the aluminized reflector on the pedestal in front of the model. Tighten it so that it remains exactly in the desired position, as the model is not free to hold it.

FIG. 3

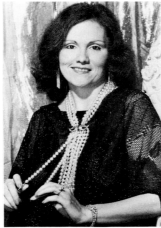

FIG. 4

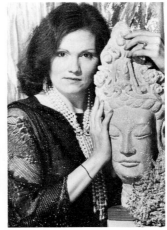

FIG. 5

5. Attach a subtle star filter to your lens. Remember that you are using it for a softening, glowing effect—you don't want large, hot ''stars'' across the image. Check the folds of the fabric in the background and adjust them carefully so that it glows, but does not have large hot spots of light.

6. Now take an exposure reading. An incident light reading from a hand-held meter is more accurate than one from your camera's meter. Raise your tripod to an appropriate height—in this case, at about shoulder level with the model.

7. Coach the model through various poses: relating to the camera, emphasizing the jewelry, emphasizing the contrast of textures, and relating to the statue.

CONCLUSIONS

In Fig. 3 and Fig. 4, the model has adopted two pretty poses. Fig. 3 shows too much background glare at the left. Note how the background has been adjusted in Fig. 3–6. This model has particularly beautiful hands, so the aim was to highlight them without competing with her face. Note how the hands are brightened and flattered by raising them into reflected light. Fig. 3 and Fig. 4 show less than ideal poses for hands—even beautiful hands can look claw-like if poorly posed. Fig. 5 and Fig. 6 are excellent examples a hand model or anyone with beautiful hands would appreciate. Working with a very high, frontal light source creates shadows under the brow, nose, and chin. Notice how well a slight upward tilt of the model's head in Fig. 6 has filled in all of these shadows. Be careful not to raise the head too high, as nostrils are better implied than shown. Fig. 6 is an excellent example of flattering diffusion used to soften the sparkling elements of a lovely and seductive portrait.

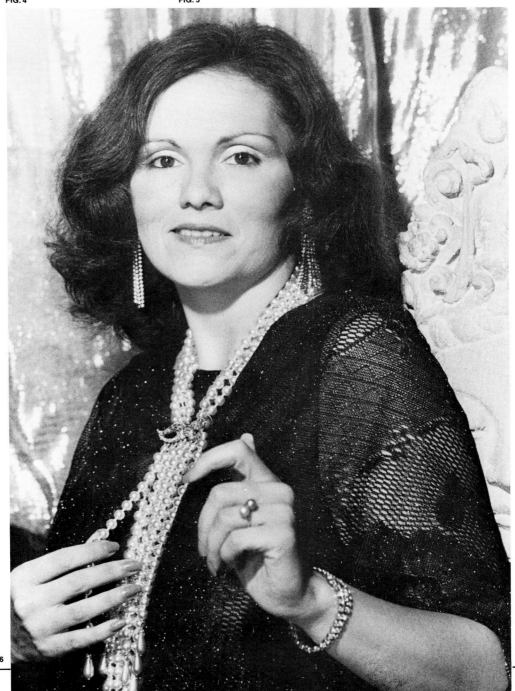

FIG. 6

LIGHTING FOR BACKGROUND SEPARATION

One of an infinite number of variations of backgrounds you can use in the studio is a freestanding panel, spray-painted to give a mottled effect similar to out-of-focus leaves outdoors. This is a demonstration using such a panel, and various techniques to separate a subject from his background through contrast, variation of background, and lighting. It is important, as in any form of picture-taking, to establish an environment in the image consisting of at least a foreground and background.

(Excellent portraits may often also include a middleground, of course.) In portraiture, however, it is desirable to light the subject in such a way that he seems somehow even nearer than the foreground. Photographing a subject against a black background is one way to make the face come forward visually, and the techniques shown here are a less extreme method of achieving good separation from the background, as well as a foreground-background relationship.

EQUIPMENT AND SETUP
Two basic lights are needed for this setup. A key 650-watt quartz light (A) is raised to a height of 7 feet (213 cm) and placed behind the subject, at his left side. This serves both as a hair light and the light that illuminates both subject and background in order to separate them by the edge-lighting it causes of the head and shoulders. A large, 350-watt diffused spot (B) is positioned to the photographer's left to illuminate the entire image. It is lowered so that it bounces a maximum of light onto the face. Position a spray-painted panel behind the model. For this demonstration, the mottling does not extend across the entire background in order to show a range of techniques, but in your session, it could. Since only two lights are used, the metallic, pedestal-mounted reflector in front of the subject becomes an essential element. Direct the diffused spot onto it, and set its position carefully.

PROCEDURE
1. Spray-paint a piece of cardboard or white board to use as a mottled background.

2. Place the 650-watt quartz key light (A) high behind the model, and direct it downward onto his head and shoulders. Check that this gives a crisp outline to his head and shoulders against the mottled background.

3. Turn on the diffused front spot (B), located to your left, raised to just above your head from shoot-

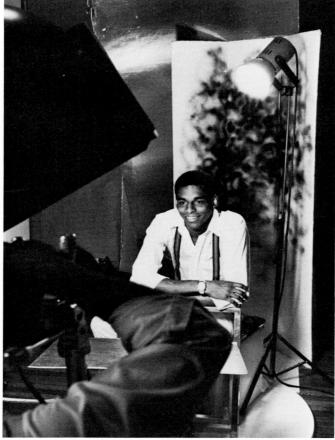

FIG. 1

FIG. 2

ing position. Angle it downward onto a metallic, pedestal-mounted reflector. Test the amount of light it is reflecting by passing your hand in the path of reflected light, and observe the effect it has on the subject's face.

4. To maximize the effectiveness of the reflected light, put a bar in place so the subject can lean forward into the bounced light.

5. Take an exposure reading. When working with anyone with a medium to dark complexion, open up a stop for good facial rendition.

6. Vary the pose during the session and try to maintain the same subject-background separation.

7. Coach the model through the session. Ask him to say "I feel terrific!" to get him to express the dynamic side of his personality.

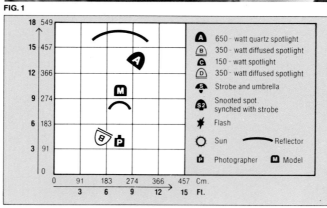

A	650 - watt quartz spotlight
B	350 - watt diffused spotlight
C	150 - watt spotlight
D	350 - watt diffused spotlight
S	Strobe and umbrella
S2	Snooted spot synched with strobe
✴	Flash
☼	Sun
Reflector	
P	Photographer
M	Model

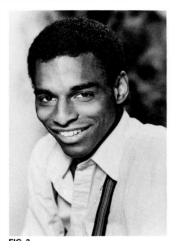

FIG. 3

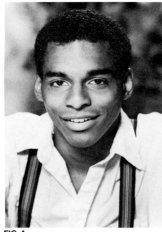

FIG. 4

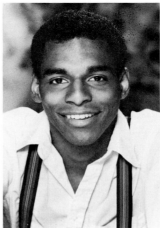

FIG. 5

CONCLUSIONS

Fig. 3 is a good example of a portrait that emphasizes not only the face, but the silhouette of the person as well. Notice how crisp the line of separation is along the shoulders, face, and head. Fig. 4 and Fig. 5 show how low contrast loses subject-background separation. Fig. 6 is the portrait selected at the end of the session. It shows excellent separation from the mottled background, without using the extreme of a halo effect. The face is beautifully illuminated, and all the subject's features are flattered by the lighting arrangement. Take a close look at his eyes; as in many studio portraits, there are two highlights. Some clients don't mind—but some prefer to have the extra one retouched out.

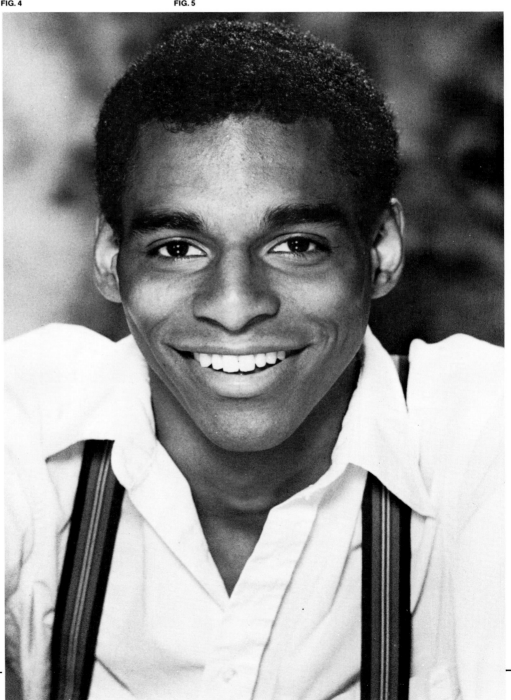

FIG. 6

FLAT STUDIO LIGHTING

Even lighting with a medium overall tone is called *flat* lighting. It can be a useful, or a weak effect to use in portraits, depending on your skill in setting up such an arrangement. It basically involves using many lights and reflectors to maximize direct, diffused, and bounced light on the subject. This is an ideal look to include in a commercial portfolio as a variation on the clean-cut, big-smile look agents want. In this demonstration, the subject wore a striped shirt, which was anticipated as a good graphic element. This is a technique used on tele-vision: even, brilliant lighting and graphically interesting clothing. Imagine what the portraits on the opposite page would be if the subject had been wearing a pale or white shirt, with no bright graphic element added: this would have made a flat, studio lighting setup look uninteresting. The background in this case is an even, gray tone, which is what most commercial headshots use. It works just as well as a portrait to show in the home.

EQUIPMENT AND SETUP

Three studio lights and a number of reflectors are required to achieve the even, overall illumination that will be both "flat" and flattering. Two large, 350-watt diffused spotlights (B) and (D) are used side-by-side in front of the model, and angled both on the subject and the aluminized pedestal-mounted reflector in front of him. The evenness of this lighting setup is achieved by maximizing the intensity of bounced light, so this reflector is a key element. The hair light (C) is fairly high, and positioned on the model's left, just behind his head. Look at the reflector positions in Fig. 1—not only is the pedestal-mounted reflector clearly bouncing a maximum of light, but the model also is holding a white reflector *behind* him to bounce more light up onto the aluminized background. This in turn bounces a great deal of light forward, as it is resting at an angle with its bottom edge closer to the back wall of the studio than its upper edge. This is illustrated in Fig. 2. A white, columnar reflector is at his left, increasing the reflective environment.

PROCEDURE

1. Turn on the two diffused front spotlights (B) and (D), and angle them so they light the subject evenly while a maximum of light is bounced upward off an aluminized reflector mounted on a stand in front of the model.

2. Show the model how to hold the reflector at a good angle if you cannot affix it in the proper position on the stand.

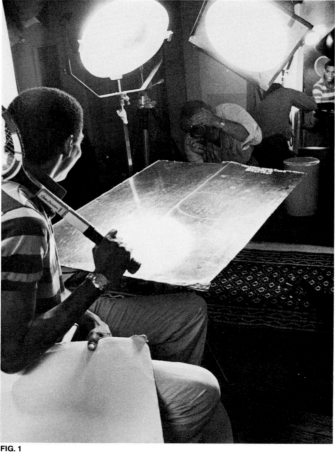

FIG. 1

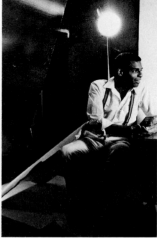

FIG. 2

3. Set up a white, columnar reflector at the model's left, and adjust the angle of the aluminized backdrop so that it shows no hot spots, and will bounce a maximum amount of light off the reflector he holds behind him, and off the floor.

4. Set up the hair light (C), and raise it so that it provides strong but general illumination over the model's left shoulder. It should be high enough so that it will also direct light onto the pedestal-mounted reflector in front of the model.

5. Move your hand in front of the reflective surfaces, to observe their effectiveness.

6. Check your exposure. If your model has a dark complexion, open up a stop for good detail.

7. Coach the model during the shooting. Use props, or have him pretend he's doing a television commercial to get a range of personable, attractive expressions and poses.

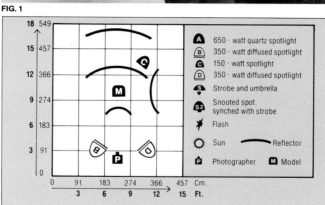

Ⓐ	650 - watt quartz spotlight
Ⓑ	350 - watt diffused spotlight
Ⓒ	150 - watt spotlight
Ⓓ	350 - watt diffused spotlight
Ⓢ	Strobe and umbrella
Ⓢ²	Snooted spot, synched with strobe
✷	Flash
○	Sun ⌒ Reflector
Ⓟ	Photographer Ⓜ Model

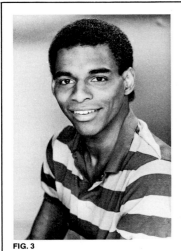

FIG. 3

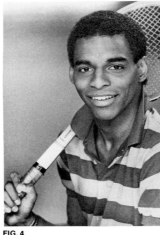

FIG. 4

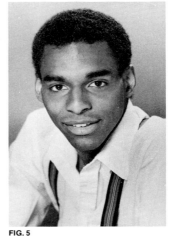

FIG. 5

CONCLUSIONS

Here are four examples of the use of flat lighting. Fig. 3 and Fig. 4 are good portraits, but lack impact because they are too low in contrast. The addition of the tennis racket in Fig. 4 adds a great deal to what the picture expresses, and offers an interesting composition device. Fig. 5 and Fig. 6 are flattering, personable portraits with good lighting, good contrast, and direct eye contact. Either one would be a good addition to a portfolio. Fig. 6 shows the subject as people probably see him in real life—there is a dynamic feeling to the picture that is well stated by the overall lighting and diagonal composition.

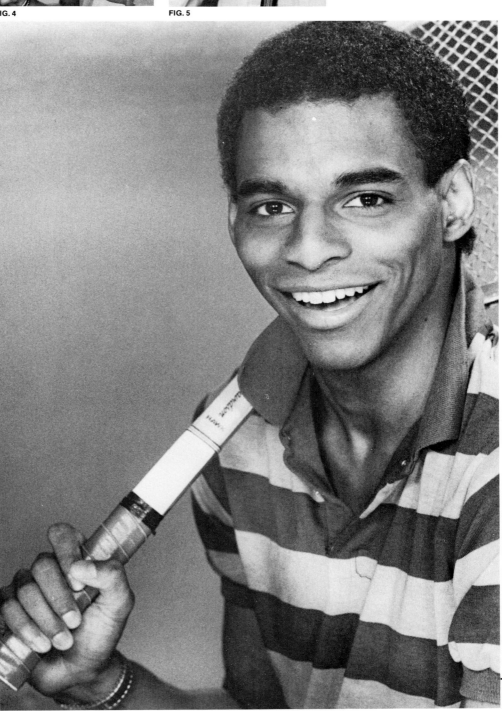

FIG. 6

ROMANTIC, LOW-LEVEL LIGHTING

This truly romantic, low-light setup is a lovely, mood-setting technique that works especially well for portraits of couples. This technique lends itself to the use of props and furniture. For this demonstration, the couple was placed in an imaginary corner of a sophisticated restaurant. After all—what could be more romantic? This technique can be used for a portrait of an actual couple or for a commercial shot, advertising jewelry, crystal, champagne, or even a restaurant. It is important that the models relate well to each other when using this technique. After all—you are trying to re-create a feeling of romance. If you are working with models who have

just met, give them time to relax and get to know each other. The photographer should also be helpful here and act as a director of the scene, giving them suggestions for conversation and posing. Hopefully, the models will be equally creative. Other situations can be created besides a restaurant. With inventiveness, a few props, and a little furniture you can create many scenarios—the corner of a park, a garden, or a cozy living room. The use of low-level lighting enhances any romantic effect. This lighting technique is soft, intimate—and terrific!

EQUIPMENT AND SETUP
To ensure a romantic mood, a 150-watt flood reflector light is used for the main light (C). To give the impression of a cozy restaurant corner, a painted background, plants, and a table were used. The silver lamé tablecloth will act as a built-in reflector. A 650-watt, quartz light (A) is used as a hair and key light, diverted and bounced off the ceiling for a soft fill light. The front fill light (B) is placed to the left of the photographer. It's use is optional. It is important to get an accurate incident light reading because of the low-level of the lights in this setup.

PROCEDURE
1. Turn on the main light (C) and adjust it so that the faces are well lit without too much shadow under their noses. Turn on (B) for fill light.

2. For added light that will also provide very soft backlight for the hair, raise the 650-watt quartz key light (A) up toward the ceiling behind the couple.

3. Take an incident light meter reading, holding the meter directly in front of the couple and pointed directly toward the camera.

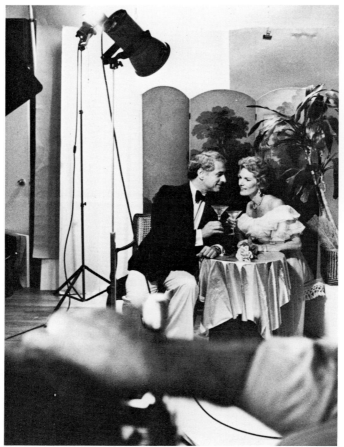

FIG. 1

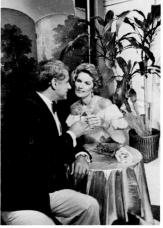

FIG. 2

4. As with backlighting of any kind, make sure there is a substantial shading hood on your lens to prevent any flare.

5. As you view the couple through the lens, keep adjusting the background elements (such as the plants) so that they frame the subjects but don't distract attention from them.

6. Continue to advise the models on the romantic mood you are trying to create, and keep experimenting by moving both the models and the environment for varieties of emotion and mood.

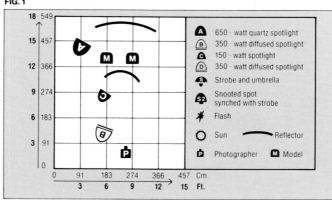

A	650 - watt quartz spotlight
B	350 - watt diffused spotlight
C	150 - watt spotlight
D	350 - watt diffused spotlight
S	Strobe and umbrella
S2	Snooted spot. synched with strobe
✱	Flash
☉	Sun
	Reflector
P	Photographer
M	Model

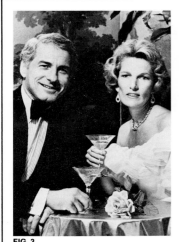

FIG. 3

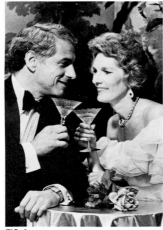

FIG. 4

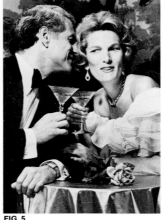

FIG. 5

CONCLUSIONS

In Fig. 3, the couple has established a nice rapport—between themselves, and with the camera and photographer. Only the 150-watt flood light (C) has been used directly here, with the light from the 650-watt quartz light (A) bouncing off the ceiling for a very soft backlight and general added fill light for the entire scene. The models vary their pose and look at each other in Fig. 4. Interesting shadows have been formed on the male model's profile, while his partner is still very well lit by the main light. In Fig. 5 the models have used their imagination to the shot's advantage. Notice that this portrait favors the female model. When working with professional models, always try to have each model featured in an equal number of shots. Fig. 6 is chosen as the best of the series. The models have obviously gotten into the mood, and the shot is alive, as if it were a still from a movie. Both models are in profile, and receive equal emphasis in the portrait. All of the details—the rose on the table, the clothes, the jewelry, and the background—enhance the models to create an overall romantic setting.

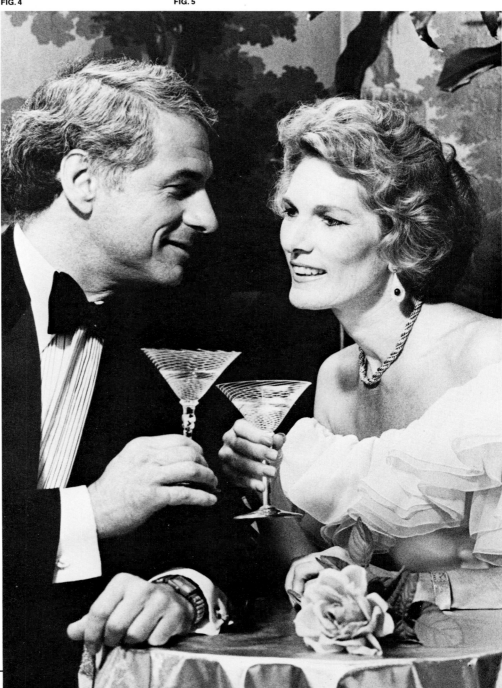

FIG. 6

ROMANTIC LIGHTING WITH HAIR LIGHT

Romantic lighting is soft, low, and on the dark side. It evokes the feeling of a hide-away place for lovers—or even very good friends. For this variation of a lovely lighting technique, add a diffusion filter and, for the feeling of a movie set, a hair light. A couple has been used as the subject for this technique, to emphasize one of the best situations for its use. The hair light, as always, separates the couple from the background. With the diffusion filter or star filter as a complement, the light gives the hair on both the male and the female a soft, but brilliant, sheen and glow. Notice that the hair light also falls forward and onto the crystal champagne glasses, giving them extra light and sparkle—even to the point of adding those extra romantic "stars" to the highlights on the goblets. Even the leaves were sprayed with water to give them extra highlight and sheen. The hair light adds to the overall mood of the picture, while at the same time giving it a more sculptured look. Try this technique with those couples who come to your studio for an anniversary portrait. What a welcome relief these romantic setups are compared with the standard shots of the couple sitting next to each other and smiling into the camera.

EQUIPMENT AND SETUP

To establish a low-light, romantic mood for this setup, a 650-watt quartz key light is used as the main light (A). It is raised to a height of 7 feet (213 cm), and tilted down at a 45-degree angle to fall on the hair of the models. An additional light is now added to the initial setup. A 350-watt diffused frontal fill light (B) is added, but is placed at least 12 feet (366 cm) back from the models, so that it does not dominate the main light. Hair light (C) adds additional brightness to the front of the set, though (A) is actually serving as the light that brightens the hair. The shiny tablecloth adapts itself as a reflector of fill light. For added highlight to the eyes, an assistant tilts a hand-held reflector at a 45-degree angle slightly below the couple's eyes.

PROCEDURE

1. The hair light (C) is placed about 3 feet (91 cm) from the subjects, raised to a height of 4½ feet (137 cm) and tilted toward them at a 45-degree angle.

2. The key light (A) is adjusted behind the couple, raised to a height of 7 feet (213 cm) and tilted down at a 45-degree angle toward the hair of the couple. The light reading is taken from the 650-watt key light, used as (A).

3. The tablecloth acts as a reflector, and the key light (A) provides its own fill light because it is a flood light.

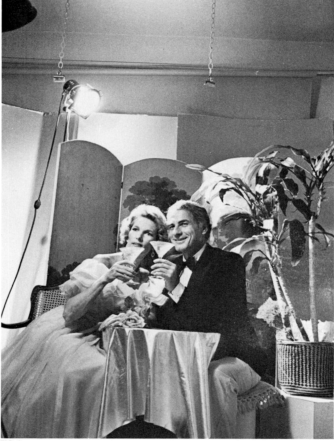

FIG. 1

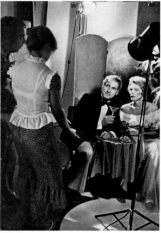

FIG. 2

4. Make sure that the hair of both the male and the female is particularly neat, as the addition of the hair light will show any stray hairs.

5. Use a deep lens shade with such a strong backlight to make sure that there is no flare in your lens.

6. Check the background and take as many shots as you want.

7. Add an extra aluminum reflector (E) just below the subjects' eyes, placed at a distance of about 4 feet (122 cm).

9. Check your meter reading, and bracket your exposures for different effects.

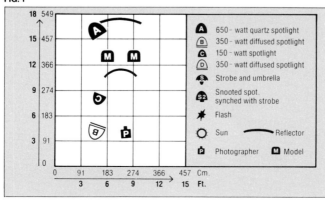

Ⓐ	650-watt quartz spotlight
Ⓑ	350-watt diffused spotlight
Ⓒ	150-watt spotlight
Ⓓ	350-watt diffused spotlight
Ⓢ	Strobe and umbrella
Ⓢ2	Snooted spot. synched with strobe
✳	Flash
☼	Sun ⌒ Reflector
Ⓟ	Photographer Ⓜ Model

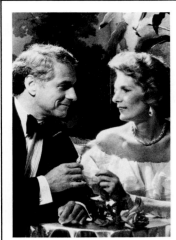

FIG. 3

FIG. 4

FIG. 5

CONCLUSIONS

Notice the specific qualities that the key light has brought to this setup in Fig. 3. It gives glow and verve to the setting, and adds highlights to the hair, the woman's profile, the glasses, and the table. In Fig. 4, the models have changed their pose. They toast the camera more directly, and there is interesting backlighting on both models' hair because of the changed position. The eye contact in this portrait is particularly good. In Fig. 5 there is a return to a more intimate mood. This shot could also serve as an illustration for any number of magazine stories. The subjects are closer together, and the camera is zoomed in tight for more visual impact. In Fig. 6 both models are very relaxed and comfortable with the setting. This shot was picked as the most successful because it captures the mood of the session and is equally flattering to both models.

FIG. 6

HATCHET LIGHTING

Men's faces are characteristically angular and made up of fascinating planes and textures. Lighting arrangements that emphasize this kind of bone structure often produce the most effective portraits of men. On the other hand, lighting setups that suggest softness, curved planes, and glamour are generally the most promising for women's portraits. Though hatchet lighting can be used successfully for women's portraits, it is particularly suited to a male subject who has a strong face. It is important to keep the face straight up and down, and not undermine the masculinity of the picture by tilting the head. Hatchet lighting is a kind of sidelighting that illuminates about 85 percent of the subject's face, and lets one side of the face rest in a fairly heavy shadow. Both eyes must be illuminated well, and a hair light is used to bring out the silhouette and add vitality to the model's hair. This is a classic, timeless style of portrait, which will flatter most men by expressing their masculine nature.

EQUIPMENT AND SETUP

Two lights are used to achieve the hatchet lighting effect: a 350-watt large diffused frontal spotlight (B) placed about 3½ feet (107 cm) from the subject at his right (if that is his better side), and raised slightly above head level. The second light is a direct 650-watt, quartz key light (A), placed just behind his shoulders, about 3 feet (91 cm) to his right, and raised to a height of about 6 feet (183 cm) so that the light highlights his entire side. An aluminized reflector mounted on a stand placed between the subject and the diffused front spot will help fill in shadows and undo any excessive harshness in the sidelighting. A white, columnar reflector placed at his left will help fill in the dark side of his face a bit. A flag was used in front of the high sidelight to avoid flare in the lens.

PROCEDURE

1. Turn on the diffused front spot (B), and direct it onto both 85 percent of the model's face and the aluminized reflector in front of him. Show the model how to tilt this reflector if necessary.

2. Turn on the high, quartz key light (A), and pull a flag into place to reduce flare in your lens. Make sure you can't see the flag in the image area, however. As always, it helps if you hold your left hand extending out from the top of your lens during a session that involves lights high in the background area to keep stray light from entering the lens.

3. Move a freestanding, columnar reflector in toward the model's side opposite the sidelight. This will help bounce some light back in so that side doesn't fall into detail-free shadow.

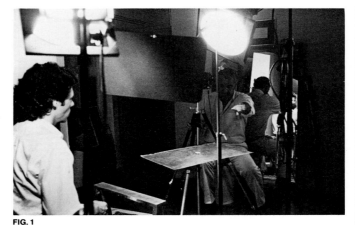

FIG. 1

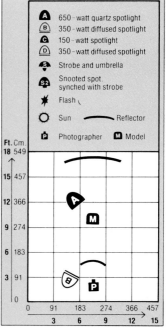

A	650 - watt quartz spotlight
B	350 - watt diffused spotlight
C	150 - watt spotlight
D	350 - watt diffused spotlight
S	Strobe and umbrella
S2	Snooted spot. synched with strobe
✳	Flash
☉	Sun ⌒ Reflector
P	Photographer **M** Model

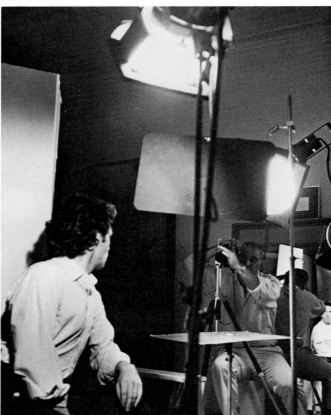

FIG. 2

4. Take an exposure reading and check the background. It will probably be evenly graded from light to dark from one side to the other—an attractive effect thanks to the strong sidelight. Change the angle of your backdrop if you feel it will improve the background and its separation from the subject.

5. Ask your model to clench his teeth slightly to emphasize the facial structure. This is a professional technique top models use to emphasize the planes and muscles of their faces.

6. Coach the model through the session, varying the pose and framing as desired.

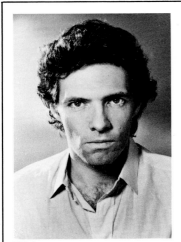

FIG. 3

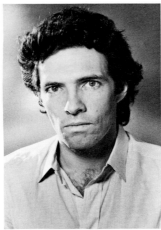

FIG. 4

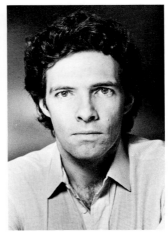

FIG. 5

CONCLUSIONS

The four portraits on this page show a range of variations of hatchet lighting, any of which might flatter your subject to best advantage. Fig. 3 does not give the full, three-dimensional look desired from this session. Fig. 4 is well lighted, and has a strong highlight along his right cheek, but in fact, it is inconsistent with the even 85 percent lighting that hatchet lighting aims to achieve. Fig. 4 also illustrates why a straight up and down angle aids in establishing masculinity in a man's portrait. Though this remains a good-looking portrait, it is not as strong as Fig. 3, Fig. 5, or Fig. 6. The angle of the nose also has an unnecessary hot spot of sidelight along the right side of the model's nose. Fig. 5 and Fig. 6 are good examples of hatchet lighting, well filled in by light bouncing upward from the reflector. The handsome planes of the man's face are drawn out by the lighting in a totally flattering way, and a slight lowering of the chin brings his eyes into good contact with the camera for an excellent portrait.

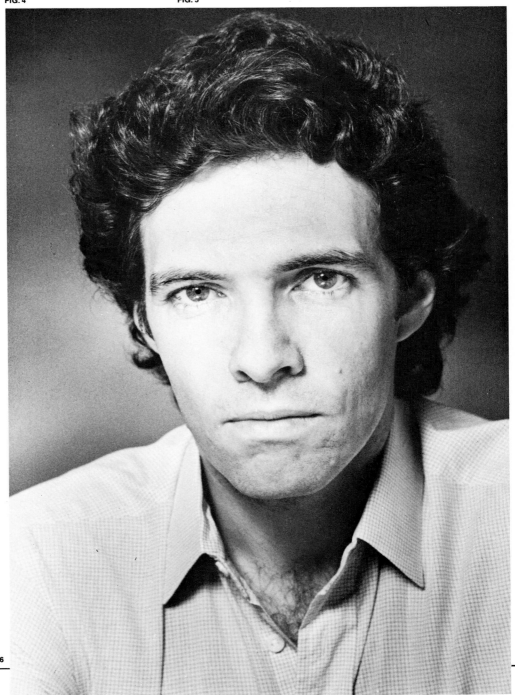

FIG. 6

"CLINT EASTWOOD" LIGHTING

"Clint Eastwood" lighting is a striking form of side-lighting that is most often used in pictures of that star as it brings out the unusual and masculine planes of his face and jaw to their best advantage. As you will see in this demonstration, sidelighting is not only something a photographer uses on the side of a subject's face—it can also create dramatic profiles that could emphasize a strong brow or handsome nose. When you are considering which techniques would flatter a male subject most, look carefully at the subject and in your mind's eye visualize what this technique could do for that subject. This is a strong, effective lighting technique that can highlight the best in a man's face from various angles. It is a simple technique involving two basic lights and a simple backdrop, and can be used in many environments as well as the studio. Because of its simplicity and effectiveness, keep it in mind for executive portraits and other commercial uses.

EQUIPMENT AND SETUP
Fig. 1 shows the 650-watt quartz key light (A) just above the model's head, placed so that it causes a strong highlight along the side of the brow and jaw. This same light will also separate that side of the model's body from the background with its strong illumination. A diffused front spotlight (B) is the only other light used for this technique. It is placed to the photographer's left, and in front of his shooting position. It is directed largely toward the highlighted side of the face. Much of its light will bounce off the pedestal-mounted reflector, but don't overdo the bounced lighting in this case, as it will weaken the powerful side-lighting effect. A white, columnar reflector placed at the subject's left will fill in the dark side of his face sufficiently. The backdrop used for this session is an aluminized sheet, selected so that it will provide a range of good gray tones.

PROCEDURE
1. Set up the key light (A), placed slightly behind the model, but directed at one side of his body. Make sure the highlighting brings out one side of his face, from brow to jaw, and extends about one-quarter of the width of his face at mouth level.

2. Add the diffused front spot (B), and find a position where it adds to the sidelighting effect, while filling in the opposite side of the face just enough for good detail without highlights.

3. Position the pedestal-mounted reflector and, if necessary, show the subject how to hold it at the right angle for bounced light. One of the challenges of this setup is to

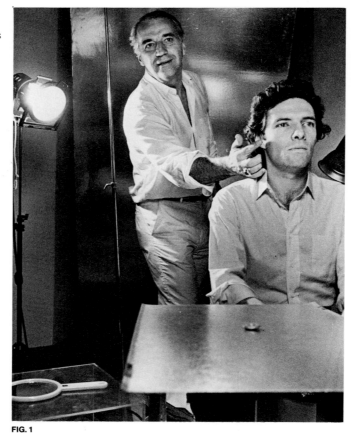
FIG. 1

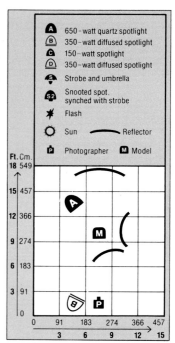

	650-watt quartz spotlight
A	
B	350-watt diffused spotlight
C	150-watt spotlight
D	350-watt diffused spotlight
S	Strobe and umbrella
S2	Snooted spot, synched with strobe
✳	Flash
☼	Sun ⌒ Reflector
P	Photographer M Model

keep equal emphasis on each eye, despite the inequity in lighting of the sides of the face. It is the reflector that evens out the brightening of the eyes and adds a three-dimensional feeling to the portraits.

4. Pull a flag into position in front of the sidelight so that you will not have flare in your lens.

5. Take an exposure reading. Check your background before shooting.

6. Coach the model through a number of sessions. You might ask him to clench his teeth to bring out the strength of his features, and ask him to turn so that you can use the strong sidelight for profile, three-quarter, and frontal views.

FIG. 2

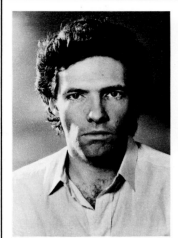
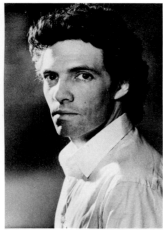

FIG. 3

FIG. 4

FIG. 5

CONCLUSIONS
Many striking portraits can be made with this technique. Compare the effect of strong side-lighting on the model in the examples shown here. Fig. 3 shows a straightforward, frontal view, with that characteristic "Clint Eastwood" lighting effect. Fig. 4 shows a three-quarter view with yet another eye-catching effect caused by the lighting setup. Fig. 5 is a classic profile shot given flair with the strong sidelighting, and Fig. 6 is the shot selected as best at the end of the session. Fig. 6 shows a well-modeled face, with good eye contact, a full, three-dimensional look, and very effective use of "Clint Eastwood" sidelighting. Keep these variations in mind— they only require moving the model once the lighting setup is done, and the results can surpass your expectations.

FIG. 6

ONE LIGHT TECHNIQUES

One of the best ways to learn exactly what effects can be produced by studio lights is to work with only one light, searching out as many portrait styles as possible. Some of the results can be quite striking, as the strong shadows left unfilled with the use of a single light can carve dramatic portraits, many of which are best suited to men's faces. You will learn in this demonstration that good control of a single spotlight can produce images as eloquent in their shadows as in their highlighted detail. This is also a good way to learn about the planes of the face: how to emphasize a particular kind of bone structure; enhance the strength men's faces have due to their naturally angular bone structure; and use shadows as compositional elements. Though most portrait lighting setups make an effort to fill in strong shadows, this is a technique that aims to use shadows and black areas as important pictorial space. This attitude toward shadows is often called "using negative space," and can be an important lesson in learning to "see" portraiture.

EQUIPMENT AND SETUP

One 650-watt quartz light (A) is sufficient for the range of one-light techniques shown on these four pages. From the photographer's point of view, this light is positioned in six steps along an imaginary semicircle extending from the model's right around to his left. Study the changing light positions and tone of the background in Fig. 1, Fig. 2, and Fig. 3. No tripod was used to allow the photographer more mobility throughout the shooting. The set involved two aluminized sheets. One is on the floor, and is covered by a "reflector," which is actually a metallic tanning blanket purchased in a supermarket. Just as it bounces more light onto your body at the beach, it aids in bouncing light in the studio! (Sometimes the most ingenious solutions are the best for lighting needs. In portraiture, found items can often accomplish as much as an expensive item of equipment—though not always.) The second aluminized board is resting on its long side on the floor, behind the model. This 90-degree arrangement of reflective surfaces re-creates the beach, with its bouncing light from a single light source (the sun).

FIG. 1

	650 - watt quartz spotlight
A	650 - watt quartz spotlight
B	350 - watt diffused spotlight
C	150 - watt spotlight
D	350 - watt diffused spotlight
S	Strobe and umbrella
S2	Snooted spot. synched with strobe
	Flash
	Sun — Reflector
	Photographer — Model

PROCEDURE

1. Build your reflective set, covering the floor and wall behind the model with aluminized materials.

2. Anticipate the movements of your light. Make sure the studio is free of obstructions so you can move the light, and yourself, without difficulty.

3. Put your spotlight (A) in its initial position, at the left of the arc in front of the model, and turn it on. As you will not have a spotlight facing you, no flag is necessary for this setup.

4. Work with your model on a variety of poses. Determine which is his best side. Keep the poses low—sitting, reclining—so the upper edge of the set doesn't show.

5. Take an exposure reading periodically throughout the session.

FIG. 2

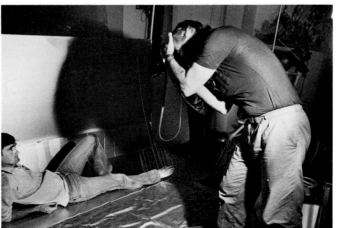

FIG. 3

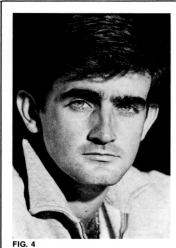

FIG. 4

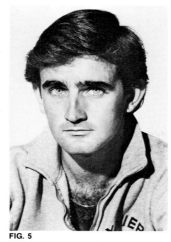

FIG. 5

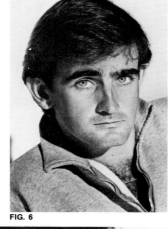

FIG. 6

CONCLUSIONS

Fig. 4 shows a face against a deep black background. This is an unusually strong portrait effect that makes the individual seem closer to you than he would if the background were less dark. This was done by turning the model so his back was to a totally unlit part of the studio, which went completely dark in the shot. Fig. 5 and Fig. 6 show strong facial modeling with 90-degree lighting from either side, arrived at by changing the model's sitting position slightly. In both Fig. 5 and Fig. 6 the background has a bright, luminous tone, as the light is directed straight onto it. This gives terrific subject-background separation. Fig. 7 is the preferred shot from this session. The background is luminous, and by contrast, the figure is lit in a moderate range that is quite effective for the strong planes and textures of this man's face. The pose is interesting, looks comfortable, and the overall composition of the picture is contemporary. This is an excellent result from a single-light setup.

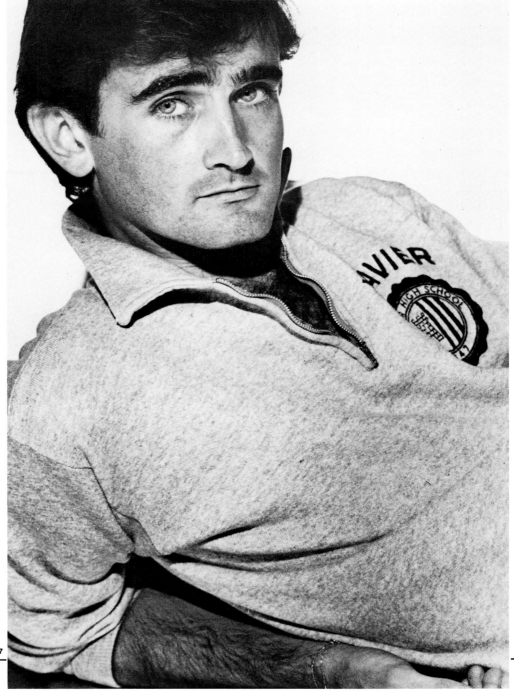

FIG. 7

ONE LIGHT TECHNIQUES

Have you ever tried looking at only one side of your face for a long time in a mirror—and then switched to study the other side? Though we are rarely aware of it, each side of a face is a separate entity, and faces are far from symmetrical. Working with a single light particularly expresses the differences in each side of a person's face, and for this reason, can show the person in a wide range of "looks." In this demonstration, the single spotlight continues to move through three more positions of the imaginary arc in front of the subject—this time, through three points on the right side of the arc from the photographer's point of view. It immediately becomes obvious that these photographs are not merely the mirror images of the previous portraits. This is in part because the light positions are not at exactly identical mirror points on the arc, and because this side of the model's face is quite different from the side emphasized on the previous spread.

EQUIPMENT AND SETUP

The same set and light (A) are used as on the preceding spread, and the model uses the same reclining and cross-legged seated poses he adopted before. Take a close look at the setups shown in Fig. 1, Fig. 2, and Fig. 3 on this page, and observe how not only the angle of the light to the subject, but also its height changes. Notice how moving the light changes the tone of the reflective background.

FIG. 1

Ⓐ	650 - watt quartz spotlight
Ⓑ	350 - watt diffused spotlight
Ⓒ	150 - watt spotlight
Ⓓ	350 - watt diffused spotlight
Ⓢ	Strobe and umbrella
Ⓢ2	Snooted spot, synched with strobe
✳	Flash
☼	Sun ⸺ Reflector
Ⓟ	Photographer Ⓜ Model

PROCEDURE

1. Practice your lighting arrangement after placing your model on the set. Move your light (A) to the anticipated positions, and raise it and lower it while studying the effects it causes on the subject's face and on the background.

2. Vary your position as well—move in close for a headshot; move far back for a three-quarter shot. Try variations in framing the subject in each successive lighting situation.

3. Make sure that the eyes are adequately lit. Ask the subject to lean into reflected light when necessary, to erase dark shadows in the eye area. While most shadows can be pictorially effective in men's portraits, good eye contact is still the secret to an effective shot.

FIG. 2

FIG. 3

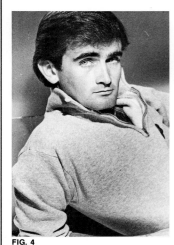

FIG. 4

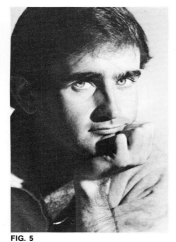

FIG. 5

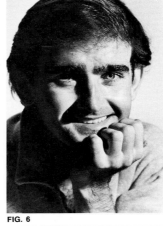

FIG. 6

CONCLUSIONS

Compare Fig. 4 to the final shot on page 123. This is the same pose, but moving the light further to the right side from the photographer's point of view renders the subject brighter and the background darker. The light positions for this series were lower than those shown on the previous two pages. This illuminates the background less, as the light is directed squarely on the subject rather than onto the background. Fig. 5 shows a portrait that has nearly 30 percent of the subject in complete shadow. This emphasizes part of his face that a multi-light setup wouldn't have. Notice how heavy the shadow to the left of the nose is, and how it seems to link as a graphic unit with the eyebrow on that side. This kind of chiaroscuro effect may not suit all subjects, but it works for this one. Fig. 6 shows stark, almost Rembrandt lighting—a striking trapezium of brightness is apparent on the left cheek as you look at the portrait, and the other side of the face is fairly well illuminated. This often works well with men's angular faces, but probably would not be attractive or flattering for a woman's portrait. Fig. 7 is a strong, flattering portrait created with skillful lighting from a single studio light. The technique matches the forceful expression on the subject's face, the eye contact is good, and even though the subject is not smiling, there is an unmistakable directness about this portrait.

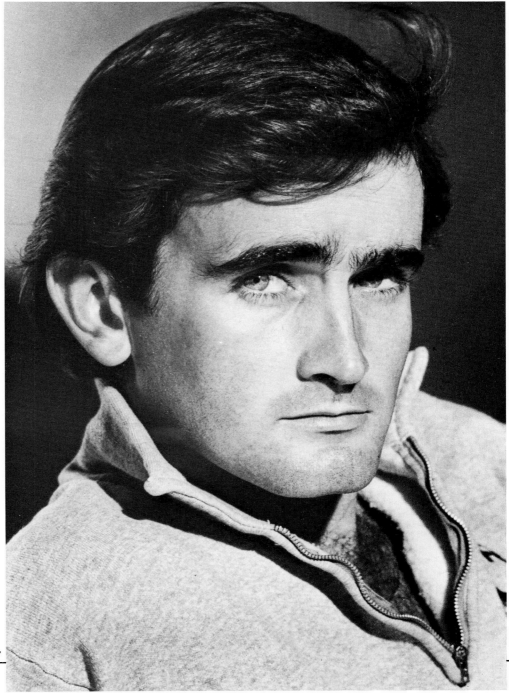

FIG. 7

THE PROFESSIONAL SIDE OF PORTRAIT PHOTOGRAPHY

STARTING OUT AS A PROFESSIONAL PORTRAIT PHOTOGRAPHER

Portraiture is the kind of professional photography that can be full-time or part-time; fortunately, your business can be launched with a minimum of investment in equipment and studio space. If you're looking at portraiture as a career opportunity, remember that compared to many other businesses you can start out small and, with high-quality work, build up a substantial business in a short period of time. Starting out is a difficult time, but if you begin with a willingness to spend some time finding clients, and if your skills are good, in time you will find a group of clients, and you will succeed. There is always room for a good photographer. Search out a group of clients, especially those who need portraits periodically for their professions, and you'll have made a terrific start on a satisfying career as a portrait photographer. Here is what I most often tell beginning professionals who ask me how they can start putting their portrait skills to use without investing a fortune in a complete studio.

STARTING OUT SMALL

What kind of equipment do I need to start out?

Three basic lights with 150-watt floods will do for basic lighting, or start shooting outside, with one white reflector. A professional 35mm camera with a 105mm portrait lens, a few reflectors, and you've got it! As you become more successful you can add to your equipment. For instance, when you're out on an assignment you've got to have a back-up camera—and extra film, pre-loaded in the second camera.

Why do you use a 105mm lens?

For its good image size at a comfortable working distance. I'm not concerned about how fast my lens is. I generally aim to have a sharp shot at f/5.6. That's sufficient—you don't want to see every pore in a portrait. When we see people, they're usually sitting across a table or across a room from us. We're not ordinarily nose to nose with people, studying their skin structure. Sure, a portrait has to be sharp, but not sharper than our average view of a person in real life. F/5.6 and f/8 are sharp enough for portraiture, and particularly with the 105mm, the background automatically blurs out, which is important because you never want a distracting background in portraiture.

Can I do portrait photography without a studio?

Once again, you've got the whole outdoors for your studio. Use it—use the shaded light of a porch, and reflectors—but never use direct sunlight. Use the sun only as backlighting, unless you're doing fashion shots. I'm partial to shaded light cast by a large tree, where the subject stands in the shade and is facing into the sun source. It's a soft and flattering lighting situation.

How much space do I need to have a studio?

Considering a face takes up very little room, a huge studio is not needed—just adequate space for your subject, lights, and you. Work outside, work in the basement. Learn the basics of natural light, as this is the foundation of indoor lighting. A front porch, the shaded area of a sunlit building, or any brightly lit, white room is adequate. I know one photographer who simply seats his subjects next to a window in front of his desk.

Do I need a staff, or is it possible to start out working alone?

If you have a friend or relative who wants to volunteer some time, fine. But realistically in the beginning you'll have the time to go it alone. If you're married and the wife or husband isn't working, that's perfect. If not, the local unemployment office is always there. I was in business for several years before I hired an assistant.

Should I do my own darkroom work?

In the beginning, yes. You can always buy used equipment to save money. Later on when you get too busy—pay someone else. Again, insist on the very best quality, either from yourself or whomever you may hire. You're going to take great photos, and the processing has to match it.

Can I start a business just doing black-and-white portraits?

Probably. Most clients only need a black-and-white portrait for the newspaper or publicity. However, color shots seem to be preferred for the home. If you show fabulous black-and-white work, they'll probably want some color portraits, too. Starting out with black-and-white, however, is certainly adequate. It goes without saying that if you're going to do weddings and such, color is essential.

Is it better if I start my studio in my own vicinity, or do I have to go to a big town?

How much money have you saved for a long haul? Make it local first, then get really ambitious. Compare money-making opportunities—big fish in small pond, or small fish in a big pond. Unless, perhaps, you have a contact at a magazine or newspaper or you have submitted a portfolio and they have hired you. Better to get hired by a big studio in a big town, then wait to open your own. I started out in New York. If you've saved enough money, you're covered while you find your place in the city. If I were just out of college, I'd start in a big, busy place. That's where the clients are—particularly commercial clients such as actors, actresses, and models who constantly need portraits for their portfolios. It's true, though, that in portraiture, you can find people who need pictures everywhere.

ESTABLISHING YOUR CREDIBILITY AS A PORTRAIT PHOTOGRAPHER

Do I need special credentials to be a portrait photographer?

No. A portfolio is all you need; your reputation will spread by word of mouth. A degree is not necessary, really. I'm assuming that the talent is there, and that you've studied and prepared yourself and gotten enough experience to go ahead.

What can a portfolio do for you to provide tangible credentials?

If you're going to see ad agency people, editors, or any other kind of picture buyer, you've got to have a portfolio. You can use friends and relatives to build a portfolio. It all depends on what kind of work you're looking for. Make sure you show pictures that prove you can do that kind of work. Your portfolio should carry no more

than 18–20 shots. Most people have a tendency to overdo their portfolios, and drag in everything they ever photographed. You have to edit your portfolio dramatically, so that there is contrast and each picture has impact. You need to sequence it: headshot, medium shot, full-length shot, then repeat the process. Don't put shots similar in scale or any other quality next to each other. Use indoors, then outdoors; vary your lighting techniques—showing 20 different lighting setups would prove without a doubt what kind of work you can do. For ad agencies, show color. Black-and-white is good to show newspaper editors and acting clients. When you're showing your portfolio, you're like a salesman selling his wares. He has catalogs to show what the company produces, and you, too, have to have a well-prepared sales kit— that's your portfolio.

Is it a good idea to keep a gallery of recent portraits on display so I can discuss such things as lighting, style, composition with new clients?

Naturally. It goes without saying that you should keep a neat, attractively lit gallery of your best work. If there's a local or national celebrity in your collection, keep his photo on the wall. Clients will be impressed that they are working with a photographer who photographed "so and so." I prefer a gallery of my best work to a portfolio. For one thing, you can put more pictures up and they are more easily seen.

Do I have to hire professional models to do my starting portfolio?

No. Use anyone who is willing to pose. But again, I stress the professional approach. Don't just toss off a shot because it's Aunt Mimi and not Brooke Shields.

How can I make a lot of money doing portraits?

Hustle that portfolio around, or hire a rep to do it for you. He or she can take it around for you to local advertising agencies and businesses. Advertise, build up your reputation—go, go, go.

Do I need business cards and stationery?

To make a professional impression, of course. You want to create that "pro" image right from the start. I suggest that you have one of your photos put on your card. It makes for a double selling point in that they can see your work at the same time that they're looking at your name and address.

Is it possible to do part-time portrait photography and also work at other things?

Of course. As a matter of fact, it's advisable. You're learning before you take the big leap. How about an evening job, while you get things rolling at the studio during the day? Then there's the possibility of doing your portrait work in the evening, although you'll be missing that marvelous daylight.

Should I apprentice in a portrait studio before starting a business of my own, or can I learn enough through courses and books to skip the apprenticeship stage?

Apprenticeship is ideal, although I didn't do it. I felt secure enough with a portrait background to go ahead. Camera technique has to be mastered, however, and if there is a local studio in your area, I would certainly inquire about apprenticing. In a larger city there will certainly be more opportunities. It *is* the ideal way to learn the photography business.

FINDING YOUR FIRST CLIENTS

How do I find clients?

Place ads in your local paper. Use friends and relatives to build up a portfolio (even local politicians and businessmen are happy to pose for a picture in return). Tell them you're planning to set up a studio in town and want to put pictures in the window—this will attract people to your window. Get out and meet people, join clubs, visit local galleries, and tell them you're interested in exhibiting your work. Soon you will be taken seriously because you're serious about your talent.

How can I show people my work?

Exhibit in your studio window, take your portfolio around to local people and businessmen. Try to find local exhibition space in a bank, railway station, stores, county fair, etc. Local frame shops and photography shops are good too. Advertise in the local paper. Have a nicely designed card with one of your best photos on it. Pass it out everywhere, and to everyone.

Who needs portraits in a small town?

Local theater groups, high schools, stores, beginning models, store models, local businesses, high school bands, clubs, social functions, church groups, fairs, parades, newspapers—the list is endless. Most people like to stand out from the crowd with their own individual portraits.

What other opportunities are there for portraits and pictures of people that could increase my income?

Greeting cards, local newspapers, agencies that deal in general, outdoor subject matter, particularly (for the greeting card people) what

we call boy-girl shots. That is, walking hand-in-hand through the park, running toward each other in a field, or gazing into each other's eyes.

What keeps clients coming back?

Good work. As in any enterprise, you've got the pressure and the expectation to consistently turn out top work. If that is your goal and your standard, clients will not only come back, they'll bring new clients in as well.

HOW TO CHARGE FOR YOUR FIRST PORTRAIT SALES

How much should I charge when I start?

Very little, but make sure you recover your film, paper, and processing costs. Try to undercut local competition slightly. Once you find out what the others are doing, you can pretty well judge where you should be in terms of price. Don't go overboard at the start and charge exorbitant fees.

When do I start to raise my prices?

When you become as successful as the other guys in town, and your work starts to be in as much demand as theirs. Hopefully you'll be better than competition and can charge more than they do.

SUPPLEMENTARY SOURCES FOR LEARNING ABOUT LIGHTING

What can you learn from studying the old masters of painting?

Even though photographers have tried very hard to separate themselves from painters, it doesn't mean that you can't learn from studying their—or anybody's—lighting techniques.

What's different in terms of lighting for painting and lighting for photography?

It's pretty much the same. We're still using Rembrandt lighting. If you look at the Mona Lisa from the point of view of a contemporary photographer, she's well lit, with straight-on light and no shadows. Most great portraits of women in general do not have dark shadows on the face. The portraits show a luminescent glow on the skin. Goya, Gainsborough—all the great painters used that soft glow about the face. Latour used a one-candle source, but that was still a soft effect. In painted portraits of men you see a tendency toward more strength through contrast and more texture. The lighting concepts are the same in painted and photographed portraiture.

Can you learn about lighting from television or movies?

You can study how the newscasters are lighted on the major networks—very much like in the portraits in this book, they are well backlit, the spotlight is on them, the hair is lit, and there is reflected light for shadow fill. You can see what kind of lighting they use in commercials, and notice how they match indoor and outdoor lighting for spots using various locations. You can learn by watching. Best of all, watch old films—they spent time lighting the films and achieved beautiful effects. In particular, watch James Ward Howe movies—he worked as recently as *Hud* in the 60s. The photographer for *Citizen Kane* was Gregg Toland, and it was beautifully lighted. Watch any Katherine Hepburn movie—she always demands good lighting. Another good way to study lighting is to take time to analyze the lighting in good magazine illustrations. Becoming a good photographer is a matter of training the eye to see. Don't take all the lighting illustrations around you for granted—you can learn from them.

Are there any other books you would recommend to a beginning portrait photographer?

Any and all art history books—paying particular attention to portraits by Rembrandt, Titian, Velasquez, Goya, Degas, and *early* Picasso. Photo books on Steiglitz, Cecil Beaton, Avedon, and Weston. Amphoto offers many good titles. In particular, *Technique of Photographic Lighting* by Norm Kerr is quite good. See the Time-Life series on photography for technical expertise. Kodak has a wide range of technical books available, although their portrait sections seem a bit bland. The trick is to acquaint yourself with the top quality work that history has distilled for us, be it painting or photography.

PROFESSIONAL ASSOCIATIONS AND JOURNALS

Are there any professional associations I ought to join?

Belonging to professional associations does help. It can introduce you to others in your field and it gives you impressive credentials to put on your wall. Many clients are impressed by sheer credentials as well as your pictures. Professional Photographers of America is a good group to join. Of course, you ought to investigate ASMP (American Society of Magazine Photographers) if you're doing portraits for editorial work.

Are there any specialized journals or publications a portrait photographer ought to read to stay on top of things?

Yes. Get a subscription to at least one good photography magazine. Frequently look in bookstores and buy a few photography books. Taking the time to read about the latest in the photographic world will keep your ideas fresh.

THE BUSINESS SIDE OF PORTRAIT PHOTOGRAPHY

It takes more than picture-taking skills to turn portraiture into a long-term business. Like any business, there are decisions to be made about how much to invest, insurance, whether to hire a staff or not, how to comply with sales tax and employment regulations, how large a studio space to rent or buy, and many other important considerations. In this section, you will learn the answers to the questions I am most often asked by students and colleagues about the secrets of my studio's success.

REGISTERING AS A BUSINESS AND AN EMPLOYER

Should I incorporate to start a portrait business?

Not if you don't want to make out income tax forms every quarter. Wait until your financial situation becomes as serious as you are. Get the advice of a good accountant on every financial move. You should register with your local authorities if you're beginning a business. A call to your local municipal offices will direct you to the person with the answers you need.

If my business starts to pick up and I hire someone to help me, can I just pay this person as a free lancer, or do I have to become a formal employer and pay Social Security and such things?

You can pay the person as a free lancer. Just make sure that they don't go over the required number of hours that qualifies them as a free lancer. Check with your local Social Security office, unemployment office, or the U.S. Department of Labor.

ACCOUNTING AND RECORD KEEPING

Do I need an accountant if I start a small new business?

As soon as you get to the point where taxes are involved, advice is always helpful. You can always pay a visit to your local tax office and find out exactly what's expected of you at any stage of your business activities.

Should I charge sales tax on portraits?

This varies in different areas. Check with the local tax people. After all, you don't want to get stuck at the end of the year owing the sales tax you should have charged.

What kind of business records do I have to keep?

The government prefers to look at everything. Simple accounting record books can be purchased at any local stationery shop. It can be trying to come to the end of a business year and have to swim through a sea of billings and receipts, so it's better to regularly maintain business records.

What filing system do you recommend for negatives?

I recommend the system my lab uses. When I take the film in, each roll is marked with the name of the client in grease pencil. I send along a 3x5 card with the name and date, which will remain with the contact sheet. The card is to record payments for reprints purchased from the lab. The lab numbers the roll of film with a sticker. That same number and the subject's name are written on the back of the contact sheet. My assistant keeps a note in his schedule book of the client's names and the dates of sessions. His job is to keep an in-office list of all pertinent information. The negatives are filed in boxes at the lab according to the date of the session and the file number. If you do your own darkroom work, number your negatives, and make sure that number goes on your slides. Keep the file number consistent. This is very important—if a client needs reprints of some pictures very quickly, you have to be able to get your hands on the negatives or original slides (unless the client has taken the slides). Re-orders are frequent in a good portrait business, so a good, workable file system is very important.

What is the best method for storing negatives and transparencies?

Visit your local photo shop. There is a wide selection of negative sleeves and slide sheets available for filing and storing your work. It goes without saying that you will want to keep your black-and-white negatives in protective sleeves that will keep them from getting scratched and dusty. Your color slides deserve the same consideration.

LAUNCHING A STUDIO ON A SHOESTRING

Should I borrow money to start my business, or should I wait until I've saved enough to get it going and avoid a bank loan?

Try to save enough first at your current job. It's amazing how much we can save if we are sacrificing for a goal that's very important to us. Big business exists on borrowed money and many small businesses started that way. Just keep in mind that whatever is borrowed has to be paid back. Are you going to get that many clients in the beginning who are going to help you pay back what you have borrowed? Discuss any borrowing transactions with an accountant or, naturally, with your local bank. They'll let you know how practical your situation is.

I can't afford to hire anyone to run my studio. Is it all right to buy an answering machine to make sure I know of clients' calls?

Sure. That's a professional solution. Just make sure you return your calls the same day. If you delay in returning their calls, they'll impatiently call someone else.

Should I buying my film and paper in large quantities to save money?

Yes. Buying in bulk is always cheaper, although when I started out I could only afford five or six rolls at a time. Twenty rolls in a plastic cover intimidated me. If you do buy your supplies in large quantities, store them in a refrigerator. A note of caution: buy a *reasonable* stock, but not so much that it could become out of date.

How much money should I invest in equipment to start a studio?

How much have you got to spend? $3,000 or $4,000 would be nice, if you've saved that much. If not, buy good used equipment, get inexpensive lights—you can bring a workable studio in for under $1,000. No business is started with absolutely nothing and sacrifices must be made to get the best professional equipment at the best possible price. Shop around, don't buy on impulse, check local sales—always try to get the best for your money.

How much equipment do I need to start a studio?

Three basic lights—one key light, one hair light, one fill light—and don't forget reflectors for shadow fill. One camera body, a 50mm and a 105mm portrait lens and you're covered. As we said, you can add to your equipment as you go along. Two camera bodies should be considered, as you'll need one for back-up. Try to visit other studios first to see what they've got. Shop photo supply showrooms. It will soon become obvious what you can start with and that you can keep it simple.

Should I buy painted backgrounds and props when I start?

Painted backgrounds can look very phony if you don't use them correctly. A roll of seamless paper is just fine. Keep props to a minimum—a pen for an executive, a baseball for a young boy, etc. Don't let props or backgrounds dominate the shot. In Victorian times, painted backdrops were very popular and they were used up until recently. Backdrops, ideally, should look like out-of-focus outdoor scenes, if anything. They should never distract from the subject of the portrait.

Should I use various camera formats, or is 35mm pretty much standard for portraiture?

Use 35mm as your standard. Later on, for product or individual photographs, buy a 2¼-square format. Build as you go along or as the need arises. Becoming familiar with all types of cameras, lenses, and lights is the sign of a true professional. Also, it's fun to learn and add to your store of knowledge. But keep in mind that you don't absolutely need every bit of equipment in the camera store in order to start out.

Can I start a portrait business using only strobe light, or is it absolutely necessary to have three lights and reflectors?

Start with what you can afford. Even the great painters learned to draw first. I recommend learning the basics first with spotlights—it's how they still light movie sets, TV sets, and commercials. *If* you want to stay with it, fine. However, to start with a one-strobe setup is to miss one of the rewarding aspects of portrait photography—lighting the subject creatively.

How long does it take to become established and have a regular clientele?

Several years. Let's face it, nothing happens overnight.

How long will it take for a new portrait studio to start making money?

Give it a year or two—remember, the more serious you are, the more you're going to "hustle" your work.

HOW TO DEAL WITH THE COMPETITION

Is it possible to set up a high-quality business and still make a living? How can I compete with better-established portrait studios, or chain-type, low-cost portrait studios?

In answer to the first question, yes. People with money to spend will always demand quality work. The phrase "you get what you pay for" applies to quality photographs as well. Anyone can take a Polaroid. You'll compete with the better studios because you're going to be as good, if not better, than they are. Quality will always search for quality.

Should I specialize, or do just one kind of portrait, such as headshots for models or executive portraits?

It would be nice to develop a specialty from the start, but in the beginning, take any business you can. Have you saved enough money to specialize? I think that it would be terrific to open a smart-looking studio in a chic part of town and handle only beautiful clients who are willing to pay my high price. But, unless you just married a princess (or prince), it seems a bit unrealistic, don't you think?

INSURANCE

Do I need insurance?

Yes, especially to cover liability for clients in the studio. God forbid that Aunt Clara should trip over a wire. Keep the studio clean and uncluttered, and don't get the hot

lights too close to hair. Make sure you have protective screens on all lights in case a quartz bulb pops out. Keep makeup clean—use disposable puffs, or only the client's own makeup, with the client's brushes.

Should my photographic equipment be insured?

Yes! A robbery could put you out of business. It's worth the cost of insurance to have the protection of money for replacement.

CHARGING FOR YOUR WORK

Should I bill my clients, or have them pay when the pictures are taken? How can I be sure to be paid?

I suggest a one-third deposit, then you know they're serious. One-third more on the day of shooting and the balance when contacts are ready.

Should I charge more for double or family portraits?

Yes, because it requires special lighting and compositional changes that require much more time.

How much should I charge for doing an entire portfolio for commercial use?

Multiply whatever you charge for "headshots" by three. After all, you're working with at least six changes and you'll be working three times as hard. You'll be spending, say, three or four hours with your client instead of one or two. There are some photographers who will spend an entire day with someone, running all over town for location shootings. I seem to be more creative working under the pressure of only three hours.

Should I take pictures for free once I've set myself up in business?

Very selectively—or the word's going to get around that you're doing freebies! Close friends and relatives are just fine, and who's to know if they paid or not?

If a client wants reprints, do I charge for them?

Yes. Each additional 8x10, for example, is $5 or $10 for openers. This especially applies if you are doing your own lab work.

Should I charge a client who doesn't show up for an appointment?

Good luck. You can try it, but get a deposit in advance and you're covered.

Should I have a standard scale of prices, regardless of whether the shoot is at a wedding or office or in my studio?

Time is your main factor in charging. The more time you spend, the more money you should get. Location is number two. Time away from your studio should be more expensive to the client. The American Society of Magazine Photographers (ASMP) would be happy to send you a current listing of suggested fees for various jobs.

What about reshoots—who pays for them?

If you goofed—you pay for the film and processing. But, if it is obvious to both you and your clients that their hair or clothes photographed unsuccessfully—then they should pay for film and processing, or a percentage of the original shooting fee that you feel you deserve.

Can I become rich as a portrait photographer?

I doubt it. But you can make a comfortable living doing something creative and satisfying. There are a few who make it big, and while the chances are small, there's no reason why you can't be one of them.

KEEPING A GOOD THING GOING

Is it a good idea to keep a mailing list of clients, and periodically send a card or other reminder to get repeat business?

That smacks of a traveling baby-photo salesman to me. I'd rather work on continuous smart advertising and, more importantly, continuous good word-of-mouth. That's your best repeat business card. That's not saying that I don't send out Christmas or Hanukkah cards every year from my mailing list. Also use your mailing list if you're going to exhibit your work. Again, good judgment is your best advisor.

Will referrals be enough to get my business going, or do I have to spend money advertising?

If you've saved money for advertising, fine. Placing few modest ads in the local papers is good. Also, try the less expensive advertising handouts that charge little or nothing—we had one back home called *The Town Crier*. More important, attend those meetings at the Rotary Club, Jaycee's, Kiwanis, etc. I can't stress enough how important it is to continually circulate and be seen all over the place. This will impress people with the seriousness of your photographical endeavors. Of course, a certain percentage of any active photo studio's business expenses should be allotted for advertising. If necessary, cut out expensive restaurants for awhile. Put your income into what will bring future results in your business.

What can I do if business gets slow to perk it up?

Attend social events. Get on the phone. Become good at business lunches. They are fun and they are tax deductible. Advertise a bit more, or make your ad bigger. Offer specials, or a summer discount if recommended by a client, etc. Get your creative imagination going!

What should I do if I get too busy, and there are too many clients calling? Should I refer them to another photographer, or would that be giving my future business away?

Never recommend another photographer—are you crazy? If a client doesn't want to wait, leave the decision to him. But don't push him to the competition. If you're great, a client will wait.

Will starting as a portrait photographer help me move on to fashion photography? What other options will it open up for me?

Do you want to do portraits or fashion? They are quite different. It's possible that you might want to move into fashion photography after becoming a portrait photographer, but I'd prefer it the other way around. Portrait photography, to me, is the higher "calling."

If I think I have some great pictures, how can I sell them to magazines or newspapers?

Call up the picture editor—he's listed on the masthead. Tell him you're mailing that shot in, but enclose a self-addressed envelope just in case. It's often just a question of getting the picture editor on the phone and selling your work in order to get an appointment. Many magazines accept unsolicited photos but it's chancy. Better to get yourself an agent first.

THE LEGAL SIDE OF PORTRAIT PHOTOGRAPHY

There are several areas of legal matters that even the beginning studio portrait photographer must be aware of in order to avoid future problems. The two main issues are the use of model releases and determining who owns the rights to the photographs and negatives. There are a number of books on the market directed at helping the photographer understand these and other issues. It is a wise investment to buy and read these books, and have a solid background in questions of copyright, model releases, and rights for resale of pictures. You should be ready to cope with any eventuality that may arise in your business. Here are the questions I am most often asked in this area.

MODEL RELEASES

Should parents sign model releases for young people? How can I be sure I am adequately protected when I photograph children?

In your day-to-day business, releases for children aren't needed. However, the child's photo is to be used in your advertising or someone else's, the parent must co-sign a legally acceptable model release if the child is under 16.

What should a model release say? Is there a standard one?

This is an example of a standard release. It prevents you from being sued later on.

Who has to sign a model release?

Anyone whose picture is to be used by you publicly, to advertise either for yourself or your client. Legally, you must be covered if anyone's photo is used to advertise anything. Or, if that sexy shot of last year's girlfriend happens to appear in *Playboy* magazine or such and she didn't sign a release, she could sue your head off.

Adult Release

In consideration of my engagement as a model, and for other good and valuable consideration herein acknowledged as received, upon the terms hereinafter stated, I hereby grant _____, his legal representatives and assigns, those for whom _____ is acting, and those acting with his authority and permission, the absolute right and permission to copyright and use, re-use and publish, and republish photographic portraits or pictures of me or in which I may be included, in whole or in part, or composite or distorted in character or form, without restriction as to changes or alterations, from time to time, in conjunction with my own or a fictitious name, or reproductions thereof in color or otherwise made through any media at his studios or elsewhere for art, advertising, trade, or any other purpose whatsoever.

I also consent to the use of any printed matter in conjunction therewith.

I hereby waive any right that I may have to inspect or approve the finished product or products or the advertising copy or printed matter that may be used in connection therewith or the use to which it may be applied.

I hereby release, discharge and agree to save harmless _____, his legal representatives or assigns, and all persons acting under his permission or authority or those for whom he is acting, from any liability by virtue of any blurring, distortion, alteration, optical illusion, or use in composite form, whether intentional or otherwise, that may occur or be produced in the taking of said picture or in any subsequent processing thereof, as well as any publication thereof even though it may subject me to ridicule, scandal, reproach, scorn and indignity.

I hereby warrant that I am of full age and have every right to contract in my own name in the above regard. I state further that I have read the above authorization, release and agreement, prior to its execution, and that I am fully familiar with the contents thereof.

Dated: _____

(Address)

(Witness)

WHO OWNS THE RIGHTS TO A PICTURE?

Who owns the rights to the pictures—me or the client?

You do. Legally, the photographer owns his own negatives.

Should I copyright portraits I take of people, assuming that I might be able to sell them again in the future?

Only if they have a very special quality—I think too much of that "signing" interferes with your day-to-day operation. Once in a while you'll photograph someone who is quite exceptional that you want to use for modeling, or whose pictures you'd like to sell. In which case, definitely have them sign a release, and file for copyright when you feel it may prove worthwhile for the future.

Is there anything a client could sue a photographer for?

Assuming you've taken terrific shots, and not made any unauthorized use of them, and that you have a signed model release you can only be sued if there is an injury in the studio. (Tape down those wires and make sure there is a safety screen on those quartz lights.) By conducting oneself in the most professional manner possible in your personal approach to a client and in your work (barring a ridiculous accident), you are keeping yourself at a low risk level.

WORKING WITH CLIENTS

Though up until the time you started your studio, your greatest worry may have been learning to take superb pictures, now you have a whole new realm of techniques to learn—those that help you deal with your clients. People are people, and there are inevitable problems that can occur among a large number of clients. Establishing an organized procedure—including an interview a week before the session to determine what the client is looking for, a brief chat before the session to make sure your goals for the session are similar, and a standardized procedure for the session—keep my studio running smoothly. You will need to learn to make clients relax, and make a nonprofessional model look as though she were a top model in an agency; you will also need to learn to handle yourself professionally and act as the *director*, who draws out the best possible result from your model, your camera, and yourself.

THE INTERVIEW IN ADVANCE OF THE PORTRAIT SESSION

In the pre-shooting interview, what do you discuss with the client?

A pre-shooting interview is a good idea to help you get to know the client. Sometimes it's not possible, so you have to talk to him or her just before the shooting. But if you can find a half hour to talk to the client in advance, you look at his or her portfolio, discuss makeup, give advice on what to wear and how to fix his or her hair. Find out what you client expects to see. This is what the interview is for. The client gets to know you, and you get to know the client. When you both begin to feel at ease, it's time to take the portraits. The pictures will be all the better for your effort.

What do you talk about with a client before the session?

First you talk about nothing having to do with the photography session. You ask, "How are you feeling?" or you say, "That's a nice-looking dress (or suit.)" Start with the positives, and use good manners, as in any general situation. Sit down, relax with the client. After the general chitchat, ask what agent the client is with, and whether the client does commercial work. From that you'll know the "look" the agency is after. The agent may even have requested something specific from this shooting. Make sure you and the client agree on what "look" is desired from the shooting. You can look through the portfolio and see what's needed Sometimes people have pictures in their portfolio that are not bad photographs, but don't express their personality well. Talk to the client about what shirts or blouses to wear during the session. The main purpose is to find out specifically what they want out of the shooting.

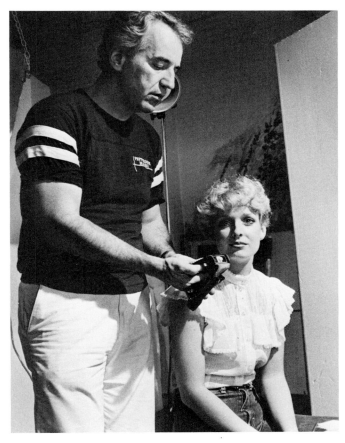

HOW TO MANAGE A PORTRAIT SESSION

How much time should a portrait session take?

One to two hours. That's enough, in most cases for head-and-shoulder shots. Some photographers like to spend a whole afternoon with a client, but I feel this is only necessary when working toward an entire portfolio. When the client arrives you've got to spend a few minutes chatting about anything but the shooting. Serve a cup of coffee or tea. Gradually get into talking about the purpose of the portraits.

What should clients wear for portrait sittings?

I recommend three or four different tops in light pastel colors. Avoid harsh blacks. Keep it sporty—the "preppie" look is always good, or a V-neck sweater over a simple-open-collared shirt. Beige always photographs great. For dressier shots use creamy satins, silks, or nubby-textured sweaters.

How many pictures should I take of a client?

Two rolls (72 shots). I think that's plenty, although often with some

clients who get into it very slowly, it's best to take another roll. I try to make every shot count and I don't shoot "off the cuff" hoping by chance to get a good one.

Is it a good idea to take a variety of shots within one sitting?

Make sure the client gets from you the basic shot that you both have discussed. After that, experiment with more over-the-shoulder positions, having your subject looking down or up at the camera, etc. I like variety, too, but don't have them look at the contacts and say, "But where's my commercial shot?" If they bring three or four different tops to the studio, each change will dictate a different mood or feeling. If it's a sporty look, then a fan in the hair could be discreetly used. Don't go overboard with tricks.

Whose artistic taste is more important in a portrait session—the model's, or the photographer's? What do I do if we disagree?

The photographer dominates the session. Otherwise the models can buy cameras and take pictures of themselves. In speaking to other professionals, I find that any photo session goes best when the clients put themselves into the competent hands of a "pro." That's what they are paying you for.

People seem to expect me to make them look better than they do in real life. What can I do about this?

Tell them they *could* be more photogenic than they realize. Start with their inside qualities—if you feel beautiful inside you'll look more beautiful. Pay attention to shadow-free lighting, add a diffusion screen, have them pretend they're a movie star on a movie set, or tell them this shot's going to turn on that love in their life. However, in the commercial business where

the head shots have to look very much like the subjects when they walk in, you can't overdo glamour or any other effect.

How can I take a good picture of someone who is nervous and tense? Is there something the photographer has to do to get the best out of his clients?

You've got to meet the client first; sit down and chat. Avoid cold calls: interview first. Offer them a cup of tea. Listen to their problems. Be reassuring. Unless they have come late, tell them that there is no reason to hurry. Start very low key and let their energy level build. Don't *ever* force them to smile. If you establish a nice rapport between you, them, and the camera, they will acquire a naturalness that is very professional.

After I've taken the pictures, should the client come back to look at the slides or contact sheets? Who picks which pictures are to be printed?

The professional thing is to stick with your client to the end. I have always made it a practice to meet my clients several days later to go over the contacts with them, usually with a loupe or lighted magnifying glass. We mark the ones we like with a red grease pencil, they live with them a day or two, put their order in for enlargements, and then we check out the enlargements to see if they need any retouching, etc.

What do I do if a client doesn't like the pictures?

Convince. Remember, you're terrific, but you're not a plastic surgeon. However, if they admit their hair or clothing was all wrong, then it's possible to take another roll, charging them only for film and processing. It's a very arbitrary situation, depending on the client's ego, *and* yours. On occasion, I

have charged half the original shooting fee if it was obvious to both of us that they just wanted some extra shots for their portfolio.

TIPS FOR WORKING WITH NONPROFESSIONAL MODELS
Could you give some advice for working with nonprofessional models?

Ask your client to look at current fashion and consumer magazines, and study what makes people look best. If your model wants to look professional and doesn't know how, show him or her the pictures in your gallery or portfolio, and discuss how they were made. Practice a session—pose your model under the lights and show him or her in a mirror how he or she looks. This goes for both men and women. Show them how they will look under the lights. Experiment. They'll quickly get a sense of what they expect, how to do it, and what is expected of them. A bit of practice, showing them how to sit for a portrait, can make them more confident. The photographer is the director of a situation, and as such you can ease a lot of a person's tension by working in a calm and professional manner.

How do I get a nonprofessional model to relate to a camera rather than me during a session?

Tell the client to look right into the lens. I tell them that if they're looking into the lens, they can even see my eye. Too many portraits show people looking into outer space—always try to get good eye contact between your subject and your lens. Eye contact is a more satisfactory, and contemporary, look. There is also a good reason for using studio lights rather than flash

units. Professionals, in particular actors, actresses, and models, love those spots, as the continuity of the light helps them maintain their concentration. Flash, on the other hand, is intermittent and very distracting. Actors love a spotlight. They exist for the lights and it brings out the best in them. Everyone has a touch of the actor in him and will respond to bright lights by role-playing for a little while. This is especially true when working with children. I tell them to pretend that they're doing a commercial. They watch TV more than anyone else, and they're familiar with commercials. Kids love to pretend to do commercials and the pictures benefit from such role-playing. With adults, sometimes I ask them to pretend they're a movie star and, instantly, they become glamorous. They feel pretty, and look better for the camera. Sincere flattery can be a big help, and it's true: under your lighting, with good makeup and poses, they do start to look their best. Many people leave my studio feeling better, having learned how to look better every day.

SUPPORT SERVICES
What other services should I be able to offer, or be able to refer my clients to—retoucher, printer, hair stylist, makeup artist, etc.?

A professional photographer should have all of the above at his or her disposal. I do my own makeup, and I suggest that clients go to a good hair person first. If I don't do my own printing, I hire the best in town. Quality should be apparent in every phase of your photography. Work with whatever experts you can find. If they are not available locally, then you become the expert at all of the necessary services.

How can I learn makeup skills so that my clients look really good? Is it necessary to know how to correct makeup?

You should know what looks good with your lighting situation. Learn from beauty magazines. Watch commercials. When a client is under lights, always take the medium route—nothing too dark or too light. Some local beauty schools offer makeup courses. If you don't want to go to it, send a relative or friend. Then there's always the local department store where they demonstrate makeup to sell. You can always watch and learn.

ON PROFESSIONALISM
Define "professional" in your terms.

Being on time is the first element of being professional. Your clients should be as professional as you are. They should arrive just before their appointment; they should have their basic makeup on so you only have to do touch-ups and slight changes; they should know what they're going to wear and have their clothes laid out; they should have a check in hand for the deposit. It's the idea of knowing how to interact with other professionals. The professional photographer should know what he is doing at all times, and have everything prepared and at hand so he doesn't have to fumble for things. The mark of the amateur is being disorganized, particularly on location. When you arrive at a session for, say, an executive portrait, when they see you set up your equipment and prepare everything, they know you're a pro and have command of the situation. It is evident that you know what you're doing. This comes only from experience. The professional has his equipment, attitude, and personality geared for a shooting—he's ready.

RETOUCHING

Since the aim of portraits is to make people look their best in most cases, there are times when the skills of a retoucher may be needed to improve on the relentlessly accurate eye of your camera. Retouching can make a good portrait better—but it will not save a poor one. If you enjoy the delicate work of retouching, fine. But if you'd rather employ someone else, that's fine also. The services of a retoucher will be needed in your portrait business, to undo an unfortunate flaw in an otherwise perfect portrait. Too many photographers count too much on the wizardry of retouchers, adding unnecessary expense to the portraits' costs. Try to shoot as well as you can, so that retouching is only needed for occasional problems. For example, don't count on a retoucher to undo shadows you could have corrected while shooting.

Do I have to know retouching to be a portrait photographer?

It wouldn't hurt, but it does take a while to learn it. Why not ask a local art student to practice until he's good—then he can charge a small fee. Most clients are understanding when it comes to retouching. They realize that you're trying to make them look their best. In any case, particularly in black-and-white, lines and shadows go a bit darker than in real life.

Can you explain what retouching can, cannot, or should not have to do?

It's better to shoot well than to count on the retoucher, whose work involves a great deal of added expense to your client. Retouching is the last resort. If you handle your lighting well enough, you can avoid most common errors that need correction by retouching. Most of the retouching I've seen was done to eliminate shadows. This is another reason I try to imitate outdoor lighting with straight-on light, which reduces shadows. Black-and-white does exaggerate lines, though. Any slight shadow, such as those under the eyes, or laugh lines, will come out a bit darker. However, these areas should be lightened with makeup beforehand to minimize retouching later. Common faults that need retouching are: shadows under the eyes, complexion problems, glare on the teeth, deep-set smile lines. Remember, though, the picture has to look like the person, so don't overdo it. Especially for commercial purposes, the retouching has to allow the photograph to remain realistic. But there is no reason why a person can't look his best in a portrait. Hot spots on the eyes caused by several lights can be retouched out. Leave one—take out the extras. If you leave them in, it's distracting, and the eyes look as though they are moving.

My philosophy of retouching is that if you don't see it in real life, why should you see it in the photograph? The photographic printing process can emphasize even the smallest facial flaws that might otherwise go unnoticed. This is especially true in black-and-white photography, where the grain will cause anything with a bit of shadow to go darker. This can apply to lines and circles under the eyes (even with the best of makeup and lighting). Also, any blemish with reds in it will photograph a bit deeper, so make sure makeup is offsetting it.

A good case in point is the photographs at left. In real life, the model has lovely teeth and they have photographed beautifully in many of her portofolio shots. However, in this portrait the shadow from her upper lip is falling on her teeth to make them appear darker in the line between the two front teeth. She also had some unattractive lines around the mouth.

Using a very thin scalpel knife, I slowly, very carefully, scraped away the grain emulsion, thus lightening the shadow. Whenever the knife caused a scratch (you'll know when you see the white of the paper) it was eradicated with the use of retouching ink, which is available in any art supply store.

This method of retouching takes a lot of practice—using old photos. It is a very delicate balancing act—not too dark, not too light, not overdone, not underdone—that always aims toward keeping the photograph looking as natural as possible.

ORIGINALITY, STYLE AND CREATIVITY IN PORTRAITURE

Some photographers may think that portraiture isn't as "creative" as some of the well-known glamorous professional photographic opportunities—but this is not true. There is room for a unique style, creative work, and even for the development of greatness in portraiture. Think of Youseff Karsh and Arnold Newman and other well-known portrait photographers. They have influenced the world with their images. In portraiture, the photographer and the client have to work out an idea of the kind of images they are after. Realizing the client's goal is in itself a creative challenge. After you've gotten the shots the client wants, you can try other techniques and effects, and go for an unexpected and unusual portrait. Of course there is individuality and self-expression in portraiture! No two portrait photographers take the same picture of anyone. If you strive for quality, your own unique vision will create a style that will become known as *yours*.

Is it possible to have a unique style in portraiture?

Striving for excellence will help you to develop your own unique style—it will come mainly out of your positive personality and enthusiasm for your work. If you have the spark—you will light the fire of style. Excellent lighting will certainly contribute to your developing style.

What's the worst mistake a beginning portrait photographer can make?

Taking bad pictures! You can't become anything overnight. You've got to study with someone, or at least buy books like this one first. You shouldn't start out unless you're ready, and don't inflict yourself on the public until you are. *Quality* and *professional* should always be your bywords.

What are the qualities of a good headshot?

Good lighting, good makeup, nice clothes, and professional printing and developing. Quality is the result of working with a top-notch team all the way through to the finished prints. If the photographer thinks only in terms of high quality, he's going to get high quality. Don't settle for less than the best in any stage of your work. For a headshot, capture the personality of the subject with good lighting, sharp focusing, and your own inimitable style. Always maintain eye contact. Composition and tonal range should also be given serious consideration. There are many examples in this book.

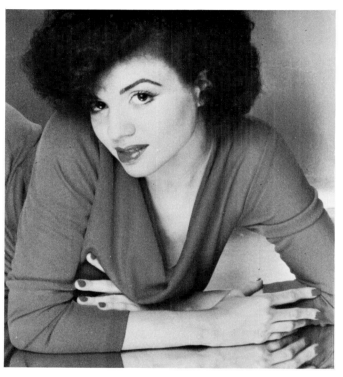

Are compositional experiments acceptable in portraits?

You should experiment. You don't want a contact sheet to look like a row of postage stamps. Everybody has angles that are better than others. Only commercial headshots require strict, straight-on pictures. For other portrait work, ask the subject to turn his or her head, try three-quarter views, put a fan on the air (not too much!), have the subject looking over a shoulder, and change the placement of the face within the frame.

When is it all right to try special effects in portraits?

After you get the basic shot—the one everyone will relate to. Then you can feel free to experiment. Listen to what the client really wants. You're not going to use "romantic" lighting or diffusion filters on corporate executives. Nor do you want engagement photos to look like harsh, documentary street photography.

Does "portrait" just mean a picture of someone's face? Could it also be a portrait of someone doing something, or walking around?

Sure. Have them sit down first. Mom can be sewing and then suddenly look up. Have Joey do the same as he is fixing his bike. These can be genre portraits and very real and attractive. I've had subjects run toward me and then I snapped as they got into focal range. It's fun, but you don't do it with everyone.

Do portraits age? Is there anything I can do to make sure people will still appreciate the portraits many years later?

If a picture is overly stylized, it will go out of date quickly, though there are times when I'm really inspired to document a specific current style or trend. For commercial portraits, the profession demands that the pictures be an accurate view of the person—this means no distracting clothes, just a simple open-collar look with a simple hairdo. In general I try for a classical kind of portrait for everyone, although it's fun to try for more glamour, more style. But it's the face that counts. I try to photograph people in such a way that their portraits will remain attractive and in style for a long time.

Are there "styles" in portraiture that come and go? Should I change my style from time to time, or is it better to become known for a certain "look?"

A "style" will come out of your own individual approach to your subject. If 10,000 photographers are using two strobe umbrellas, the style of the lighting will be the same, and perhaps a trifle bland. Only the subjects will *look* and dress differently. Add *your* personal interpretation and yours will be different from all others. I feel each subject deserves to be well lit, with no overpowering shadows. The second main ingredient is the personal style—*your* very personal approach to your subject. Basing your indoor lighting on the naturalness of outdoor lighting will give the portrait a timelessness that transcends "come and go" styles. Get known for your *natural look* and you'll always be in demand.

TIPS FOR BETTER EXECUTIVE PORTRAITS

Many executives need portraits for annual reports, promotions, in-house publications, and other uses. Local newspapers often need portraits of executives in the news. So you see, there is a large market for just this kind of portrait alone. Take a look at your newspaper and an annual report or two to see the kinds of executive portraits that are used. These portraits emphasize the leadership abilities of the individual, and may show him at his desk, in the boardroom, or even standing in front of a new factory. Many new portrait studio owners forget the potential in executive portraits. Here are some of the tips I've given in response to questions about developing this area of portraiture.

What kind of situations are best for executive portraits?

Photograph the executive sitting at his desk. I use a 50mm lens, because in this case I'm not interested in a head-and-shoulders shot, but rather the executive in his environment. The environment tells about his achievements and stature. Usually executive portraits are from the waist up, or leaning on the desk. The subject can look friendly in such surroundings, while at the same time expressing his command of his business.

How much should I charge for executive headshots?

You should add at least an hour's rate, but doubling your ordinary portrait rate is in line. Remember, this is location work—it takes you time to go there, take the photographs, and get back to your studio.

What is the best way to handle lighting for an executive portrait?

If you want to bring lighting equipment, try a two-light setup. Bring two spots and use one as backlight, one as frontal light. Put a white card on the desk to use as a reflector, as long as it doesn't show in the finished picture. Take plenty of extension cords, and be careful not to overload the electrical circuits. You don't need hot backlighting in this situation—a small, 150-watt flood will suffice. Sometimes I take two umbrellas and two strobe units on location. For a number of executives in the same location, try to find a room you can use as a temporary studio, so you can set up your lights and get consistent portraits. Again, two lights will be enough—one for the background and hair, and one in the front.

TIPS FOR BETTER PORTRAITS AT WEDDINGS AND OTHER FAMILY EVENTS

Weddings and other special occasions offer a wide range of opportunities for candid and formal portraits. Meet with your clients in advance, find out what they expect in their pictures, and do your best to meet those expectations. You can set up a formal portrait session in the studio for portraits done in that controlled setting, and you can work spontaneously, taking pictures during the ceremony and celebration. There are opportunities for some special effects and techniques in order to express romance and all the positive emotions inherent in the event. Here are some questions and responses that will help you make the most out of pictures in these situations.

Should I try to use studio lights at formal ceremonies?

I take a flash unit, but try to do as much as possible with available light. Take a battery pack if you're going to use a flash—you don't want to miss the event because you're looking for an electrical outlet! Make sure your battery pack is in good shape before you leave, and, if you have to, recharge it the day before. One flash unit, used imaginatively, is enough. Remember to use a reflector card to soften pictures—wedding pictures are romantic and should express the emotions of the ceremony and reception. You can use filters for creative effects, but keep the look romantic for the serious, still situations, and do creative documentation of the rest of the wedding experience. Look for the personal, intimate, fleeting things that occur at such gatherings.

What ideas can liven up pictures taken at weddings?

Try to avoid horizontal lines in the picture. Take romantic shots above all, but watch the backgrounds and get action shots. Find locations with built-in frames—any kind of arch behind the couple is nice. Look for the background shots that candidly express what went on at their wedding. Try framing the foreground with the flowers she's carrying; always try to include flowers in the picture. I usually use a wide-angle and a 50mm lens at weddings so I can move in and out faster. A midrange zoom is very useful for candid shots. Try to get the story of the wedding on film—pictures that cover all the events, and fall into a beginning-middle-end pattern. Make sure you

take an assistant with you to carry an additional camera preloaded with film. The worst thing that can happen is to have the bride and groom arrive at the altar and you discover you've used your last frame. Make sure that second camera is all ready and, at the most, all you have to do is put your lens on it. There are many beautiful backgrounds in a church—particularly stained glass windows and altars. Everyone loves those silhouette shots—take your exposure reading from the light behind them and don't use the flash. Do a silhouette with the couple's hands and lips together. At the reception, make sure you get a picture of the cake cutting, the throwing of the bouquet, and the couple saying hello to relatives.

What ideas can you use for couple and family portraits to make them more interesting than usual?

Again, break up the horizontal—do anything that breaks a static arrangement of faces: a pyramid, a diagonal, one head above the other, people peeking around a door for informal portraits. With a couple, have one person behind the other, kneeling with a hand around the shoulder of the forward person—not on top of the shoulder, just below the shoulder—with the face peeking over, in the same focal plane as the forward person. Try cheek-to-cheek poses. Portraits where the couple is simply sitting next to each other are just boring. This does not necessarily mean that the person who is in the farther position has to be the man, or the parent in a child-parent shot. Experiment with poses and visual relationships.

TIPS FOR BETTER COMMERCIAL PORTRAITS

All models, actresses, and actors need a portfolio filled with top-notch, current "headshots," which they use to show agents that they can do films, television commercials, and other opportunities. The work a commercial client has in his portfolio generally fits a certain format, as follows: several headshots, taken both indoors and outdoors; several medium-length shots that are often fashion-oriented; several full-length shots that are often fashion-oriented action shots; and a composite of a group of shots expressing different "roles." Commercial portfolios are a terrific opportunity for a portrait photographer, because these models, actors, and actresses constantly need updated portraits and can become regular, repeat clients. Find out who in your community falls in this category, and find a way to contact them.

What should be in a model's portfolio?

Six or eight different changes—something sporty, something dressy, some casual clothes. Take them to various locations outside.

How often should a professional model or actor re-do his or her portfolio?

Every one or two years. However, the good ones are constantly adding to their portfolio as they delete older shots.

Is it true that professional models are difficult to work with?

On the contrary—even the big names are very professional. They come to the studio knowing exactly what's expected of them, and they perform for the camera accordingly. They make big bucks—so why should they bite the camera that feeds them?

What do actors, models, and agents do with headshots?

Actors and/or models mail in their headshots (8x10) or composites to agents, who receive hundreds of these every day. If the shot is good and the agent sees something he likes in the face (it is clear that the individual is a professional, and the shot is interesting and really stands out from all the others that agent receives), he'll call that person for an interview. Then those shots go in a file.

What is a composite?

A composite is two or more photographs of the same person in different situations. When I do a portfolio, for example, I may have someone playing tennis, drinking a can of soft drink, and then a close-up headshot. I think an ideal formula for a composite would be a headshot, a medium shot, and a full-length shot. You can get as many as five on a page.

Michele Ferguson

Height: 5'6'' Size: 4-6 Bust: 34 Waist: 24 Hips: 34 Shoe 7½ Hair: Dk. Brown Eyes: Blue/Green

How should a commercial headshot be printed?

An 8x10 glossy, of as high quality as possible with a full bleed (no border). For large quantities the client often goes to a local offset printer.

What's the best lighting to use for fashion-type portraits?

Some of the best fashion shots are runway work, where I've used one on-camera flash, and shot as the models come by, moving to music—the shots are fantastic. Often there's a stage behind them, which makes a great background. Fashion is clothing, movement, and good-looking people. In some magazines, they're starting to pose people as if they were in 1930s Hollywood movies—draped against pillars, using strong lighting with shadows falling behind them. The image is one of total elegance. Strobes are ideal for showing the movement of the person and the clothes. Men's fashion usually doesn't involve movement—the models are usually standing still, leaning against a doorway or wall. In recent years a more casual look in fashion photography for men has been introduced. It is easiest to use outdoor lighting for fashion. Try having your model come up a stairway in bright sunlight which shows the clothes well. Just turn the face away from the bright sunlight. The fashion look, in portraiture, or for straight fashion work, means you use the mood the outfit dictates. If a man is wearing a tweed jacket and an open-collared shirt, make sure he is photographed in a comfortable situation. If he's in a tuxedo, the situation is more formal. Clothing can determine a lighting setup—how dramatic it should be and how dominant.

SPECIAL TIPS FOR PORTRAITS OF MEN, WOMEN, AND CHILDREN

A fine portrait photographer knows exactly how to best emphasize beauty in a woman, spontaneity in a child, and masculinity in a man. Certain posing, lighting, and makeup techniques that become second nature to a good portrait photographer apply for portraits of men, women, or children. While many of the tips included here are scattered throughout the specific lighting techniques presented in the book, for the reader's conven-ience I have grouped many of the important ones together here. I have also included a listing of techniques that are particularly well-suited to either men, women, or children. This does not mean that any technique can only be used for one and not the others—the photographer should always feel free to experiment with and alter the techniques to suit his or her creative needs.

Are there any different techniques to use for portraits of women and men?

Yes. Men should be shaded a bit more. Avoid shadows (except for checkbones) on women's faces. Men seem to favor more contrasty lighting, in order to bring out the bone structure. We seldom think of women as having bone structure; rather, we say that they have "great cheekbones." With men you shade the top of the cheek-bones—with women you shade under them. Men have more angular faces. Yes, you use makeup on men sometimes, but only tan, earthy colors, and you put it on top of the cheekbones. For women, you use blushers under the cheek-bones to bring them out. You don't have to do anything to bring out men's cheekbones—usually, they are evident anyway. You photograph men to bring out the angularity of their faces. You can use more contrast with men—more light on one side, deeper shadows on the other. For women, try to get a softer, straight-on lighting setup. Emphasize the cheekbones. You always keep a man's face straight up and down. Any angle weakens the portrait—men's faces should represent strength. The gaze into the camera has to be different from a woman's—don't ask a male model to lower his chin, or tilt his

head, just to look straight and firmly into the camera. You can photograph a man with a straight-on spotlight—the shadows will flatter the angularity of his face and features. If you used the same spotlight on a woman's face with a reflector, you'd get an appropriate, softer, rounder look. You can go for more texture in a man's face. For a woman, you want to keep the portrait soft and light. Some of the techniques in this book that are especially well-suited to men's portraits are techniques 7, 14, 34, 48, 49, and 50. The lighting setups most complimentary to women are techniques 1, 10, 12, 13, 21, 27, and 43.

Are there any special techniques to use when photographing children?

Yes. Have a galaxy of props like fake food to play with. Tell them they are doing a commercial and make it play time—not a chore. Take them outside where they'll be more relaxed—it's *got* to be fun for them. Try to photograph children out-of-doors, or in bright, even lighting—no shadows should fall on their faces. Always try to keep Mommy in the other room (she has a tendency to want to direct). The techniques that represent the best lighting setups for children's portraits are techniques 16, 17, 19, 23, 32, 33, 36, and 37.

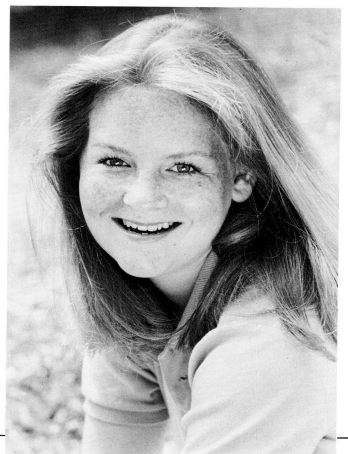

INDEX